# Master Drawings

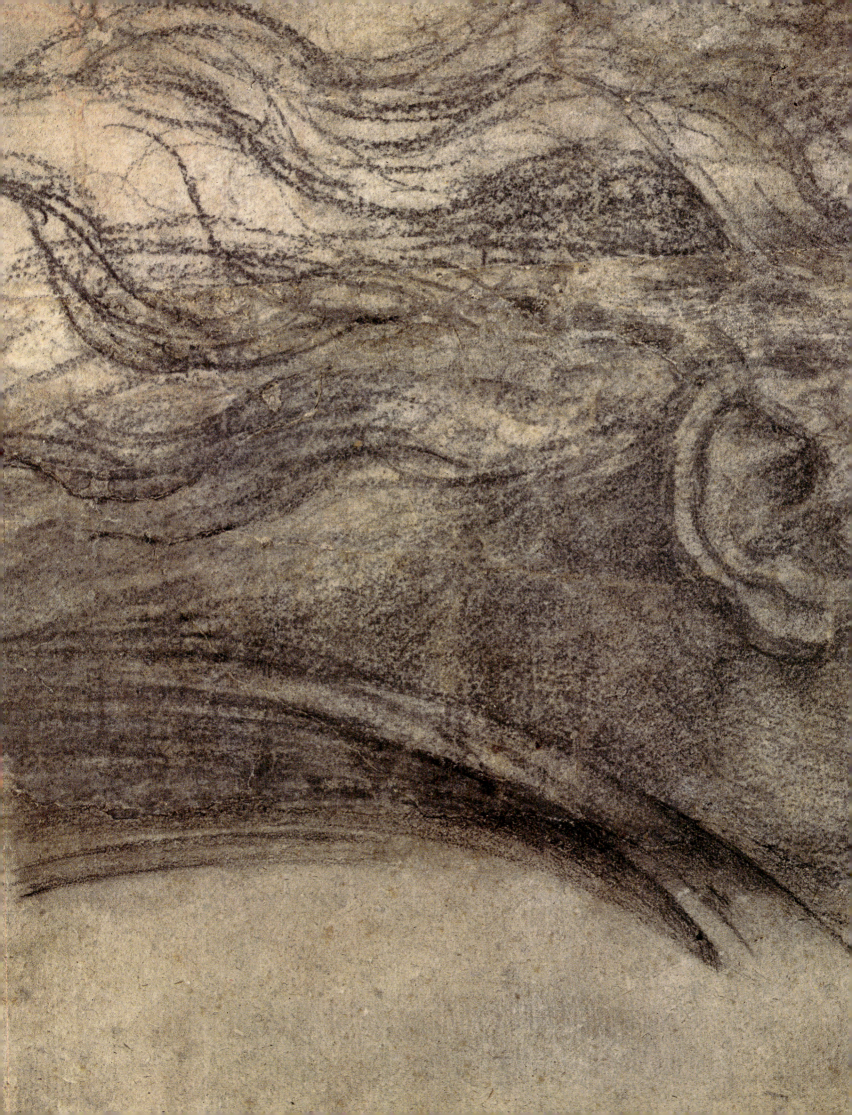

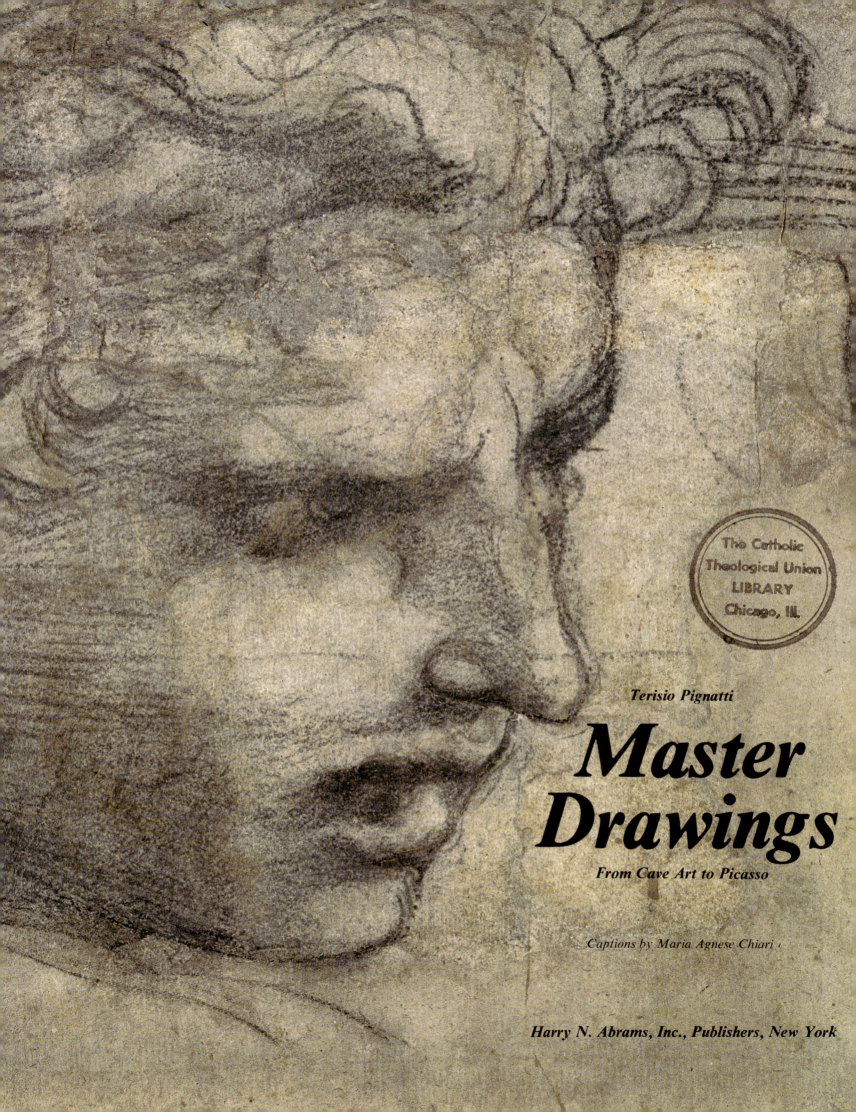

*Terisio Pignatti*

# Master Drawings

*From Cave Art to Picasso*

*Captions by Maria Agnese Chiari*

**Harry N. Abrams, Inc., Publishers, New York**

Jacket and frontispiece:
Raphael: *Head of an Angel* (detail)
Musée National du Louvre, Paris

Library of Congress Cataloging in Publication Data

Pignatti, Terisio, 1920–
    Master drawings.

    Translation of: Il disegno.
    Bibliography: p.
    Includes index.
    1. Drawing.   I. Chiari, Maria Agnese.   II. Title
NC52.P513   741'.09   82-4048
ISBN 0-8109-1663-0   AACR2

Translated from the Italian
by Sylvia Mulcahy
© 1981 Arnoldo Mondadori Editore,
S.p.A., Milan
English translation © 1982
Arnoldo Mondadori Editore S.p.A., Milan

The extract from Cennini's *Il Libro dell'Arte*
on page 15 is taken from Daniel V.
Thompson Jr.'s translation (New Haven,
NJ, 1961).

Printed and bound in Italy by
Officine Grafiche di Arnoldo Mondadori
Editore, Verona

# Contents

# The Great Draughtsmen
# from Antiquity to the Present Day

**Primitive Drawing
in Greece, Rome
and Byzantium**

For how long has man felt the urge to draw? For centuries? Millennia? Since the Stone Age? And how has he drawn? What has motivated him? Anthropologists have been seeking to answer such questions as these by studying the art of primitive peoples of the present day. Their reasoning goes something like this: if a tribe of hunters, living in isolation in the African or South American or Australian jungle, completely devoid of any trace of civilization, is found to be practising some form of decorative art (as distinct from its traditional crafts), then it follows that graphic art has existed for as long as humanity itself. Further, these primitive people will be using almost exactly the same techniques as their prehistoric forebears, who lived thousands of years before Christ.

The art of drawing has always been an integral part of human life. It seems justifiable, therefore, to regard such examples as can be found in the lifestyle of contemporary primitive people as analogous to the artistic traditions of those who have vanished into the mists of time. Nevertheless, this tantalizing hypothesis contains a shadowy area of doubt for it is a fact that, when certain semi-primitive peoples such as pygmies or Bushmen have been asked to demonstrate their skill at drawing, the results have been inferior to the work of their much more savage prehistoric ancestors. Not only do their techniques appear to be inferior: their imagination also seems to be lacking, and they give the impression sometimes that their desire to create figurative work has been extinguished. However, even if the primitive peoples of today are unable to re-create for us the precise way in which their distant forebears depicted scenes from life as they saw it, the principle is still valid, in so far as we can at least recognize certain expressive tendencies and the techniques involved in realizing them.

Between 20,000 and 15,000 BC, primitive man found an outlet for his artistic expression by making rock pictures in which he depicted subjects with which he was familiar. These included domestic and wild animals, hunters with bows and arrows, warriors with lances, and even ritual dances and magic symbols. Through such work he felt he was appeasing the forces of Nature which, for him, were personified in the gods of hunting and of fishing. It was customary, too, according to a tradition which is still observed in many parts of the world today, to carve or draw on a tangible surface a simple outline of the animal that was to be hunted or of the enemy to be overcome. This representation of the 'victim' assumed a magical significance, almost as though man were trying by this means to ensure the capture of his prey. Alongside social, animistic and religious motivations, of course, ran the artistic streak too, demonstrated with great clarity in such examples as the

rock carvings already mentioned. Communication through a graphic medium had been achieved. In close harmony with the anthropological motivation, man's irrepressible poetic sense now began to emerge.

Just how many of the figurations that have survived the centuries are actually drawings, that is wholly artistic representations motivated by artistic impulses as distinct from mere painted likenesses, it is difficult to establish. Probably the only way to arrive at a definitive answer is by closely examining the techniques. The prehistoric artist worked with a pointed black stone or a piece of charred wood (a form of charcoal) on a white background; he would then either colour or shade in the areas within the outlines he had drawn, usually using red ochre or a brown vegetable dye, either of which was often blown on to the picture through a reed. The pigments were then fixed with some kind of oily substance or with white of egg. We can therefore most certainly describe these early efforts as drawing in the artistic sense. The dark lines stood out boldly against the light-coloured rock – which had sometimes been artificially whitened – with burning vitality; there was a constant tension, an expressive existential rhythm. In the initial phase, at least, there can be nó doubt that much of the figurative work was drawn as an artistic expression, if we are to regard 'drawing' as described in some dictionaries as the outlining on a surface of shapes which can then be enhanced by the application of close parallel lines (hatching), light and shade, colours, and so forth.

*Prehistoric engravings on a pebble, from La Colombière*
Cambridge, Mass., Peabody Museum of Archaeology and Ethnology

I believe it is fair to say that the most outstanding evidence of primitive artistic drawing of this kind can be seen in the caves of Altamira, near Santander, Spain. These pictures, which were discovered by chance in 1869, are in a cavern only a little over 6 ft. 5 in. (2 m.) high, yet they are of gigantic proportions. A herd of life-sized European bison extends all round the walls, the huge, clumsy bodies and long pointed horns giving the impression of a pounding force of legs and hooves. Some of the beasts are depicted as they charge their predators, while others are shown resting. The expressive power of these graphic studies, given particular emphasis by the use of charcoal, is such as to suggest a vibrant tension that seems to bring the animals to life, to quite frightening effect (p. 41).

The cave-paintings at Lascaux, near Montignac, France, may also be from 13,000 to 15,000 years old. The graphic quality is particularly prominent in many of these, especially in the long frieze in which deer are depicted fording a river. The linear effect is essentially based on the sharp definition of the great antlers, which are seen from a typically contorted perspective, the heads being turned to face forwards, while the bodies are seen in sideways profile (p. 42). This profoundly naturalistic art of a people who lived by the chase, and who were themselves a part of Nature, displays a technical knowledge and a sensitivity to graphic art that was already very advanced.

Other prehistoric examples that have survived the years are to be found, in the form of rock pictures, at Les Combarelles, Niaux, Trois-Frères and Font-de-Gaume in France, at Wadi Giorat in the Sahara, as well as in other caves in North Africa. One feature that they all have in common is that the drawings – executed in charcoal or manganese black – were clearly conceived with a view to subsequent coloration.

In the absence of evidence of any kind of paper-like material, a number of pebbles have been preserved from prehistoric times on which numerous figures of animals have been scratched. The fact that such drawings are frequently superimposed on each other, creating an apparently confused jumble of lines, seems to support the idea that these

may well have been used as trial-and-error tablets on which the drawings to be executed were casually positioned, just as for many centuries artists have used sketchbooks to try out particular effects.

It is clear therefore that drawing has always been one of Man's activities throughout the ages. Fundamental to this universal skill has been the discovery of the importance of line, which is, after all, an exceptionally pliable figurative element. Thus the miracle of linear art first found expression in the mysterious gloom of those prehistoric caverns.

As we move forward into the early centuries of recorded history, the surviving evidence of graphic art seems to diminish rather than proliferate. Very little can be identified, for instance, from the Sumerian civilization, that could be described as graphic art. Rather than depicting figurative shapes, these people – who flourished three thousand years before the birth of Christ – were more interested in experimenting with designs related to their hieroglyphic and cuneiform characters. The concept of drawing as an art-form becomes clearer, however, from the civilization of Ancient Egypt in the third millenium, and the imperial age of Rome. In fact, the technique of wall-decoration known as the fresco certainly involved the making of preliminary sketches *in situ*; these outlines were generally executed with brush-point in red and were only partially concealed by the final painting. In many of the more beautiful frescoes, such as the extremely realistic ones executed during the period of the New Kingdom (1567–1329 BC) in the Tomb of Nebamon, the colours have been applied in delicate shades of deep blue, ochre, sky blue and pale green. These are individually bounded by precisely defined outlines which, in their crisp yet fluid distinctiveness, produce a fresh and vital effect (p. 43). During this period, the artist would make preparatory work-drawings by sketching on flat pieces of terracotta, *ostrakas*, some of which can be seen in the Egyptian Museum, Cairo.

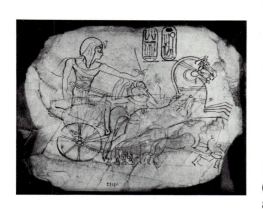

*'Ostrakon' with Pharaoh in his war-chariot*
Cairo, Egyptian Museum

From the Phoenician, Hittite and Mycenaean civilizations of the Mediterranean, nothing of a pictorial or graphic nature remains to us at all. In Crete, on the other hand, many pictures have been preserved which can be dated to between 2500 and 1500 BC, but it is not easy to distinguish any element of individual artistic expression in their iconic rigidity.

The Greeks were particularly active in Attica during the last thousand years prior to the birth of Christ. Although their main means of artistic expression was through architecture and sculpture, a great deal of this work contained important graphic elements, at least in the creative process. The painted vases of the period are an excellent example of this. Their decoration consisted at first of black figures whose anatomical features were emphasized by incised lines; a little later on these figures came to be executed in red, especially in Athens.

Even more attractive are the pots on which figures were painted on a white background, the best examples being those dating from the fifth century BC. These are the famous *lekythoi*, so called because of their distinctively elongated cylindrical shape; the design was first drawn in dark, opaque colours with brush-point, giving a similar effect to that of a quill pen used on parchment (p. 44). A wonderful fluidity of line distinguishes this technique, which more than any other approaches the modern conception of artistic draughtsmanship.

It is only through literary sources, in which the history of art has been meticulously documented, that it is possible to gain some inkling of the remarkable technique and surprising realism of artists in the fifth to third centuries BC. Such artists as Polygnotus, Apollodorus,

9

Parrasius, Zeusus and Apelles achieved fame in their time, but it is only thanks to historians that we know of their work. These masters of their art all exercised their drawing ability in the planning stages of their work, in addition to using it as an entirely separate art-form. The Roman historian Pliny the Younger mentions the use of wooden panels which were prepared with a white background made from powdered bones; he also refers to parchment on which the artist would draw with soft metal points made of silver or lead. As a result of training in this medium, the pupils of Parrasius learnt the techniques of graphics and painting.

The Romans, due to the importance they gave to architecture and sculpture – perhaps because these afforded more scope to the glorification of political greatness – left little room for drawing as an art form in its own right. Indeed, Roman painting during the early Empire, the best examples of which are in Pompeii and Herculanium, was typified more by its pictorial quality and colour than by linear and graphic characteristics.

On the other hand, a definite awareness of the expressive possibilities of graphic media can be detected in Byzantine art. The return to draughtsmanship as an art-form was probably due to the tendency in Byzantine painting to dispense with the illusion of reality, and to concentrate on stylization and the transformation of natural things into unreal symbols.

There was also that strange, isolated culture that developed in the peninsula we now call Italy between the sixth and fourth centuries BC. This was the Etruscan civilization. Because of their religious beliefs, the Etruscans used their artistic skills almost entirely in the decoration of their tombs. The graphic qualities that predominate give great linear energy and emphasis to the idea of movement. Fine examples of this can be seen in such well-known tombs as the *Tomba degli Auguri* (Tomb of the Augurs) (p. 45) and the *Tomba della Leonessa* (Tomb of the Lioness).

**Asia and the Far East**

At least two thousand years before the birth of Christ, a remarkable tradition of painting developed in India, alongside other art forms, of which the best examples are to be found in the rock sanctuaries of Ajantā. These are frescoes inspired by themes illustrating everyday life and court ceremonies in that part of India.

Whilst it is difficult to identify traces of drawing as such in what survives of Hindu art, we can detect them in some of the later illustrations of sacred and profane texts on decorative tiles or painted panels. The illustrations in the codices, which were executed on palm leaves in Southern India, also come under the category of drawings. In these, the outlines were first incised with a stylus and then darkened with coal-dust. The Bengali technique, however, was to prime the ground surface with plaster. It was not until after the introduction of paper from Persia in the fourteenth century AD that there was any real artistic draughtsmanship in Indian art. This showed itself particularly in the form of black-ink sketches on a light background, and these were known as 'Persian style' (*iráni qalam*) drawings. After 1600, however, this form degenerated into ordinary illustrative work to appeal to the popular taste and no longer purported to be creative art. Hindu artists also made use of doeskin to make drawings for tracing (*carba*) and these sometimes displayed genuine graphic characteristics.

With the advent of Muhammad (AD 622) and the foundation of

Islam, a new, important trend began to develop in the Middle East which had a strong influence on the surrounding civilizations, particularly India. Islamic art grew out of the convergence of various cultures, incorporating such basic elements as the linear arabesque from the Arabs, geometric ornamentation from the Turks, and pictoral imagination from the Persians. The Islamic religion itself tended to concentrate artistic attention on ornamental and abstract features which favoured the development of an essentially graphic form of expression. Reproduction of the human figure was, of course, totally prohibited in religious iconography, but did appear in illustrated manuscripts, achieving very high levels of excellence in miniatures and in the rare frescoes that adorned some of the patrician houses. From the beginning of the thirteenth century, the miniaturists were organized in workshops under the protection of the courts, engaged in illustrating the epic poems and stories of the period.

With the establishment of the Tamerlane (Timur the Lame) dynasty, Persia became the centre of Islamic art. Painting continued to develop in the following period under the Safavids, colour and graphic qualities becoming increasingly refined. The frescoes by Reze-i-Abbasi in the Ali Qapu palace at Isfahan are fine examples of this work. After 1500, the influence of the Persian miniature spread even to India, where it contributed to the growth of the calligraphic school in Kabul. The resulting style was called 'Mogul' in India and was distinctive for its narrative tendency, which was expressed in essentially graphic terms, as well as the rich chromatic qualities of its ornaments.

In about 2000 BC, the artistic culture of the Chinese was beginning to take shape. In order fully to appreciate the qualities of figurative Chinese art, it is essential to consider its technicalities. Above all, we must remember that there is very little difference between painting and drawing in Chinese art, as a brush is always used for both. Such difference as there is lies in the way in which the brush is used. For instance, the ink may be applied in rather even strokes, that is 'linear profiling' (producing an effect very similar to our concept of drawing) or it may be used to give tonal variety, the 'calligraphic touch', to achieve effects that could be more specifically described as painterly.

In the oldest drawings, which were produced during the first century AD – and particularly in the T'ang dynasty (AD 618–907) – the linear effect prevailed, achieved by means of the controlled and sparing movement of the brush. In the pictures painted on silk, where the calligraphic brush strokes are lighter, the colours invest the drawing with delicate shadings, creating an atmosphere of timelessness. An artist whose work typifies this style is Chou Fang; he lived in the eighth century AD and worked in one of the courts (p. 49).

For thousands of years the Great Wall was not only an impassable military bulwark in the defence of China but also, and above all, the perfect frontier, with its powerful symbolic significance. China's place in the field of figurative art was therefore totally unassailable. Nevertheless, it is possible to sense that, in some very ancient Chinese figurative art, there is an echo of links with primitive cultures unrecorded in history, transmitted mysteriously through the brushes of those early artists. Some of the ceramic plates, for instance, which are decorated with raised brush strokes and which date from soon after the birth of Christ, may well recall the representative expressiveness of the prehistoric rock drawings. It seems not impossible that contact may have been made between migratory peoples

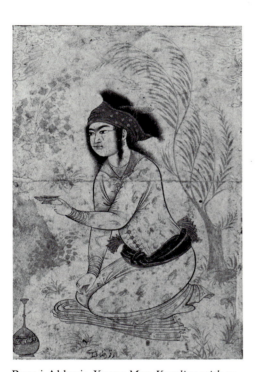

Reze-i-Abbasi: *Young Man Kneeling with a Cup of Wine.*
Washington, DC, Freer Gallery of Art

in those Dark Ages before history; these nomadic tribes may well subsequently have become scattered throughout various regions, far away from each other, but still retained something in common in their deeply rooted means of figurative expression.

With the spread of Buddhism from the sixth century onwards, the figurative arts acquired a common theme in innumerable representations of the Deity. Then, as the Taoist and Confucian religions became established, Chinese artists adopted a more liberal approach to the life of Man and to Nature. For example, drawings depicting landscapes proliferated, particularly in the T'ang and Sung dynasties (AD 618–1260), their charm and freedom of style becoming the basis for the same themes right up to modern times. It should be remembered, of course, that the countryside has a profoundly religious significance for the Chinese artist, since it reflects 'the universal soul' of the world. To achieve the required effect, linear strokes are used in conjunction with soft washes of watercolour applied with a brush with delicate unevenness (pp. 50–1).

During the Yüan dynasty (AD 1271–1368) naturalistic themes were developed, as well as those relating solely to scenery, including animals and the human form (p. 52). Not even the Mongol invasion, led by Genghis Khan at the beginning of the thirteenth century, could stop the work of the Chinese painters. Among these, one in particular stands out: this was Wu Chên, who discovered the graphic and painterly qualities of the bamboo plant. He found that, in depicting its leaves with a brush, the ink created magical effects of transparency and mobility (p. 53).

The next dynasty, the Ming (AD 1368–1644), saw the painting and draughtsmanship of Chinese artists reach its peak; it was during this period that they perfected their techniques. In the rarified atmosphere of the Peking court, a wide variety of figurative work was produced, including a great deal of portraiture (p. 56). The greatest masterpieces in the graphic sphere were, however, still to be found in landscape work, and it was the painter Tu Chin who was particularly outstanding. The graphic style was becoming increasingly free, with a technique of brush-strokes that we would now call Impressionist in the artists' attempts to catch the effect of light on a subject, giving the appearance of disintegration.

Japanese pictorial culture, although historically drawing its origins from China, is quite remote in style from the Chinese tradition. Its centre of production was in the ancient capital of Kyoto, which was founded in AD 794.

The establishment of the Buddhist religion, with its demand for representations of the Deity, was the first influence on the imagination of Japanese artists. From the twelfth century AD, therefore, completely autonomous and original styles were emerging, especially in the illustration of religious and popular texts. Representational designs were frequently drawn against the dark background provided by silken scrolls; these would be emphasized with powdered gold and silver bonded with resins. Subsequently, the use of ink came to the fore; the usual brush technique was employed, similar to that used for calligraphic ideography and closely linked to the contemporary Chinese styles. Nevertheless, Japanese figurative design was quite distinctive because, in my opinion, it gave particular importance to dynamic line (p. 55). There was a forceful linearity – exemplified in the drawings of the fourteenth-century painter, Kao (p. 57) – which was to remain typical of Japanese art through the succeeding Momoyama and Edo periods (AD 1567–1867) right up to

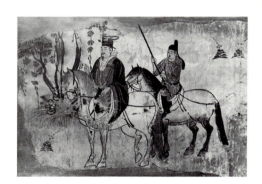

*a T'ang Nobleman with Groom*
Paris, Musée Guimet

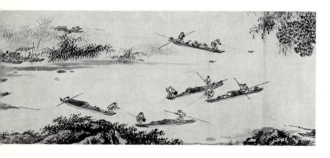

Tai Chin: *Fishermen on the River*
Washington, DC, Freer Gallery of Art

the present day. This style is clearly represented in the wood-block prints (xylographs) of landscape by Utamaro (eighteenth century) and by Hokusai and Hiroshige (nineteenth century) (pp. 58–9).

## The Middle Ages in Europe

The Middle Ages can be seen as a period of decisive importance in the cultural development of Western Europe.

In a dramatic but mainly consequential succession, which centred on Central Southern Europe, there was the Lombardic period (sixth to eighth centuries), the Carolingian (ninth to tenth centuries) and the Ottonian (eleventh century), each period being named after the people who replaced each other within the boundaries of Roman culture in Europe, the Near East and in the Mediterranean area that once belonged to the Empire.

What role did artistic draughtsmanship play in the vast and complex spectrum of medieval figurative culture? Generally speaking, the main figurative tendency to emerge from the early Middle Ages – the period coinciding with the arrival of the 'barbarians' – was inspired by the desire to break away from the Classical image and was based on an attempt to reproduce reality in as natural a way as possible, with a strong emphasis on proportion and formal harmony. The 'active principle' to emerge from 'barbarian' art – especially from such items of industrial art that have survived in the form of small objects, decorative sculpture and architectural decoration, as well as from the miniature – seems to have been founded on characteristic motifs of entwined foliage and animal themes. This consisted of a tangle of dynamic linear drawing, potentially abstract but effective in its own right (*simplegma*). Although Lombardic in origin, this linear motif was undoubtedly inspired by a centuries-old art-form of protohistoric times; it retained its intrinsic strength even when passing through the various medieval cultures that followed one another, dominating the Western world. It is thus possible to identify one typical feature of that period as expressive strength of line.

Even in the Middle Ages, drawing as an independent art-form certainly existed, not only as a planning medium but also as an exercise in free graphic expression. The first signs of it can be seen in the marginal sketches in some of the very old codices, and later there was extensive activity in the pen-and-ink illustration of manuscripts, in miniatures, in *sinopie* for frescoes and in the sketchbooks of painters. If little of this kind of material – apart from the codices – has survived to our own day, the reason is partly to be found in the medieval aesthetic viewpoint which regarded a drawing as being purely of use as a working guide and thus not worthy of any particular attempt to preserve it. Another factor was the high price of parchment – the usual basis for a drawing – which must have placed a severe restraint on an enthusiastic draughtsman. This situation continued until at least the end of the fourteenth century, when paper, being much cheaper, became more widely used.

The oldest medieval drawings are therefore the marginal sketches, remarkable in that they may be attributed not only to the expert calligraphers who copied the manuscripts but also to anonymous artists who often managed to convey an impression that was at once ingenuous and keenly caricatural. There are some marginal drawings in a fifth-century Coptic Bible from Naples and others, in the Carolingian style, in a Bible in the Vallicelliana, Rome; there are also some in a drawing of the 'Last Judgement' in a manuscript from the

Capitulary of Verona. The symbol is usually executed free-hand, with the point of a quill pen, producing an effect charged with subtle energy.

An important contribution has also been made to the evolution of early medieval linear language by the Northern cultures which developed in isolation. This was disseminated throughout Europe by Benedictine monasteries such as that of Bobbio in Montecassino, Italy. A particularly good example is that of the school of miniature painting in Ireland. In looking closely at various eighth to ninth-century Hiberno-Saxon masterpieces, such as the Book of Kells, Dublin (p. 62), one is immediately aware not only of their exquisite decorative quality but also of the intrinsic dynamism of their geometric forms. Much of the essential restlessness and excitability of the Irish temperament is transmitted through the graphic style of the early Middle Ages, of which some evidence can be seen in certain frescoes and in illustrations in codices.

Even though no example of a really graphic work has been singled out, there is no doubt that the production of frescoes in the early Middle Ages can to a large extent be linked with similar influences in the North. On this basis, therefore, it is not difficult to imagine what would have been the graphic forms of the time. Possibly some of the best examples can be seen in the pictures of Castelseprio, near Varese (seventh to eighth centuries), with their colours accentuated by shafts of light, or in those of the eighth century in the church of Santa Maria Antiqua, Rome, in which the strongly dynamic effect is due mainly to the skilful use of lines.

The illustrations in many of the codices that came from the scriptors' offices (*scriptoria*) in the Benedictine monasteries were unquestionably drawings in the true sense of the word. Between the eighth and tenth centuries, the monks, who were dispersed throughout Europe from Switzerland and southern Germany to the south of Italy, evolved a kind of artistic language of their own. It amalgamated the dynamic and linear expression of the Northern idiom with Byzantine decorative abstraction. Thus the traditional 'barbaric' style became blended with those of Roman extraction from late Antiquity. The new 'vulgar' language that emerged from it managed to achieve an extraordinary narrative force.

The pen-and-ink sketches illustrating the famous Utrecht Psalter (*c.* 820–32), a masterpiece of Carolingian outline drawing, had a similar effect. The narrative style of the unknown draughtsman, who may have learnt his skills in the school of Reims, is based on unerring strokes which, by tapering at the ends, sought to give the effect of movement (p. 63).

The graphic styles of the succeeding periods can also be identified through illustrated codices. Examples range from the somewhat classically based styles which stemmed from the Carolingian restoration to the more incisive and realistic ones of the Ottonian school (p. 64). Examples such as these take us well into the Middle Ages, to the twelfth to thirteenth centuries in fact, when schools of painting and artistic groups were developing a system of making 'pattern-books'. These relatively durable sketchbooks became invaluable, not only for their immediate purpose of providing a source of reference for copying drawings and guide-lines for new works, but also for enabling succeeding generations to gain an insight into the mental processes that were involved in the production of drawn images.

The most famous sketchbook of the period is that of the early thirteenth-century French architect and stonemason Villard de Honne-

*The Flight of St Paul*
Naturno, N. Italy, Church of San Procolo

court, in which the drawings already contain a strong element of Gothic linear style, showing a distinct Northern influence. Even the artist's technique and artistic theories are carefully classified, rather like an instruction manual in which drawing often assumes a completely independent dimension.

The largest collection of advice was produced in the fourteenth century and simply called *Il Libro dell'Arte*. The author, Cennino Cennini, was an insignificant painter but a shrewd and precise writer of treatises. He devoted a great deal of this work to drawing, which for the first time was presented both from the technical point of view (the preparatory work) and the conceptual (the independent quality produced by structural comprehension).

Cennini was very proud of having been apprenticed in the studio of Agnolo Gaddi (a painter in the Giottesque tradition) which was one of the more typical corporative bodies of Florentine pictorial art at a time when the artists' guild was struggling to acquire the right to be accepted on a level with major guilds such as those of the doctors, chemists and merchants. Cennini's precise theorizing about drawing enables us to understand the autonomy of this medium, just when documentation on the subject was beginning. Particularly relevant is the section dealing with *sinopie*, in relation to the large number of fourteenth-century examples to be found in the Camposanto, Pisa. Even more rewarding is his reference to one of the most important drawings to have been handed down to us which can be seen in the Louvre, Paris; this picture was not only drawn but also shaded and painted in watercolours by Taddeo Gaddi, the father of Agnolo, Cennini's teacher (p. 65).

'Do you realize what will happen to you, if you practice drawing with a pen? It will make you expert, skilful and capable of drawing out of your own head.' This was how Cennini expressed himself in Chapter 13 of his book and, in so doing, made a statement that had never been made before. He affirmed categorically the independent conceptual value of drawing. Faced with the traditional overriding themes of medieval culture – either theological, as seen in religious painting, or aesthetic, as in the way Nature is portrayed – the book does not arrive at the awareness of the complete, inalienable freedom and moral independence of the artist; but there is no doubt that, after Cennini, drawing can be viewed both technically and theoretically with a modern eye, that is to say it can be related to the artistic whole right up to the present day.

It is difficult to say just how long Europe took to graduate through the various art-styles of the Italian Renaissance and reach the modern age, because the pace of this evolution in art varied from one cultural zone to another. In Northern Italy there was an artistic culture with a strong 'Gothic' flavour, which lasted throughout the fourteenth century until at least 1450, while in the rest of Europe it survived even longer. On the other hand, new styles had already been established in Florence in the first decades of the fifteenth century by such artists as Brunelleschi, Donatello and Masaccio. Naturally, these new trends spread to the graphic field as well, but it is important to note that by the late Middle Ages painters were already, with much confidence and sophistication, making full use of drawing, imparting to it the fundamental characteristics of their personal style. The recent attribution of drawings to artists known primarily for their painting activities thus becomes completely credible. One has only to recall the subtle silverpoint modelling by Simone Martini (p. 66) for his Berlin *Angel*; or the incisive and majestic *Archer* in Oxford, which has been

Villard de Honnecourt: *Figure and Gothic Apse*
Paris, Bibliothèque Nationale

attributed to the same (unknown) master who painted, on silk, the altar frontal (*c.* 1375) known as the *Paremont de Narbonne* (p. 67); or the *Education of Mary* in Nuremberg, which it seems may indicate the art of the refined court of Prague. (p. 68). .

One common graphic element seems to link these sheets which belong to cultures so distant and so different from each other. It is to be found in the fine lines that seem to suggest a blending of the forms with the delicate grace of the extreme Gothic style of architecture, so widespread throughout Europe, which had become reunited in the fabulous wealth of its courts.

International Gothic culture is very rich in graphic works ranging from sketchbooks depicting animals, botanical and pharmaceutical subjects, and early fifteenth-century costume (p. 69) to preliminary drawings for panels and frescoes. There are many drawings extant from this rich '*ouvraige de Lombardie*' (the extreme Gothic style, so called after its main region of origin) attributed to Giovannino de' Grassi (p. 71), Michelino da Besozzo and Gentile da Fabriano (p. 70). These undoubtedly display a certain technical harmony – silverpoint or pen and watercolour on parchment or prepared paper – which gives them an obvious unity of language.

The first draughtsman whose work could be collected into a lengthy catalogue was Pisanello. While he used the same graphic media as others, he stood out among the rest because of his exceptional independence of style. He made use of every type of drawing from the simply sketched note in pen or brush – drawings of costume and of the nude – to the finished 'study' or preliminary art-work for a panel or fresco (p. 72–3) in which every detail was accurately defined. Pisanello's style offers so much more, both in quality and expressiveness, than that of his contemporary artists; it is as though he had caught the spirit that was pervading the culture of the spoken word – for this was the time when court troubadours were singing their Provençal poetry, when delicately languorous melodies were being played on the lute and the measured rhymes of songs were to be heard. Through the pages of his note-books the fabulous world of the late medieval courts seems to come back to life.

In the meantime, in Florence, such artists as Lorenzo Monaco ('the Monk') and Lorenzo Ghiberti were already exploring fresh channels that were to lead into a new realm of art – that of the great artists of the Renaissance.

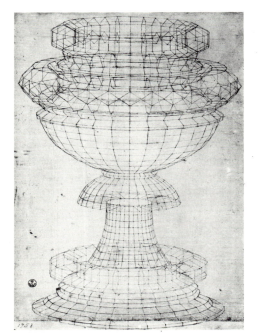

Paolo Uccello: *Perspective Study of a Chalice*
Florence, Galleria degli Uffizi

## The Early Renaissance

The early Renaissance gravitated between three main constellations – Florence, Venice and Flanders – and the most outstanding draughtsmen of the time are associated with these cultural centres. But it was, of course, Florence that instigated that complex phenomenon known simply as the Renaissance. More than a mere revival of Classical values, it offered a new perspective of life centred on humanistic ideals and an awareness of reality. It was a period that seemed to inherit all the philosophical and historical greatness of Antiquity. In short, the Renaissance involved the acquisition of a new awareness of the world in all its poetic and rational forms. One of its more important phenomena was, indeed, the complete reassessment of the laws of perspective on which Brunelleschi theorized and which was applied by such artists as Masaccio and Piero della Francesca.

The combination of these factors exerted a surprising effect on the attitude of the cultural world towards draughtsmanship. Its position

16

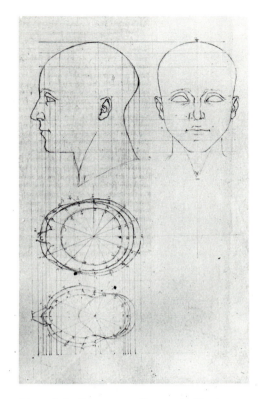

Piero della Francesca: *Geometric Heads*
Milan, Biblioteca Ambrosiana

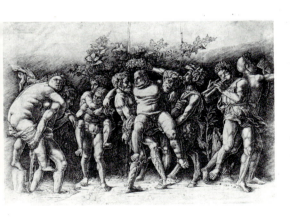

Mantegna: *Silenus* (engraving)
New York, The Metropolitan Museum of
Art, Harris Brisbane Dick Fund

as an art-form became pre-eminent until, almost as though by a natural process of logic, it became the epitome of figurative values. The early fifteenth-century Tuscan artists came to regard drawing as a means of reappraising the significance of reality, as though this were to be discovered through Nature in landscapes or through Man in portraiture.

Painters such as Paolo Uccello (p. 79) and Piero della Francesca held strong views on the significance of perspective and made use of the graphic medium to emphasize it. While the application of such theories can certainly be seen in Uccello's very distinctive drawings of objects – detailed headgear, for instance – with their many facets executed with such close attention to perspective, they are even more clearly illustrated in the work of Piero della Francesca. Here the graphic skill with which he obtained his effects of plasticity and light is paramount; he succeeded in achieving a complete reinterpretation of the values of colour in the representation of form.

The Florentine theorists of the early fifteenth century, Ghiberti for example, regarded drawing as the 'foundation of painting' because of its semantic, experimental qualities. As a result of this attitude, the graphic means of expression came to be used widely in all aspects of art – in the preliminary research and preparation as well as in the final solution of the problem of portraying the image. It became, in fact, one of the main features of Tuscan art.

In Florence, a good draughtsman was esteemed as much as a good painter. It is a very difficult task to select the most outstanding among them; many hundreds of sheets of drawings are still extant from the early Tuscan Renaissance and the standard was exceptionally high. Certain drawings which have been identified as the work of recognized masters would by themselves amply account for the extraordinary influence their work had on other artists of the time. It is easy, for instance, to understand the importance of Antonio Pollaiolo by considering the two or three drawings that are attributed to him, in which the linear strength clearly indicates movement and is at the same time charged with expression (p. 81). In the case of Verrocchio (p. 83), although only a few of his pages of drawings are available to us, the fluidity of his lines, which give such substance and plasticity to his figures, influenced a whole generation of artists from Sandro Botticelli (p. 82) to the sculptor Luca Signorelli (p. 87). Other draughtsmen, for example Benozzo Gozzoli (p. 80), Domenico Ghirlandaio (p. 84), Filippino Lippi (p. 84), Lorenzo di Credi (p. 85) and Pietro Perugino (p. 86), were more subtle in their figure modelling, using silverpoint embellished with touches of colour and taking skilful advantage of the pale yellow, pink, green and grey of their grounds. These artists undoubtedly turned to linear composition – which seems to have been the leitmotiv of Tuscan design – in their attempt to depict forms with full three-dimensional qualities.

In Venice, on the other hand, the tendency seems to have been much more towards achieving maximum effect through colour, almost as though consciously making the linear aspect of only secondary importance. Even at the time of transition between Gothic and the early Renaissance, Jacopo Bellini seems to have succeeded, in his complex architectural drawings, in harmonizing the effect of perspective with the pictorial qualities achieved through the use of light of dazzling limpidity. His drawings, collected into two volumes now in the British Museum and the Louvre (p. 88), thus formed a foundation for the development of all graphic activity in Venice.

Meanwhile another culture, based on the Tuscan pattern, was

developing in Padua. Francesco Squarcione, an entrepreneur and a prominent figure in the Paduan school, made great use of drawing in his work both as a teacher and as a painter in his own right: a drawing by Pollaiolo is, in fact, known to have been in his studio-workshop; and it is not difficult to see that the graphic style of engraving and design used by Andrea Mantegna – the greatest of the artists working in the revived classical style in Padua in the latter half of the fifteenth century – sprang from Florentine patterns, although these are somewhat modified by the special effects produced from his palette, which reflected the cold and changing light of the Venetian idiom, as illustrated in the Paduan frescoes (p. 89). Mantegna nevertheless assumed the position of master-painter in relation to his contemporaries, as can be seen from some of the graphic work produced by other artists who attended the school at Padua at that time; outstanding among these were the engraver, Marco Zoppo (p. 91), and those two great painters from Ferrara, Cosmé (or Cosimo) Tura and Ercole de' Roberti (p. 90).

There are difficulties in trying to distinguish the youthful drawings of Giovanni Bellini from those of his fellow artist, Mantegna, who worked with him under the influence of Donatello in the Paduan school. Some scholars today regard only the few drawings from Bellini's later period as being of unquestionable origin; but others – possibly with justification – claim to be able to identify his youthful draughtsmanship among drawings hitherto attributed to Mantegna, in which appear the freer, more painterly qualities that occasioned the distinctly similar character of their paintings (pp. 92–3).

Of particular importance to the last generation of fifteenth-century artists was the presence in Venice in 1494 of the 23-year-old Albrecht Dürer who was to return there in 1505 for a stay of two years. With a background of training in all the artistic techniques in his home town of Nuremberg, this young man brought with him ideas of an art realistic in its themes and clearcut in its line, which had a singular impact not only on such secondary artists as the engraver, Jacopo de' Barbari, but also on those of a very much higher calibre such as Lorenzo Lotto, Giorgione and Titian.

While the Italian Renaissance was flourishing in Florence and Venice, another great constellation of the figurative arts was coming to the fore – as already mentioned – in Northern Europe, centred on the elegant courts and wealthy bourgeois homes of Flanders and subsequently spreading into the neighbouring areas of France and Germany. Here, too, a rebirth took place, resulting from a cultural process which, at the beginning of the fifteenth century, had gradually superseded the International Gothic style. The only difference was that the Flemish painters, in contrast to the Italians, concentrated entirely on reality; it became the main object of all their representational work, whether inspired by sacred or secular themes.

Artists were working in Bruges, Ghent, Louvain and Brussels of the calibre of Jan van Eyck (p. 98), Rogier van der Weyden (p. 101), Gerard David and Hans Memlinc (or Memling). Their rare drawings, which were nearly always executed in silverpoint on specially prepared paper, are evidence of a graphic technique organically connected to a delving into reality – which is also apparent in their paintings – revealing actual microcosms to the more searching, meticulous minds. Outstanding examples of this style are the van Eyck portraits, built up with so much patience and attention to detail, almost as though seen through a magnifying glass.

Nor is there a lack of interiors, exemplified, perhaps, by the

eminent German-Swiss artist, Konrad Witz (p. 102), who worked mainly in Basle. Witz seems at times to have found a point of contact with the conception of spatial effect which predominated during the Italian Renaissance. In France, the work of Jean Fouquet – also reminiscent of van Eyck in the graphic spiderweb of its design – seems to have caught something of the plasticity of the Tuscan style, following a visit to Italy (p. 100).

By the end of the century, the Flemish Renaissance was already coming to an end with the strange, isolated work of Hieronymus Bosch. Several of his drawings are still in existence, all having some relevance to certain of his paintings with surrealistic or grotesque themes (p. 103). In their detailed penmanship they undoubtedly stem from the well-established Flemish tradition which, in the fifteenth century, had enjoyed an exceptional period of poetic coherence.

## The High Renaissance in Florence and Rome

The sixteenth century saw the establishment of drawing as an art-form of great importance. From the main Italian centres of culture such as Florence, Rome, Parma and Venice, as well as from many in the Germanic world, a great inheritance of drawings has survived the centuries. These studies and sketches are of exceptional interest in that they show us how the graphic medium had become completely accepted both as an aid to research and as a creative instrument in its own right.

Leonardo da Vinci was one of the most prolific draughtsmen of his time and he used the graphic medium in the widest, most penetrating ways. In his famous codex manuscripts, for instance, which contain so much of his thinking on a variety of subjects, the pages are liberally interspersed with studies (p. 108). These include accurately drawn plans, patiently observed analyses of natural phenomena and fascinating projections of his own imagination. Leonardo's drawings, whether executed in pen, sanguine, pencil, metal-point or brush, frequently give the appearance of paintings because of the quality of shading and chiaroscuro in them (pp. 109–10). As a whole, this makes up a graphic corpus of extraordinary stylistic unity.

Michelangelo, on the other hand, was strongly conditioned by his sculptor's eye. His drawings give the impression that some super-human strength must have shaped the lines to give the onlooker a preview of the three-dimensional image already formed in the artist's mind. In the cartoons for his frescoes, too, Michelangelo drew the outlines – from which he could not deviate – with such assurance that they seem to be in full relief (p. 111). Equally confident in his use of pen in hatching as he was in sanguine and charcoal, Michelangelo has left a great many drawings; they include a number of architectural plans, original ideas and studies of details of a number of his own works.

Leonardo da Vinci: *Grotesque Heads*
Windsor Castle, Royal Library

The drawings of Raphael, on the other hand, seem to reflect something of a refined and cultured – sometimes even elegantly hermetic – personality in the light, fluid use of the pen and pencil (pp. 113–15). His early life in the Umbrian region of Italy is amply documented in the many drawings he did when very young, their style being augmented by the fine lines he learnt to use during his stay of about four years in the workshop of Perugino. While he was in Florence he would have been influenced by the harmonious realism of Leonardo da Vinci. Raphael also spent some time in Rome, where he came into contact with Michelangelo and two Venetian painters, Sebastiano del Piombo and Lorenzo Lotto; it was during this period

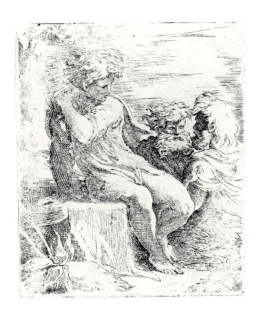

Parmigianino: *Boy and Two Old Men*
(engraving)
Rome, Accademia Nazionale dei Lincei, at
present on loan to the Istituto Nazionale per
la Grafica (inv. FC 76032)

that he finally discovered how best to achieve pictorial plasticity with pencil and charcoal.

The influence of the three great masters can be discerned in a number of prominent artists who were active in Florence and Rome at the beginning of the century. The portraits of Fra Bartolommeo della Porta, for instance, show the influence of both Leonardo da Vinci and Raphael, in that they are drawn with clear-cut lines, but are still rich in pictorial plasticity (p. 117). Andrea del Sarto, who created a vibrant effect in his outlines, shading the surfaces with the heavy, shadowy feeling of his own pictorial language, was clearly affected by his contact with both Leonardo and Michelangelo. This was particularly so in the detailed studies in sanguine for his paintings (p. 116). As the century progressed, the more highly evolved Mannerist style was developing, the first exponents of which were Pontormo and Domenico Beccafumi. They were already using the vigorous forms of this profoundly anticlassical trend within the smooth-flowing *ductus* of linear expression (pp. 118–19).

The Parma School was also to make an important contribution to Mannerist art. This was due not so much to its originator, Antonio Correggio (p. 121) – whose graphic work is still reminiscent of his early days under the influence of Mantegna, from whom he derived his feeling for a strong, clear-cut line and statuary values, while demonstrating the individual artist's right to independence in certain important pictorial styles – as to the numerous drawings of Parmigianino (p. 120). This prolific artist had been considerably influenced by the flowing, rapid style of Raphael during the latter's stay in Rome; as a result, he tended more and more towards a linear style, similar to the one he used for his etchings. And it was this dynamic style that was to prove the basis for the language of Mannerism, especially in Northern Europe. About this time, a number of outstanding draughtsmen were associated with the Parma School, including such artists as Niccolò dell'Abbate (pp. 122–3), who played a part in spreading this unquiet, emotional style far afield, even impinging on the elegant decoration of Fontainebleau.

Federico Barocci was also somewhat influenced by the Parma School. Later he came under the sway of Raphael, although his own sympathies lay primarily with the Venetian feeling for colour. He produced a great many drawings, most of which were executed in coloured chalks; they covered a seemingly endless range of themes although nearly all were studies for his paintings. Here the art of drawing is seen in its freest, most expressive form (p. 124).

**The Sixteenth Century in Venice**

In Venice, the century opened with Giorgione. While his new ideas made a significant impact on the world of painting, his contribution to graphic art is almost impossible to gauge, as the only page of his drawings to have survived seems to be his *Shepherd Boy*, which is in Rotterdam (p. 130). In this the figures appear to float on an almost unruffled sea of lines which recall not only the fine detail of the style of Giovanni Bellini – whose pupil Giorgione had been – but also something of the graphic technique so typical of the North.

Lorenzo Lotto gravitated towards a very independent graphic style which was nevertheless always inspired by story-lines and kept closely to reality (pp. 131–3). The wide range of experience he gained as he moved between Lombardy, Rome, and the Marches inevitably drove him away from the Venetian fascination with the effects of colour.

Other masters who had been working in Venice during the first decade of the century chose to detach themselves from the city's trends by moving into quite different cultural areas. Sebastiano del Piombo, for instance, was profoundly affected by his contact with Raphael and Michelangelo in Rome, and his many drawings, which nearly all belong to that period, clearly reflect this experience (p. 134).

Consequently, there is really only one early sixteenth-century Venetian draughtsman who can be discussed in depth: Tiziano Vecelli or, as he is more generally known to us, Titian. Far from being the reluctant draughtsman he was reputed to be, he left a collection of drawings that has proved more than sufficient to allow an insight into the character of his graphic work (pp. 135–7). From the first, Titian had been interested in xylography, as the rather primitive wood-engraving technique of the time is known, and in reproductive line-engraving. He clearly wanted to learn all he could in his quest for a vigorous graphic style along the lines of Dürer, in an attempt to reproduce the true effects of light. The slightly more mature Titian was then caught up on the wave of Mannerism in which the plastic element became important, giving the three-dimensional result so familiar in the work of Michelangelo. In his final phase, Titian returned to his preoccupation with light, adopting a similar technique to that used in his paintings. During this period he produced many drawings which are pure landscape, some of which are easily confused with the clear-cut, work of that fine copyist, Domenico Campagnola. (p. 138).

The graphic work of Jacopo Bassano has now been assessed, following recent research carried out on numerous pages of drawings which remained in his studio after his death and which were treated as patterns of the master's work by those using his workshop (pp. 141–4). His early period, which was characterized by his pencil and pen-and-ink techniques, seems to have been inspired by German engravings. The media whereby Bassano was to become best known, however, were two: one was charcoal heightened with opaque white-lead pigment and the other was coloured chalks on light blue or grey paper. These pages of Bassano's display the maximum effort on the part of the artist to give the illusion of painted pictures, and they do, indeed, achieve a striking luminosity through the handling of the charcoal and touches of white.

There are in existence over a hundred pages of drawings recognized as being by Jacopo Tintoretto; at least half of them are connected with the preparation of his paintings (pp. 145–7). They can be divided into two groups: firstly his youthful work, which consisted of copying from reproductions of classical subjects or from sculptures by Michelangelo in a strong, three-dimensional chiaroscuro style; and secondly his later work, characterized by a serpentine quality for which Tintoretto had clearly thought out in advance the movement of the figures who were to appear on his huge canvases.

A few of Tintoretto's drawings are complete compositions in themselves, but these are rare. The artist here seems to have been mainly concerned with studying the effects of light, which he achieved with emphatic, sweeping strokes in charcoal and white chalk.

Confusion long existed in attributing many of the drawings because the graphic style of Tintoretto's son, Domenico, so resembled that of his father. Only recently has it been found possible to distinguish the realistic style, with its narrative quality, of Domenico from that of Jacopo. Particularly distinctive in the son's work are his scenes from life in black chalk heightened with opaque white-lead pigment (p. 148).

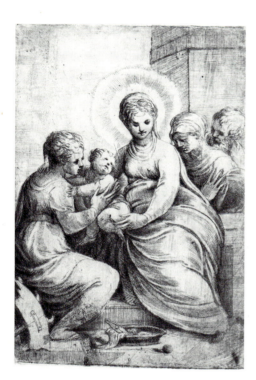

Schiavone: *The Holy Family* (engraving)
London, British Museum

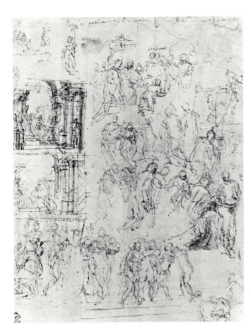

Paolo Veronese: *Studies*
Vienna, Graphische Sammlung Albertina

El Greco – whose real name was Domenikos Theotocopoulos – was a native of Crete, which at that time belonged to the Venetian Republic. It was therefore natural for this young Greek to go to Venice to study painting from the masters, probably acquiring his technique from the two main sources, the Tintoretto and the Titian schools. This much can be deduced from one of the few pages that have come down to us, a nude in charcoal, the *Study for 'Day' by Michelangelo*, now in Munich (p. 149).

One of the most prolific draughtsmen of all time, Jacopo Palma the Younger – known as Palma Giovane – also based his graphic style on the Tintoretto tradition (p. 150). In his sketchbooks, he first followed the styles of Titian and Bassano, as can be seen from some of his pages on which black crayon and white-lead pigment were used. He then changed to pen and ink, in which he developed bewildering celerity in his boldness of line which, after much twisting and turning, would be broken abruptly. But his powers of invention were inexhaustible. In many ways his work was similar to that of an outstanding representative of Roman Mannerism, Federico Zuccari; this draughtsman had a particularly bizarre and imaginative style with a distinctly pre-Baroque flavour (p. 155).

When Paolo Veronese died in 1588 he left an impressive number of drawings which remained in use as patterns in his workshop, as an inventory dated towards the end of the seventeenth century bears witness; many of these are still extant (pp. 151–3). Although the graphic work executed by Veronese developed along similar lines to that of Titian, Bassano and Tintoretto, his work indicates that he was mainly interested in the Mannerist styles of the trend developing in the Emilia region of Italy between Parma and Bologna.

Particularly interesting are Veronese's pen-and-ink sketches; in these, he often indulges in linear confusion which he then puts to rights with a few bold strokes. Many of his drawings were executed in black chalk, most of these being intended for use as studies from life and in the preparation of details for larger canvases. On the graphic level, it was in these drawings that Paolo's brilliant, silvery strokes were at their most effective. And, in a way, the sumptuous and essentially pictorial expressiveness that had typified this as the great century of Venetian art was thus brought to a close.

## The Sixteenth Century in Northern Europe

While many sixteenth-century Italian draughtsmen were primarily painters, it can be said that most of their North European contemporaries were primarily engravers. The use of the graving tool (or graver) and later of nitric acid was almost universal, spreading particularly from the Germanic countries where the technique had been successfully used since the previous century.

One of the fifteenth-century German exponents was Martin Schongauer, who was both a painter and an engraver (p. 159). His drawings give the impression that he wielded his pen with the same flair and incisiveness as he wielded his graver. He thus succeeded in bringing about an almost total unification of the styles of the various graphic techniques.

Albrecht Dürer was an equally prolific worker in all the phases of his artistic life, each of which was related to some aspect of engraving (pp. 160–4). In aiming to achieve as realistic an effect as possible with a crisp line and absolute precision, he used pen, chalks and brown ink applied with a brush.

Dürer distracted attention from the linear aspect of his pictures

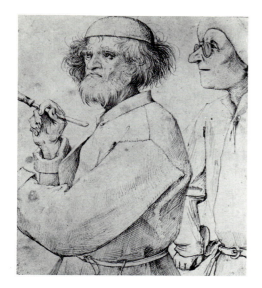

Pieter Bruegel: *The Painter and the Critic*
Vienna, Graphische Sammlung Albertina

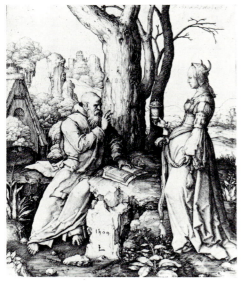

Lucas van Leyden: *The Temptations of St Anthony* (engraving)
Vienna, Graphische Sammlung Albertina

by creating interesting backgrounds. He did this in one of two ways: he would either prepare his paper in dark blue, grey or pale green, or he would highlight the surfaces with streaks of white bodycolour. The result was one of amazing clarity, with brilliant surfaces and well-defined outlines.

A great many Northern artists working in the graphic field were inspired by similar themes, although they may have placed the emphases rather differently. Lucas Cranach the Elder, a rather bourgeois traditionalist, produced portraits in pencil and in brush (p. 165) which were faithful in all their details to their subjects. But more original were such figures as Mathis Grünewald (p. 167), Albrecht Altdorfer (p. 166), then Hans Baldung Grien (p. 168) and Manuel Deutsch (p. 169). They all had in common the use of white bodycolour on dark or coloured paper, which has the effect of raising the drawing off the background and gives the pages of their work the appearance of having an independent life of their own.

A very active centre of graphic art was also established in those parts of Switzerland bordering on the German States. In this category, may be included Urs Graf, an engraver and goldsmith of outstanding veristic force (pp. 170–1). Another citizen of Basle was Hans Holbein the Younger. His favourite medium, in graphic work, was chalk, not only in a wide range of colours but in black as well, and in this he immortalized important members of the German-Swiss, and more particularly the English, nobility and bourgeoisie.

The Dutch draughtsmen, too, were greatly influenced by German trends. One of the first exponents in Holland of woodcutting and engraving was Lucas van Leyden, who derived his inspiration from Dürer. The latter's influence can be seen clearly not only in van Leyden's prints, but also in his pen-and-ink and chalk drawings, so delicately emphasized by his clear-cut line (p. 172).

Pieter Bruegel (also Brueghel, Breughel), on the other hand, modelled himself on the graphic tradition of Bosch, both in his peasant scenes – which lay somewhere between the realistic and the imaginative – and in his portraits, which were sometimes grotesque or caricatural. He achieved the effect of a painted picture even in his landscapes, which owed their style mainly to the early Italian period; in those, the use of the pen and a light ink wash applied with a brush creates the illusion of pages from a travel notebook (p. 174–6).

The graphic style of Hendrick Goltzius was based on Italian Mannerism. He devoted the greater part of his life solely to drawing and engraving, developing a technique whereby, using a wide range of colours, he was able to achieve in his landscapes and portraits most unusual effects of representational realism (pp. 177–8). In this he had been preceded by the Frenchman François Clouet, whose style was more elegant in its hatching, which he built up carefully and painstakingly into a woven tissue of lines (p. 179).

## The Seventeenth Century in Italy

Artistically, the seventeenth century gives the impression of having been a period of contradictions, since the aesthetic approach was so closely linked to revolution as well as to tradition. On one side there was the rise in importance of the Academies, in which Ludovico Carracci and his cousins, Agostino and Annibale, played such a large part. It was as though every piece of traditional art that was produced had to be measured against the 'ideal model': good design therefore implied a harmonious distillation of the Venetian and Roman cultures, something between Titian and Raphael. This meant that the graphic

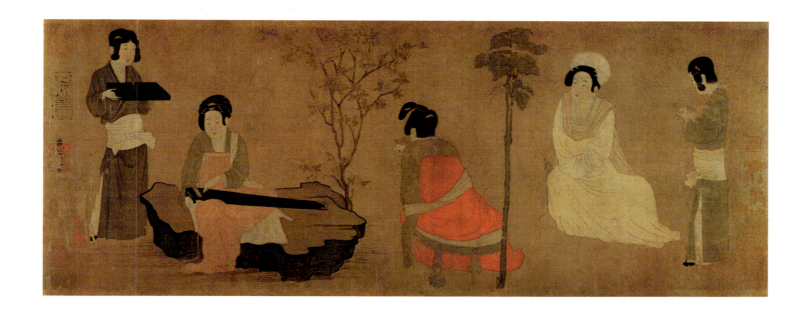

Persian painter? (*c.* 1300)
*Pegasus*
Miniature; $11\frac{1}{2} \times 17\frac{1}{2}$ in. (290 × 190 mm.)
London, British Museum, inv. Ar. 5323,
f. 30 (*v*)

This illustration is taken from a fourteenth-century manuscript, *The Book of the Fixed Stars*, by a Persian astronomer of the tenth century. Graphic and pictorial effects blend on the page in the double drawing of the constellations as they appear from the Earth, and as they would appear from the sky. The outlines are in black, with gold spots encircled in red to represent the individual stars.
*Bibliography*: Martin, 1912, I, p. 19; II, pl. XXXV, XXXIX

Chou Fang (active 780–810)
*Ladies Taking Tea*
Ink and colours on silk (handscroll);
$11 \times 29\frac{1}{2}$ in. (280 × 750 mm.)
Kansas City, Nelson-Atkins Gallery of Art, inv. 32–159/1

This work, in ink and colours on silk, is attributed to Chou Fang, a court painter of the T'ang dynasty, who worked in the late eighth and early ninth centuries. Characteristic of aristocratic art of this period is the serene atmosphere produced by a marked stylization of the natural features and perfect balance of the composition. The subject is one of the themes frequently depicted during this period: court scene showing ladies engaged in their favourite pastimes.
*Bibliography*: Moskowitz, 1963, n. 1097; Sickman-Soper, 1969, p. 115

Hsü Tao-ning (first half of the eleventh century)
*Fishing in a Mountain Stream*
Ink on silk (detail of handscroll); whole size $19 \times 82\frac{1}{2}$ in. (483 × 2100 mm.)
Kansas City, William Rockhill Nelson-Atkins Gallery of Art, inv. 33.1559

This scroll, of which only a section is reproduced here, is one of the best examples of the art of Hsü Tao-ning, a leading landscape artist of the Sung dynasty. The atmosphere of solitude and intense cold, the stylization of the sparse trees growing up the mountain slopes and along the ridges, and the continuous flowing lines of the mountain peaks emphasized with broad brush-strokes of diluted ink are all typical features of the work of this northern school.
*Bibliography*: Moskowitz, 1963, no. 1102; Sickman-Soper, 1969, pp. 139–40

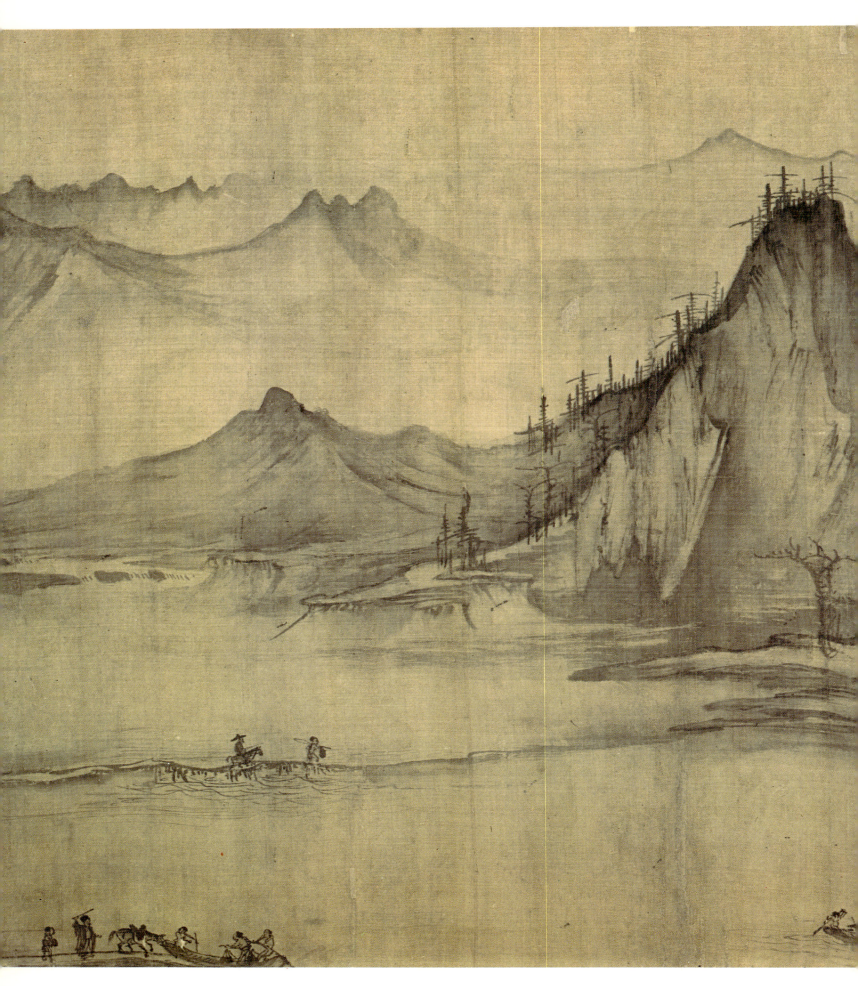

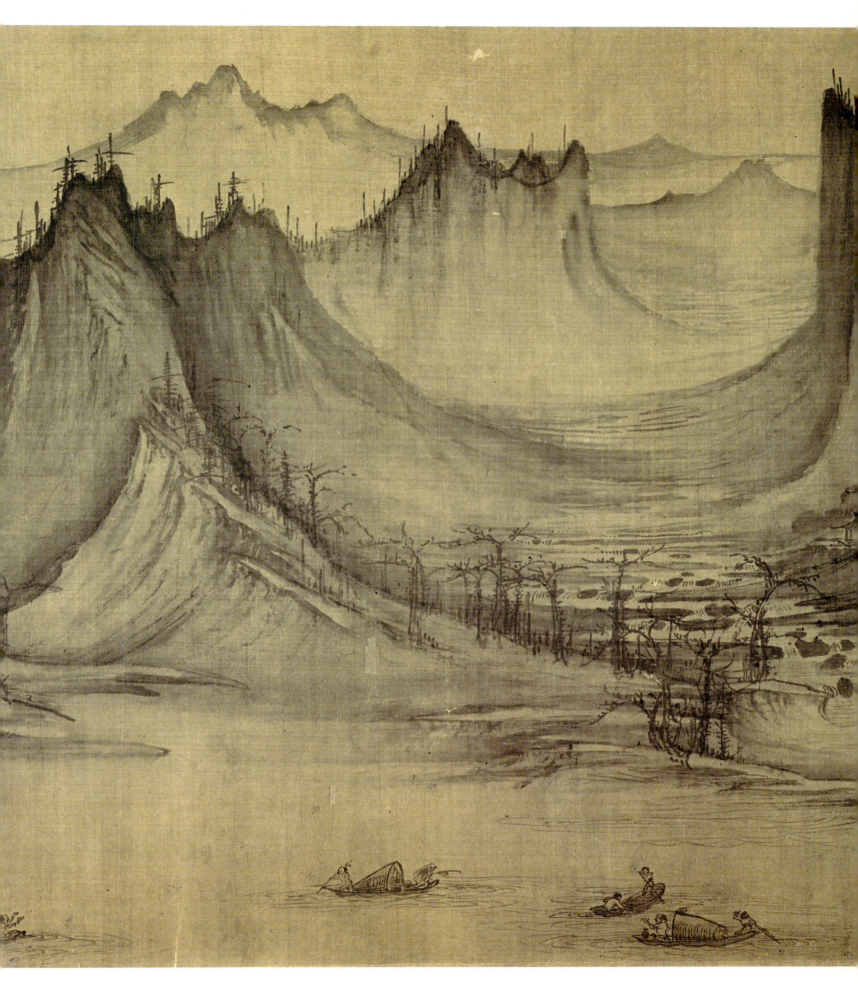

Chao Meng-fu (Wu-hsing 1254–1322)
*The Sheep and Goat*
Ink on paper (handscroll); 10 × 19 in.
(250 × 485 mm.)
Washington, DC, Freer Gallery of Art,
inv. 31.4

The fundamental feature of this folio is its
highly elegant and refined technique, which
can be seen in the different treatment given
to the fleece of the sheep and to the hair of

the goat. The sheep's wool has been marked
with patches of diluted ink, while the goat's
long hair has been drawn in with an almost
dry brush. The inscription on the left, by the
artist himself, is an integral part of the
picture, the abstract quality of the
calligraphy being in complete contrast to the
realistic representation of the animals.
*Bibliography*: Moskowitz, 1963, no. 1110;
Sickman-Soper, 1969, pp. 192–3

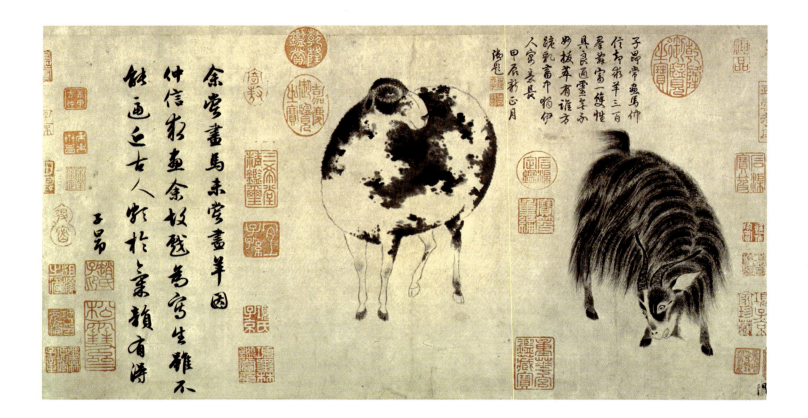

Wu Chên (1280–*c*. 1350)
*Bamboos in the Wind*
Brush and ink; 29½ × 21½ in.
(753 × 543 mm.)
Boston, Mass., The Museum of Fine Arts,
inv. 15.907

'He painted and wrote with joy', says Wu
Chên of himself at the end of the inscription,
almost as though to stress the impossibility
of excluding the calligraphic contribution

when considering the work. In spite of the
apparent simplicity of this drawing, it
involves a very skilful technique which
cannot permit changes of mind or errors.
Only thus can the artist achieve utter purity
of form, through complete linear control, in
the representation of one of his favourite
subjects.
*Bibliography*: Sachs, 1961, pl. 3

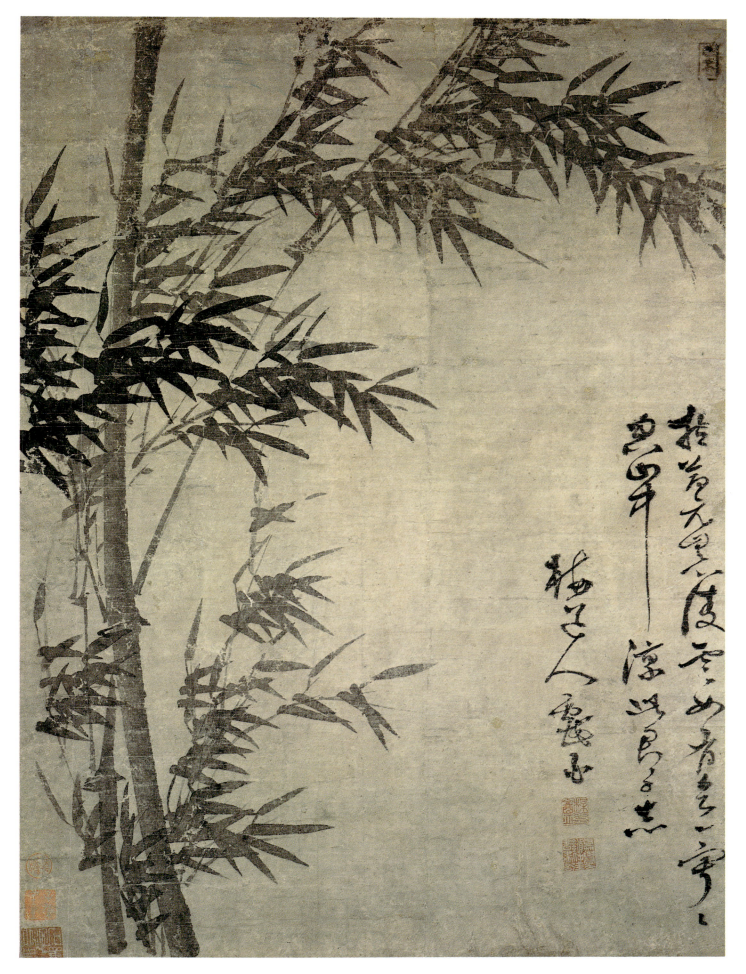

53

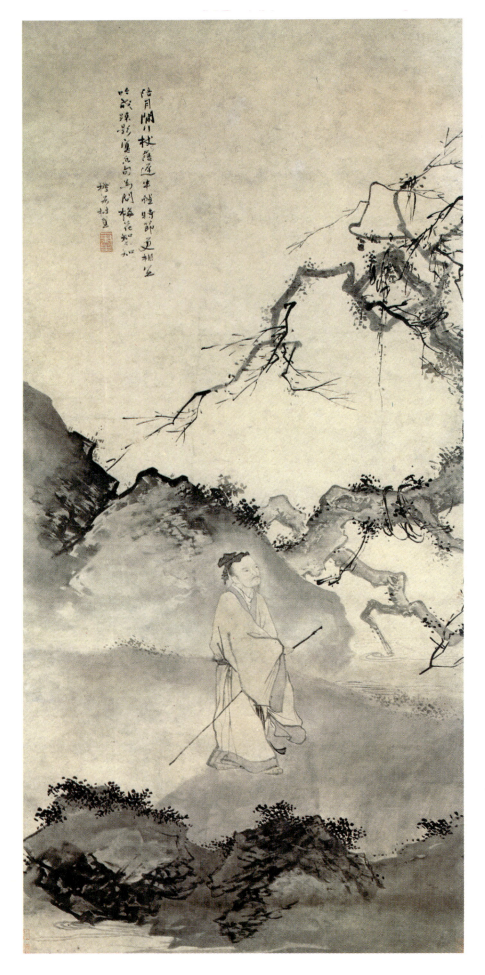

Tu Chin (active *c.* 1465–87)
*The Poet Lin Pu Wandering in the Moonlight*
Ink and light colours on paper (detail of
hanging scroll); $61\frac{3}{4} \times 28\frac{1}{2}$ in.
(1566 × 725 mm.)
Cleveland, Ohio, Cleveland Museum, J. L.
Severance Collection, inv. 54.582

The delicate sensitivity of Chinese Sung
painting is reflected in this representation of
the poet Lin Pu as he contemplates a
flowering plum-tree in the pale light of the
moon. Tu Chin was a profoundly cultured
artist, and it was due to his masterly
technique and a totally personal
interpretation that he was able to imbue his
art with the various painterly trends of the
time.
*Bibliography*: Moskowitz, 1963, no. 1115

Japanese painter (thirteenth century)
*The Burning of the Sanjo Palace*
Coloured ink on paper (detail of
handscroll); height $16\frac{1}{2}$ in. (414 mm.)
Boston, Mass., The Museum of Fine Arts

The scene illustrates the night attack on the
Sanjo Palace at Kyoto in 1159. The influence
of the oldest and most important Chinese
art, which is quite evident in much of
Japanese art, is particularly apparent here in
the complex graphic and chromatic effect of
the tongues of flame. The figures of the
warriors look like sinister war-gods seen
through the pall of smoke.
*Bibliography*: Terukazu, 1961, p. 97

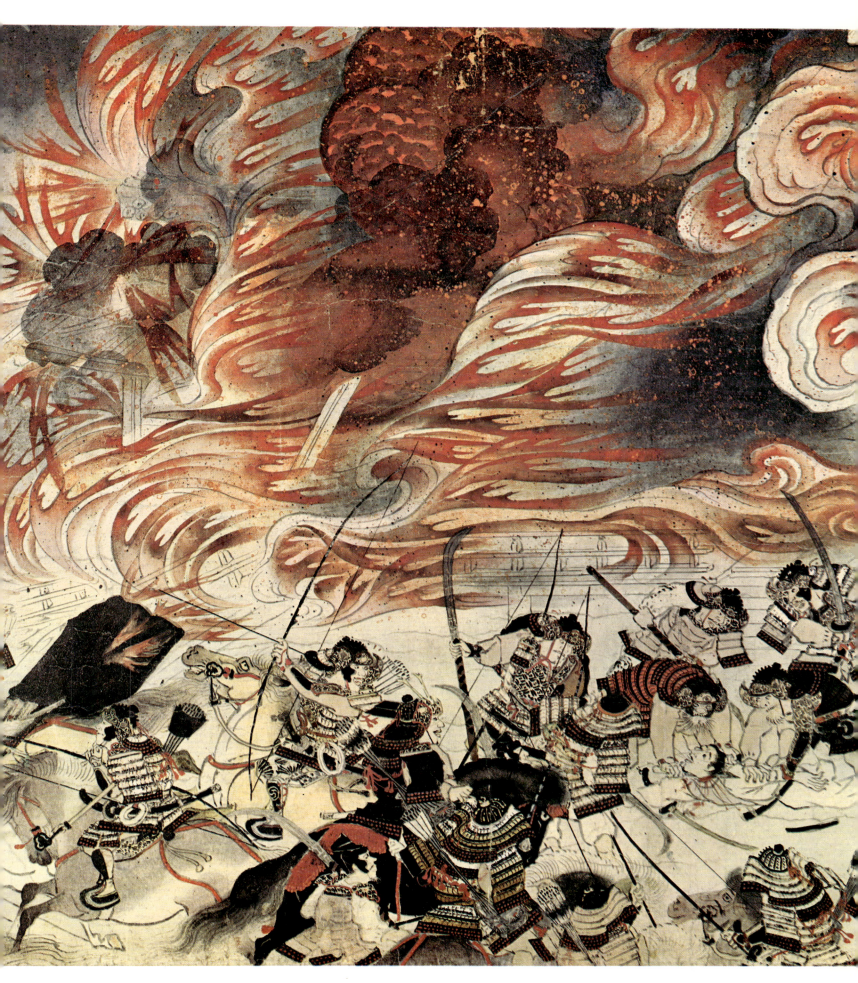

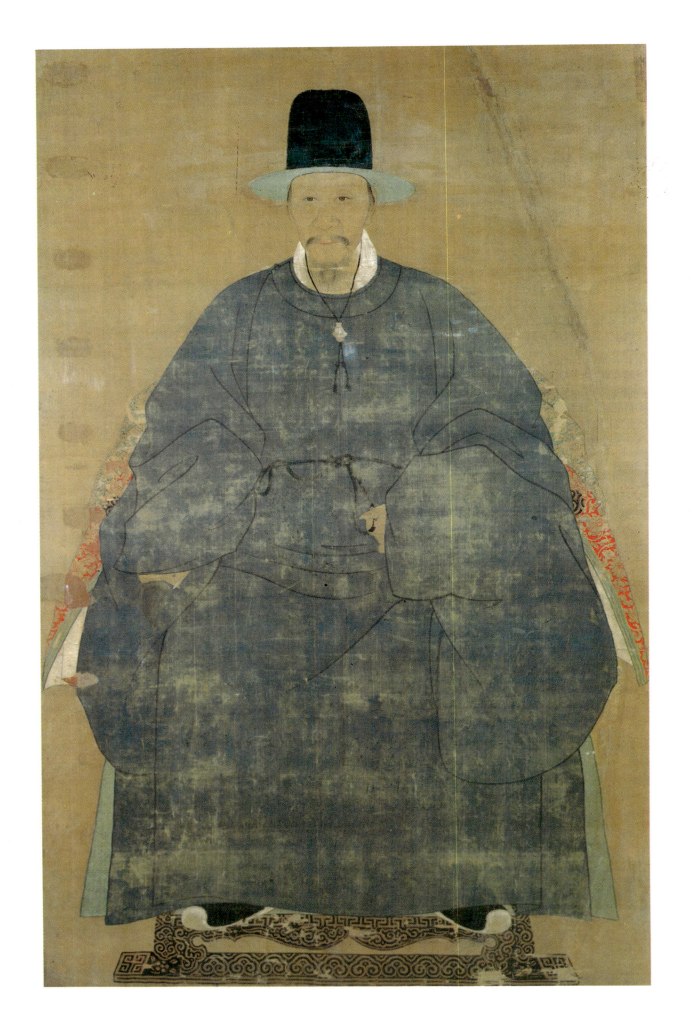

Painter of the Ming dynasty (1368–1644)
*Portrait of a Chinese Dignitary*
Ink and colour on silk; 60 × 37 in.
(1518 × 940 mm.)
Provenance: Denman Ross
Cambridge, Mass., Harvard University,
William Hayes Fogg Art Museum

The light, elegantly drawn lines and
watercolour wash – so typical of courtly art
in the Ming dynasty – have not prevented
this anonymous artist from achieving a
remarkably individualistic characterization
in this portrait. Works such as this show us
to what extent Chinese art aimed at a
faithful reproduction of reality, as opposed
to its usual adherence to conventionality.
*Bibliography*: Mendelowitz, 1967, p. 206

Kao (active somewhere between the end of
the twelfth and first half of the fourteenth
century)
*Kanzan*
Brush and ink on paper; $40\frac{1}{4} \times 12\frac{1}{4}$ in.
(1023 × 310 mm.)
Washington, DC, Freer Gallery of Art

A legendary Chinese hermit, Kanzan, has
been depicted by Kao in the best known of
his very rare works. The control of the
outline and tonal shadings, achieved through
the very expressive use of a diluted ink wash,
make this picture typical of the high
standard of graphic art in Japanese culture.
*Bibliography*: Moskowitz, 1963, no. 1128;
Swann, 1966, pp. 158–60

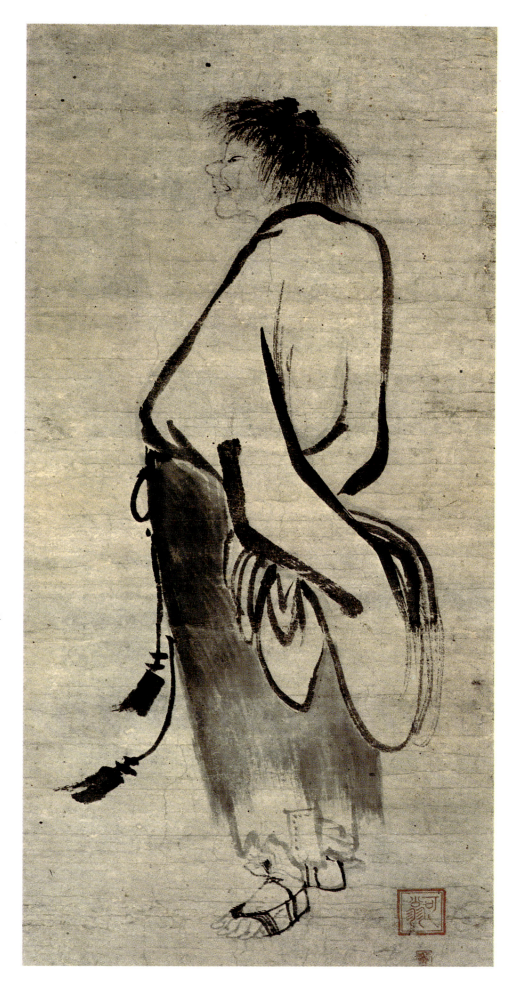

Andō Hiroshige (Tokyo 1797–1858)
*Landscape with Mountain*
Ink and colour on paper: 11 × 6½ in.
(279 × 169 mm.)
Washington, DC, Freer Gallery of Art

The work of Hiroshige and the fundamental
role played by colour exerted a strong
influence on the Impressionists. In this sheet,
taken from an album of sketches, in which
there are landscapes, figures and animals, the
artist has employed a wide range of cold
tones to bring the elegant, perfectly balanced
composition to life.
*Bibliography*: Moskowitz, 1963, no. 1141

Katsushika Hokusai (Tokyo 1760–1849)
*Birds in Flight*
Indian ink and pale yellow watercolour on
white Japanese paper; 10⅞ × 15 in.
(275 × 380 mm.)
Provenance: Pesci; acquired in 1925
Florence, Galleria degli Uffizi, inv. 99139

In this sheet, Hokusai has achieved an
exquisitely painterly effect by rapid,
fragmented brush-strokes and the use of ink
as a shading medium, enlivened by a few
delicate touches of colour. He is one of the
greatest exponents of the Ukiyo-e school.
The example of his work given here shows
just how well he could adhere to reality.
*Bibliography*: Kondo, 1980, no. 12

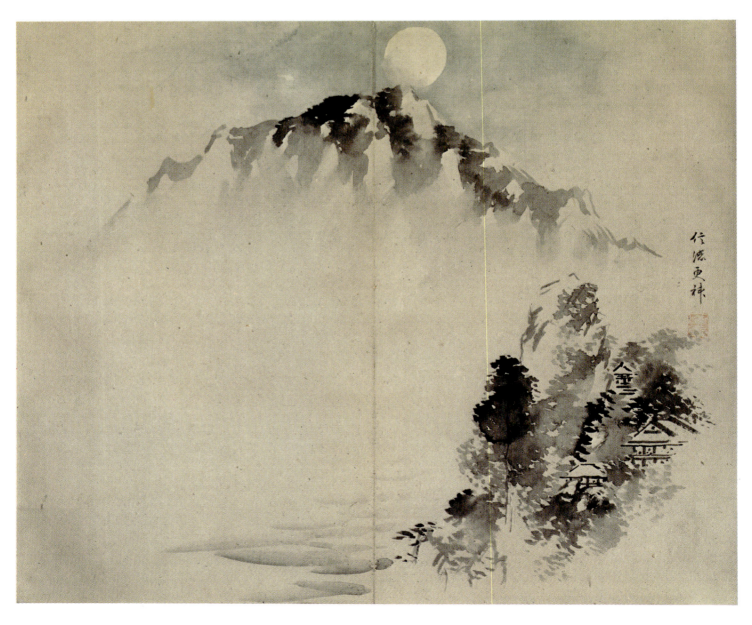

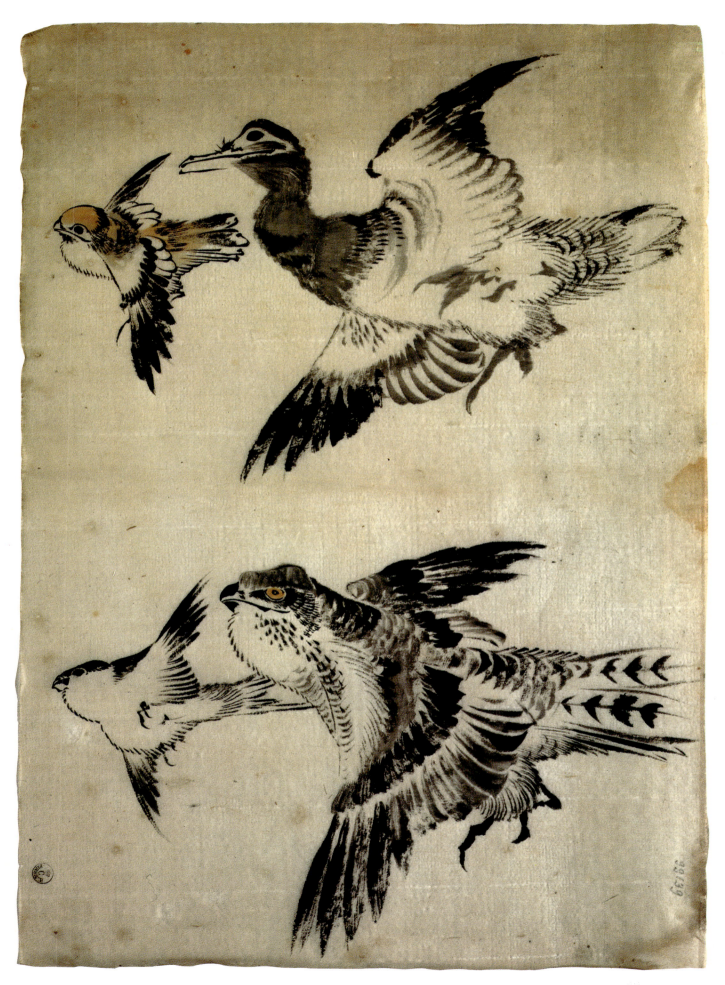

# The Middle Ages in Europe

**Taddeo Gaddi** (Florence *c.* 1290–1366). Having worked with Giotto for many years and co-operated with the master in his later works, Gaddi remained his most faithful follower after Giotto's death. He inherited from the Giotto workshop a knowledge of graphic technique, and continued to keep the tradition alive, especially in his frescoes in the Baroncelli Chapel of Santa Croce.

**Simone Martini** (Siena 1284?–Avignon 1344). The earliest important work by Martini is his large fresco, *Maestà*, painted in 1315 in the Palazzo Pubblico of Siena, almost as a companion piece to the *Maestà* in the Cathedral for which his teacher, Duccio, had been commissioned about four years earlier. To his training under Duccio he added his own particular sensitivity to linear motifs, which he selected from among the most elegant examples of illuminated scrolls and oriental fabrics from France. In an atmosphere dominated by the *dolce stil nuovo* – a romantic style of poetic chivalry which prevailed in literature and music – he tended to find more graphic ways in which to express his art. Very little of his work in this field remains to us, however, except one or two miniatures and a small number of drawings. In his more mature years, Martini went to Assisi, where between 1323 and 1326 he painted a cycle of frescoes in the church of St Francis. In 1328 he painted another fresco in the Palazzo Pubblico in Siena, and in 1340 went to France where he became a painter to the Papal Court in Avignon.

**Gentile da Fabriano** (Fabriano *c.* 1370–Rome 1427). After his training in central Italy, where he had been on the fringe of the trend towards the international Gothic style, Gentile began a working life of continuous wanderings. We find him in Venice (*c.* 1408–19), Brescia (*c.* 1417), Florence (1423), Siena and Orvieto (1425), and finally Rome (1427), where he died. Familiar from the beginning with the linear qualities of the Gothic style, Gentile showed a predilection for elegant, decorative art. This is typified in the few works of his that remain to us such as the Holy Trinity altarpiece, painted in 1423, now in the Uffizi Gallery, Florence. From the rare examples of his graphic work, it is clear to see how important his influence must have been on such a great draughtsman as Pisanello, who collaborated with him in painting some large cycles of pictures and frescoes.

**Giovannino de' Grassi** (Milan?–d. 1398). A versatile artist, Giovannino was involved in later life as a master-builder in the great undertaking, begun in 1386, of the building of Milan Cathedral. He was both a sculptor and a painter, becoming especially well known for his elegant work in the new International Gothic style and for his connections with some of the Franco–Flemish Masters. Accustomed as he was to late Gothic naturalism, he often incorporated naturalistic motifs, such as plants, flowers and animals, into his work, in the graphic tradition he developed in Lombardy in his *Taccuini* ('Notebooks'), now in the Biblioteca Civica in Bergamo.

**Antonio Pisano, known as Pisanello** (Pisa 1395–Rome 1455). Having established himself in Verona, Pisanello produced his first works in the early 1420s, both as easel pictures in the International Gothic style and in the form of large frescoes which he painted in 1423 in the church of San Fermo, Verona. In the meantime, by about 1417 he had already completed several frescoes in the Doge's Palace in Venice, probably having had some connection there with the work being done by Gentile da Fabriano; unfortunately these have now all disappeared. His next assignment, in 1424, was in the Visconti castle in Pavia, followed by commissions in the courts of Ferrara, Rimini and Cesena. About 1440 he painted a series of frescoes in Sant'Anastasia, Verona, *St George and the Princess*. Between 1449 and 1455 he went to Naples and Rome, where he was to die. Although most of Pisanello's frescoes have been destroyed, an impressive corpus of his graphic work is extant, most of which is in the Louvre Museum, Paris. His incisive style covers a very wide range of themes including the nude, animals, landscapes and portraits.

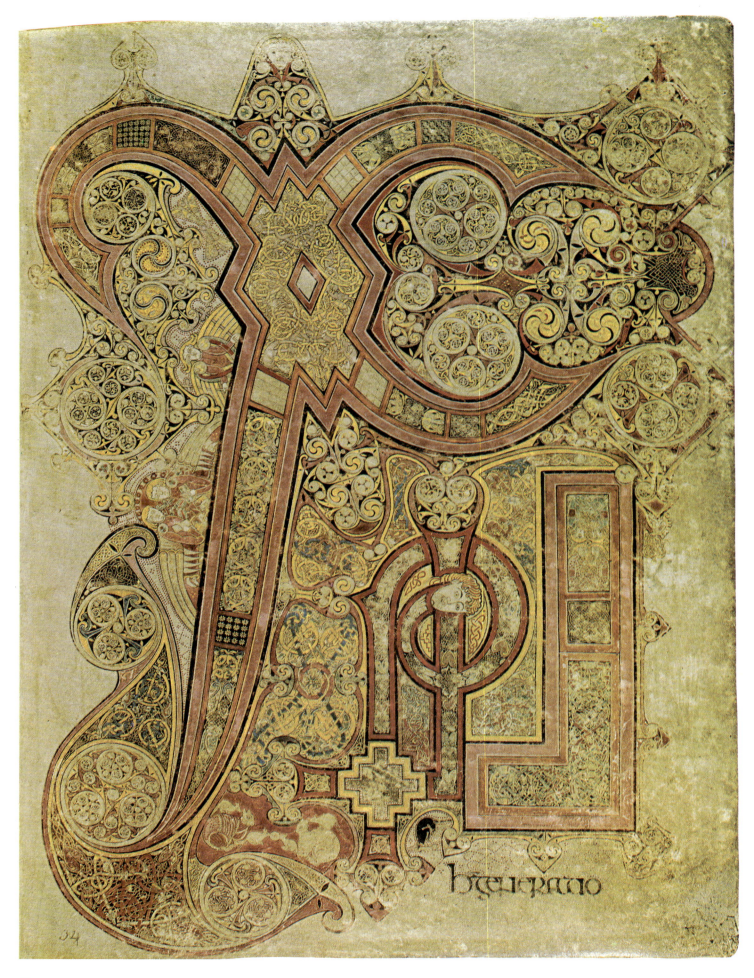

bzeuerano

Hibernian Saxon painter (*c.* 800–10)
*Book of Kells: Initial*
Tempera on parchment; 13 × 10 in.
(330 × 250 mm.)
Provenance: Kells Monastery, Ireland
Dublin, Trinity College Library, inv. 58,
f. 34 (*r*)

This illuminated initial is to be found in St
Matthew's Gospel in the *Book of Kells*, so
named after the Irish monastery where it was
perhaps finished. Illustrated in a style
common to Ireland and Northumbria (cf.
the earlier *Lindisfarne Gospels*), it is thought

to have originated in the monastery of Iona,
and to have been taken to Kells when the
monks abandoned the island because of
Viking attacks (the last in 807). The art of
illuminating, which is closely related to the
technique of draughtsmanship, is a typical
manifestation of monastic culture in Western
Europe and Ireland. It resulted from the
grafting of local barbaric traditions on to the
more classic Byzantine substratum.
*Bibliography*: Nordenfalk, 1977, pl. 44

Reims painter (*c.* 820–30)
*Utrecht Psalter*
Pen and brown ink; about 12¾ × 9¾ in.
(327 × 248 mm.)
Utrecht, Bibliothek der Rijksuniversiteit

As in other contemporary works that mark
the passage from the illuminated book to the
illustrated book, this anonymous
draughtsman has with great vivacity and
realism translated scenes conjured up by the
Psalms in the Bible with nothing more than
swift strokes of his quill pen and ink.
*Bibliography*: De Wald, 1932, *passim*

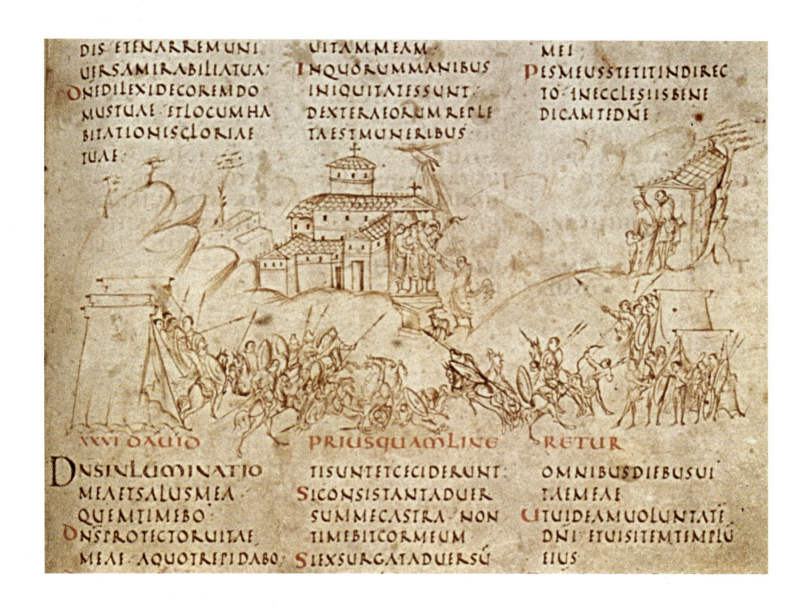

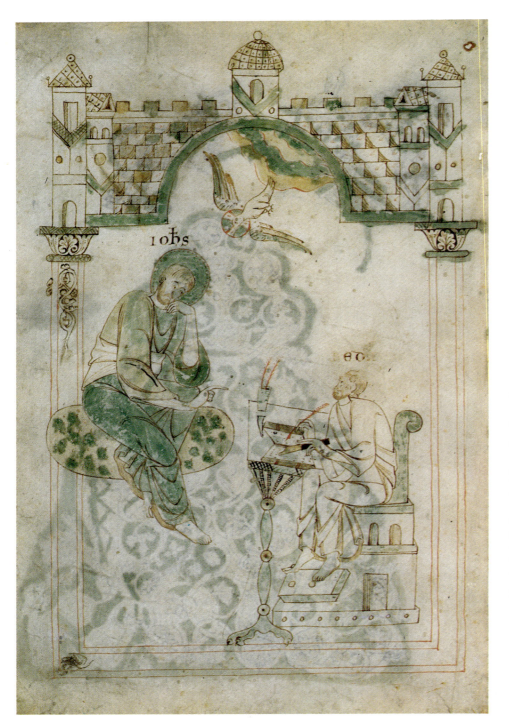

Austrian painter (first half of the twelfth century)
*The Venerable Bede*
Pen and brown and red ink with watercolour on parchment; 14 × 9¼ in. (352 × 235 mm.)
Provenance: Rosenwald
Washington, DC, National Gallery of Art, inv. B-17, 715

This sheet, which was probably a page from a missal or choir-book, is identifiable as being from an Austrian source, dating from about 1140. The realistic background details and expressive intensity of the figures are accentuated by the special technique employed of pen and ink and watercolour on parchment.
*Bibliography*: Robison, 1978, no. 15

Taddeo Gaddi (Florence *c.* 1290–1366)
*Presentation of the Virgin in the Temple*
Brush, green-blue and black watercolour, white and gold highlights with outlines in metalpoint on specially prepared paper in green; 14½ × 11 in. (364 × 283 mm.)
Provenance: Vasari (?), Baldinucci, Pandolfini and Strozzi; acquired in 1806, following Napoleon's Italian conquests
Paris, Musée National du Louvre, inv. 1222.

This sheet is almost certainly the preliminary study for one of the episodes in the fresco cycle of the *Life of the Virgin* in the Baroncelli Chapel in Santa Croce, Florence. The artist has utilized the green colour of the specially prepared paper to produce a contrasting effect with the shade of watercolour he has chosen, introducing touches of white and gold to bring the scene to life. The result is an architectural composition in which the influence of Giotto is clearly visible, both in its impressiveness and in the importance given to its three-dimensional qualities.
*Bibliography*: Berenson, 1961, no. 758; Bacou-Viatte, 1968, pl. 1: Degenhart-Schmitt, 1968, no. 22

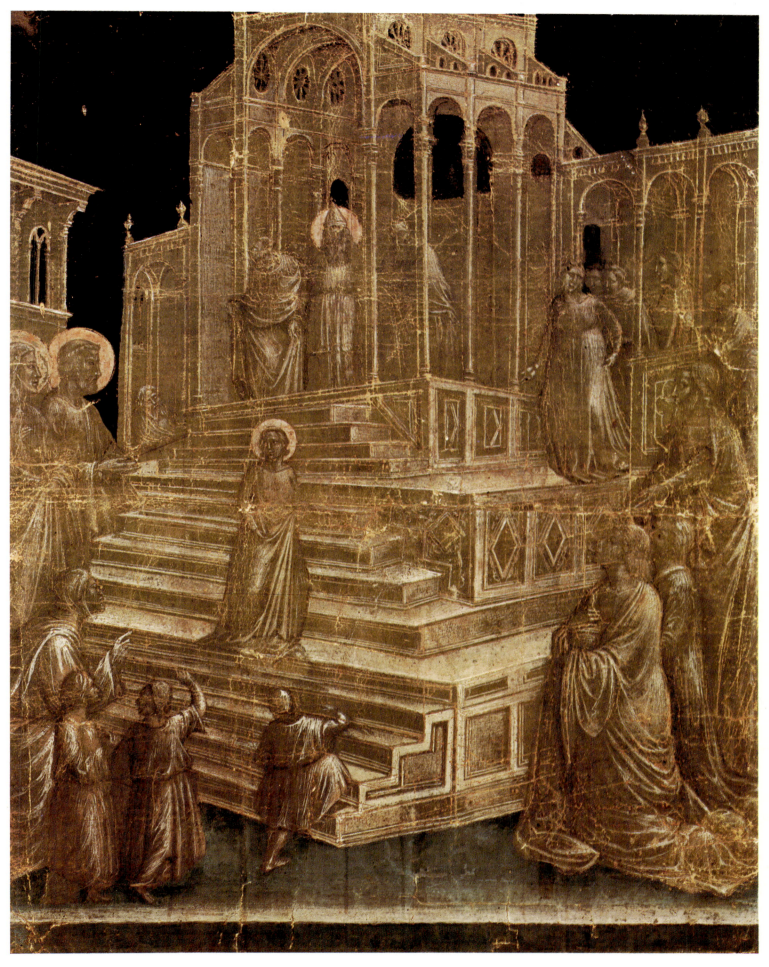

Follower of Simone Martini (fourteenth century)
*Allegory of Temperance*
Silverpoint on specially prepared paper in red; 5¼ × 3¾ in. (134 × 94 mm.)
Berlin, Kupferstichkabinett, inv. 617

The existence of a similar figure in the frescoes of the Palazzo Pubblico in Siena has in the past caused this drawing to be attributed to the workshop of the Lorenzetti brothers. However, the delicacy of the strokes, elegant rhythm and flowing line are so reminiscent of the style of Simone Martini in such works as his *Anunciation* of 1333 in the Uffizi that it seems likely the artist may have been one of his close followers, working in the 1350s.
*Bibliography*: Degenhart-Schmitt, 1968, p. 43; Dreyer, 1979, pl. 1

Master of the *Parement de Narbonne* (second half of the fourteenth century)
*An Archer*
Brush and black ink on parchment; 10½ × 6¼ in. (267 × 160 mm.), irregularly shaped
Provenance: Ridolfi; Guise
Oxford, Christ Church, inv. 0002

This drawing was for a long time accredited to an Italian hand. However, it is stylistically very close – both in its brushwork technique and its chiaroscuro – to the grey figures painted on the silk altar-hanging of Narbonne, which was probably executed between 1374 and 1378 by an artist in the employ of Charles V of France. The original attribution is understandable, as something of the style of Simone Martini can certainly be detected both in the *Parement* and this drawing.
*Bibliography*: Paecht, 1956, p. 150; Meiss, 1967, p. 132; Byam Shaw, 1976, no. 1445

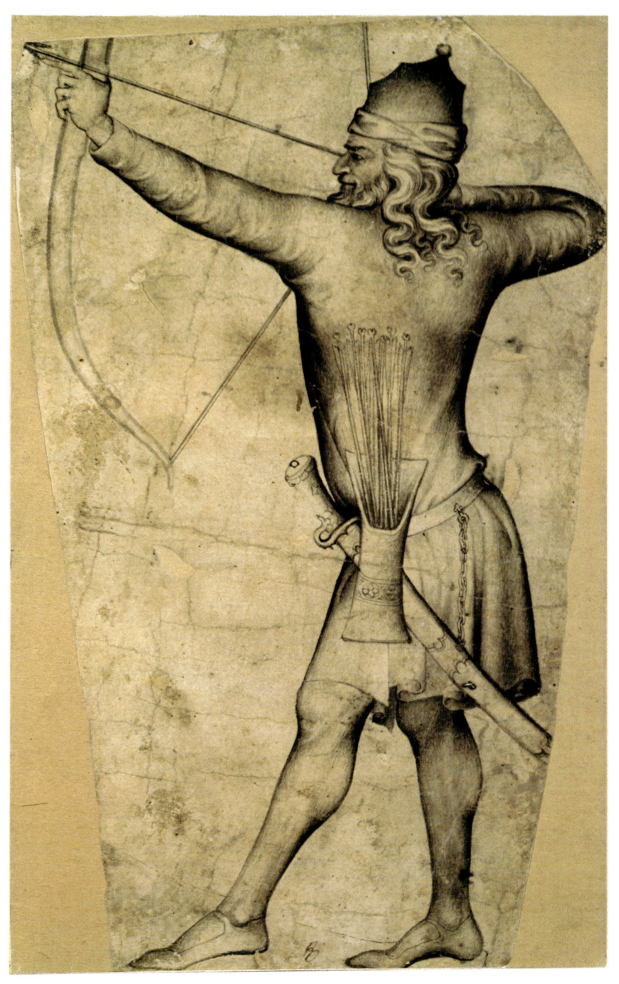

67

German painter (*c.* 1390)
*The Education of Mary*
Pen and greyish-black ink; $4\frac{7}{8} \times 5$ in.
(124 × 127 mm.)
Provenance: von Aufsess
Nuremberg, Germanisches
Nationalmuseum, inv. Hz 38 (*r*)

This sheet illustrates a rather unusual theme
in the German iconographic repertoire,
showing as it does the young Mary
concentrating on her reading, surrounded by
angels. The well-defined lines, delicate
hatching with the pen and accentuated
verticality, which characterize the whole
composition, are typical stylistic features of
northern Gothic art.
*Bibliography*: Wiegand, 1934–5, pp. 49 ff;
Halm, 1955–6, no. 2

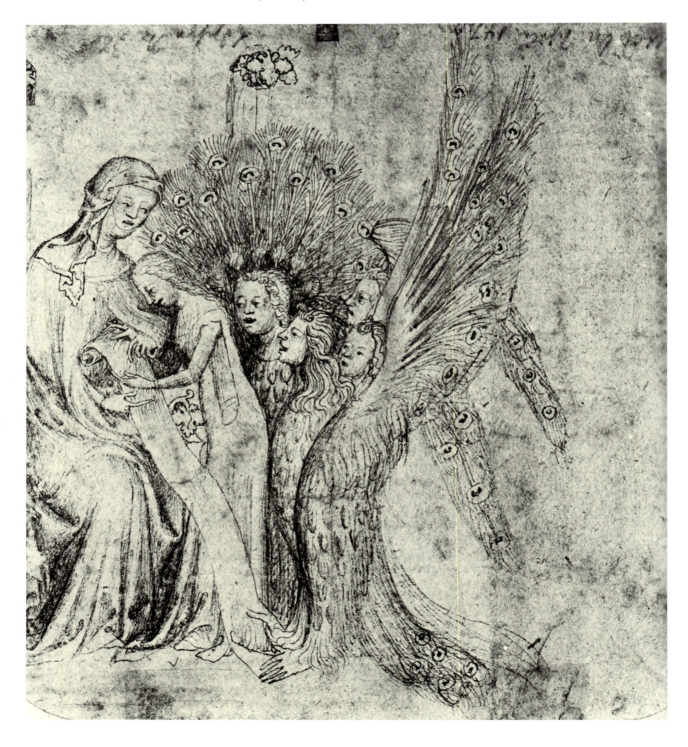

Lombardy painter (beginning of the fifteenth century)
*A Hunting Scene*
Pen, brush and indian ink heightened with white on prepared green paper; $5\frac{7}{8} \times 7\frac{1}{8}$ in. (148 × 182 mm.)
Provenance: Esterházy
Budapest, Szépmüvézeti Múseum, inv. 1778

This drawing, in which great skill is displayed in the use of the pen and brush on prepared paper, is a fine example of the realistic style found in artists' illustrated notebooks, so typical of the Lombardy and International Gothic styles. The incisive lines, the scene set against surroundings taken from life and the controlled animation of the elegant figures of the horsemen, are all indications that it can be counted, both stylistically and chronologically, as being among the finest illustrated manuscripts of the time.
*Bibliography*: van Schendel, 1938, p. 55; Vayer, 1956, no. 6; Fenyö, 1965, no. 1

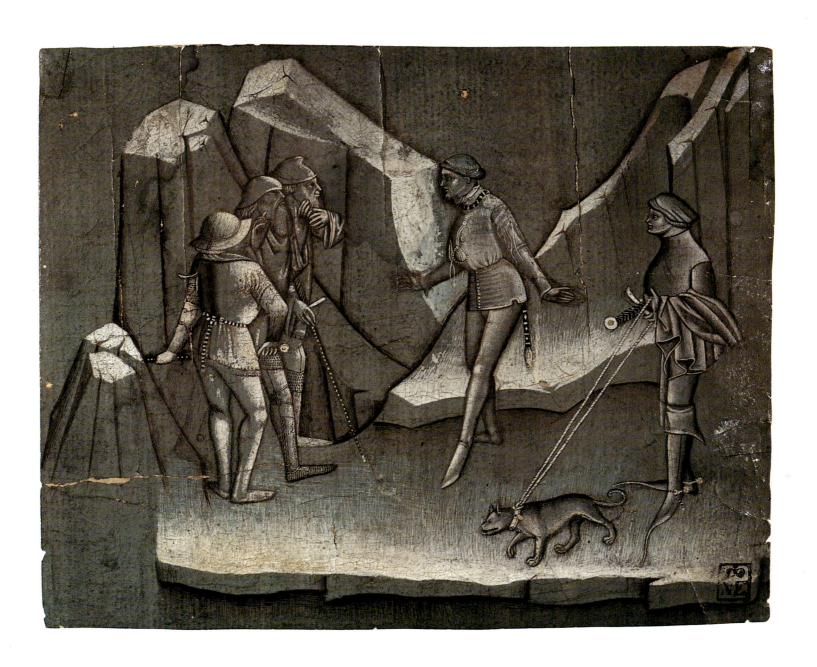

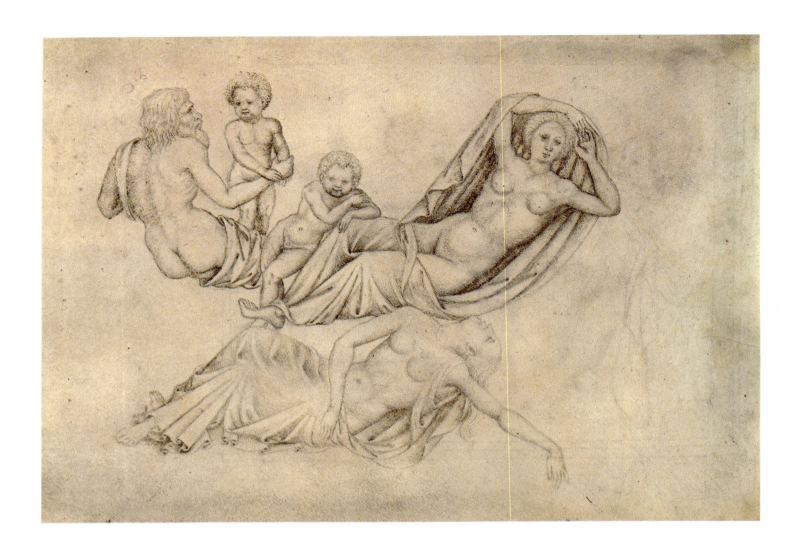

Gentile da Fabriano (Fabriano
c. 1370–Rome 1427)
*Female Nudes and Other Figures*
Pen on parchment; 7⅝ × 10¾ in.
(193 × 273 mm.)
Provenance: Resta
Milan, Biblioteca Ambrosiana, Cod. ms. F
214 lr., f. 13 (r)

Here the artist has used the Sarcophagus of
Mars and Rhea Sylvia (at one time in the
Basilica of San Giovanni in Laterano,
Rome, but now in the Palazzo Mattei) and
the Sarcophagus of Orestes (in the Palazzo
Giustiniani, Rome) as Antique exemplars
from which to make his drawings. The
pictorial delicacy apparent in some of
Gentile's other graphic works provides good
grounds for attributing this study to him as
well. He has achieved a perfect balance in
these figures between the classical motif and
Gothic linear execution.
*Bibliography*: Fossi Todorow, 1966, no. 185;
Degenhart-Schmitt, 1968, no. 129

Giovannino de' Grassi (Milan?–d. 1398)
*Two Ladies with a Cithern*
Ink and watercolour on parchment;
10⅛ × 7⅜ in. (258 × 187 mm.)
Provenance: Lotto; Tassi; Secco-Suardi
Bergamo, Biblioteca Civica, Codex VII 14,
f. 3 (v)

The linear rhythm and delicate haziness of
the colours are the main features of this
drawing, which is part of a *Taccuino*
('Notebook') of thirty-one sheets. The
illustrative elegance of the International
Gothic style blends in with the naturalistic
approach that can be seen in many of the
studies in which animals and plants are
featured. Most of the works in the collection
are by Giovannino de' Grassi, who was one
of the major Lombardy artists of the late
fourteenth century.
*Bibliography*: Toesca, 1912, pp. 298–306;
van Schendel, 1938, p. 60; [*de' Grassi*], 1961,
*passim*

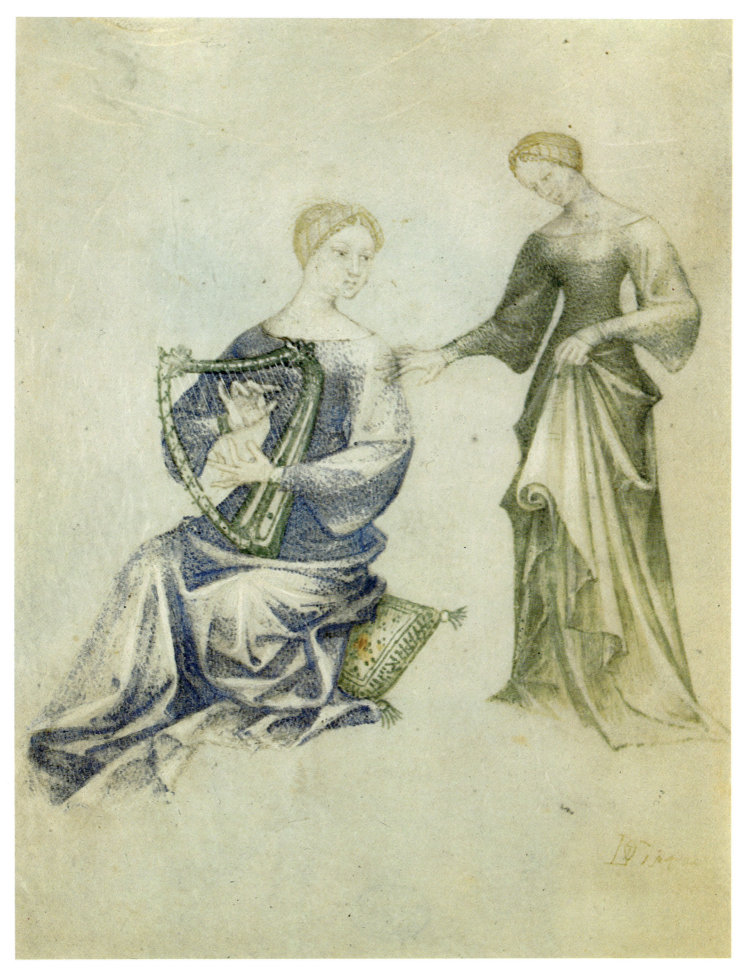

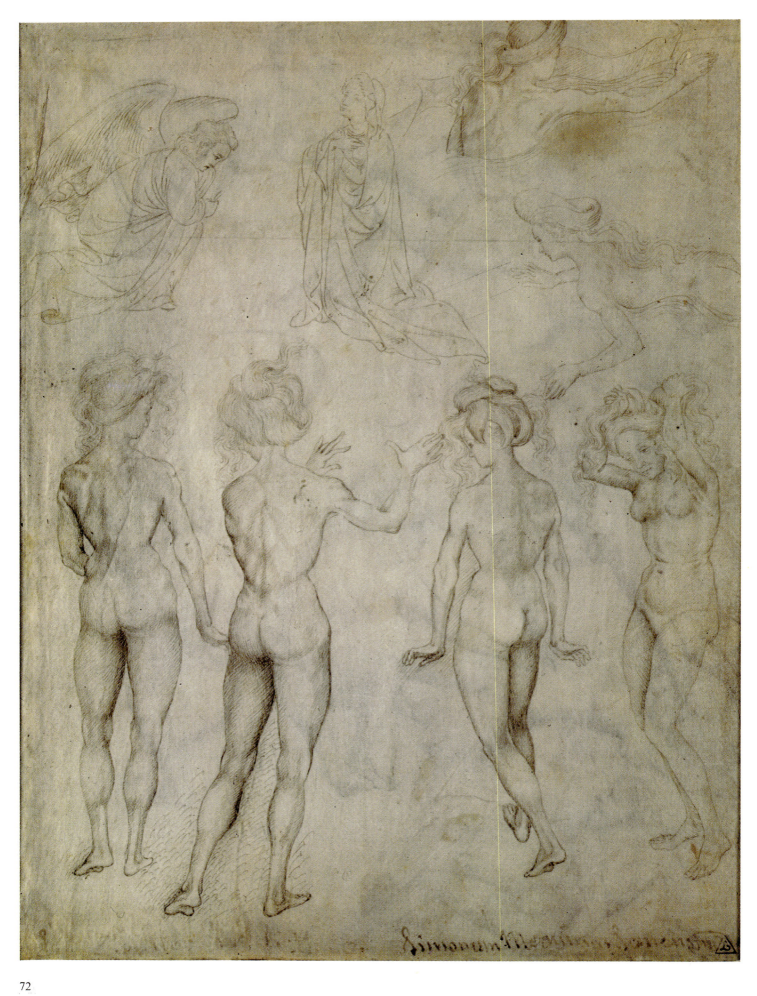

Pisanello (Pisa 1395–Rome 1455)
*Studies of the Nude and an Annunciation*
Pen and ink on parchment; 8¾ × 6⅝ in.
(223 × 167 mm.)
Provenance: Fries; Lagoy; Koenigs
Rotterdam, Museum Boymans-van
Beuningen, inv. I 520 (*r*)

The most remarkable aspect of this sheet is
the almost pre-Renaissance interest shown
by the artist in achieving a realistic and
sensual representation of female nudes, in
contrast with the still Gothically inclined,
refined quality of the figures of the Angel
and Virgin. Judging from the style, these
drawings are datable to the middle 1420s,
about the same time as Pisanello was
working on his fresco in San Fermo, Verona
(1424–6).
*Bibliography*: Degenhart, 1945, pp.
21, 24, 49. 72; Haverkamp, Bagemann, 1957,
no. 33; Fossi Todorow, 1966, no. 2

Pisanello
*Studies of Costume and a Female Head*
Pen and brown ink with watercolours,
silverpoint on parchment; 7½ × 9½ in.
(183 × 240 mm.)
Provenance: Lagoy; Douce
Oxford, Ashmolean Museum

The most characteristic features of
Pisanello's drawings are the fact that he
worked from life, the linear stylization of his
pen-strokes and a decorative quality of
international appeal. The present sheet is
one of about forty by Pisanello, all
parchment, contained in the so-called
*Taccuino di viaggio* ('Travel Notebook') –
only partially Pisanello's work. They include
drawings made from Antique exemplars and
also some very lively representations of
animals.
*Bibliography*: Parker, 1956, no. 41; Fossi
Todorow, 1966, no. 190; Pignatti, 1976,
no. 1

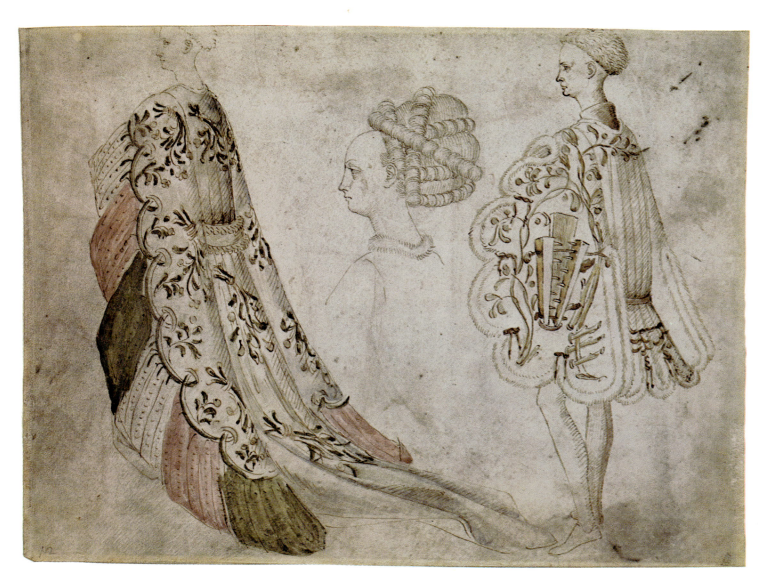

Donato Bramante
(Monte Asdruvaldo
1444–Rome 1514)
*St Christopher*
Silverpoint
heightened with
opaque white-lead
pigment on azure
paper; 12 × 7½ in.
(304 × 192 mm.)
Copenhagen, Royal
Collection

The strength and
monumental quality
of this powerful
figure of St
Christopher contrasts
movingly with the
lively drawing of the
tiny Christ Child
perched on his
shoulders. This sheet,
which is squared-up
for transference, may
have been prepared
for a fresco to be
painted in
accordance with the
traditional depiction
of the Saint –
protector against
sudden death – on
the façade of
churches.
*Bibliography*:
Popham, 1931, no.
151; Suida, 1953,
p. 30

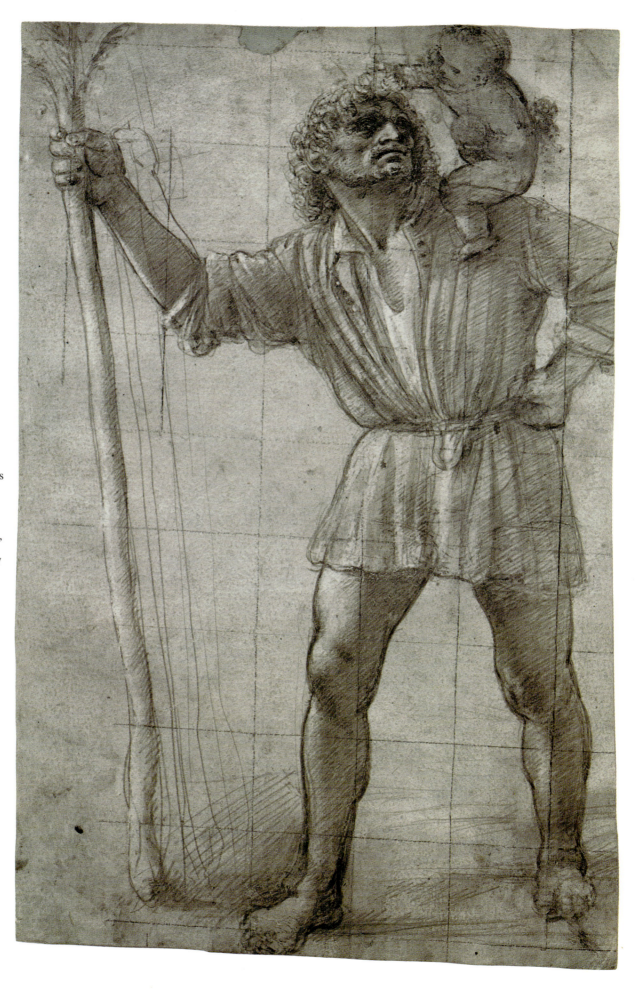

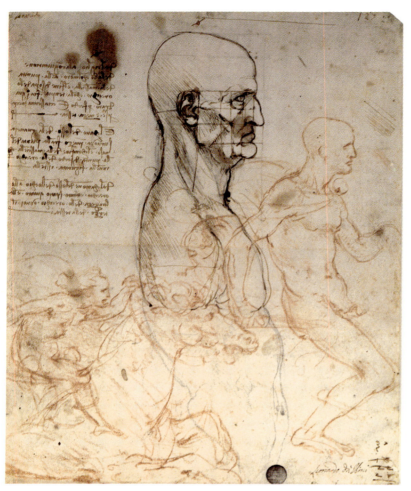

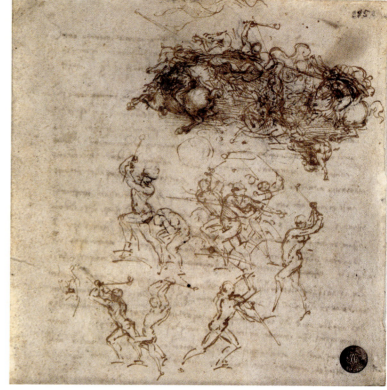

Leonardo da Vinci (Vinci
1452–Amboise 1519)
*Bust in Profile Marked up to Demonstrate
Proportions of the Human Head; also Study
of a Horse and Horsemen*
Pen, black pencil, sanguine and brown ink;
11 × 8¾ in (280 × 222 mm.)
Provenance: Bossi
Venice, Gallerie dell'Accademia, inv. 236 (r)

This folio includes a number of studies
which are partially superimposed on each
other. They are identifiable as belonging to
two different periods of Leonardo's artistic
activities: the well-defined profile in pen and
ink is datable to about 1490, while the horse
and horsemen, more flowingly sketched in
sanguine, were drawn nearer to the time of
his *Battle of Anghiari*, painted about 1503.
The long inscription on the left refers to the
grid of lines marked out to demonstrate the
measurements of the human head.
*Bibliography*: Popham, 1963, no. 191;
Cogliati Arano, 1980, no. 7

Leonardo da Vinci
*Scenes of Battle with Horsemen and Nude
Figures in Action*
Pen and brown ink; 5¾ × 6 in.
(145 × 152 mm.)
Venice, Gallerie dell'Accademia, inv. 215 A

These animated combat scenes, rapidly
sketched in pen-and-ink, were almost
certainly in preparation for his wall-painting
of the *Battle of Anghiari*, for which
Leonardo was commissioned by the Signoria
(the ruling body) of Florence in 1504. The
picture was never completed, however, and
the unfinished work soon deteriorated
because of the artist's unfortunate choice of
medium. Leonardo was trying to revive an
interest in the Antique technique of
encaustic work but it was a disaster. The
only clues that remain as to the composition
of the picture are to be found in the many
partial copies by other artists that remain to
us.
*Bibliography*: Popham, 1963, no. 192B;
Cogliati Arano, 1980, no. 13

Leonardo da Vinci
*Study of the Drapery of a Woman's Dress*
Metalpoint, charcoal, bistre and opaque
white-lead pigment on vermilion-tinted
prepared paper; 10⅛ × 7½ in.
(257 × 190 mm.)
Provenance: Corsini
Rome; Accademia Nazionale dei Lincei, on
loan to the Istituto Nazionale per la Grafica,
inv. F.C. 125770

This is an elegant study of drapery in which
Leonardo made use of a mixed technique on
the red preparation of the paper. It is similar
in style to some of his other paintings, in
particular the Virgin of the *Annunciation* in
the Louvre and of another *Annunciation* in
the Uffizi, both works which he produced
when quite young and datable to about the
middle of the 1470s.
*Bibliography*: Popham, 1946, p. 36, no. 1;
Berenson, 1961, no. 1082/b; Catelli Isola,
1980, no. 8

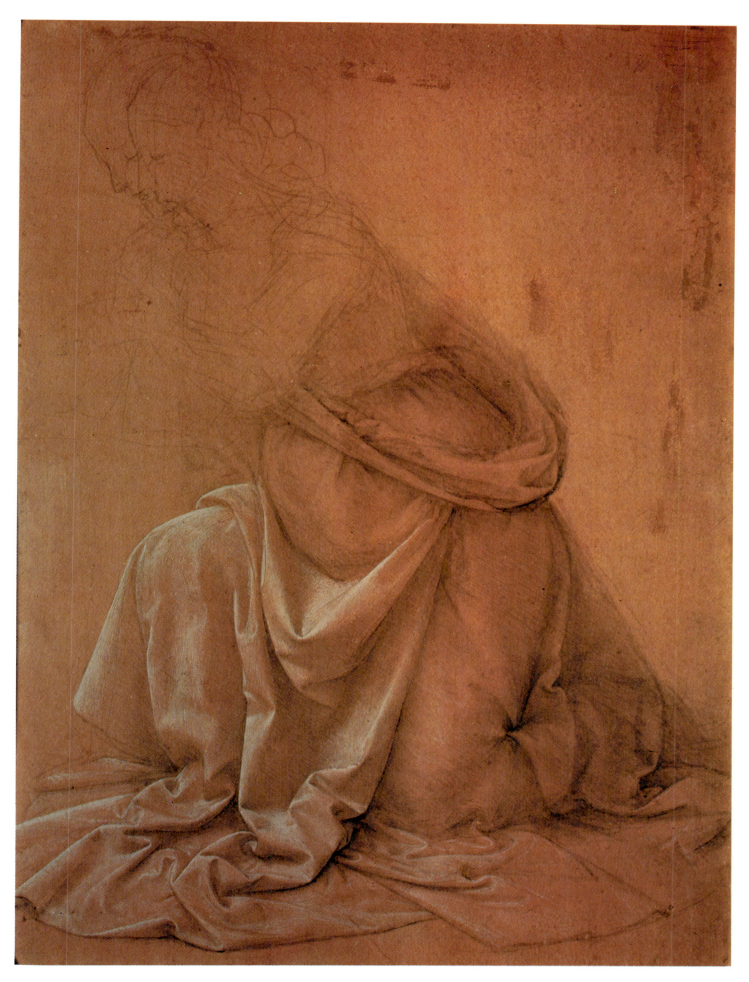

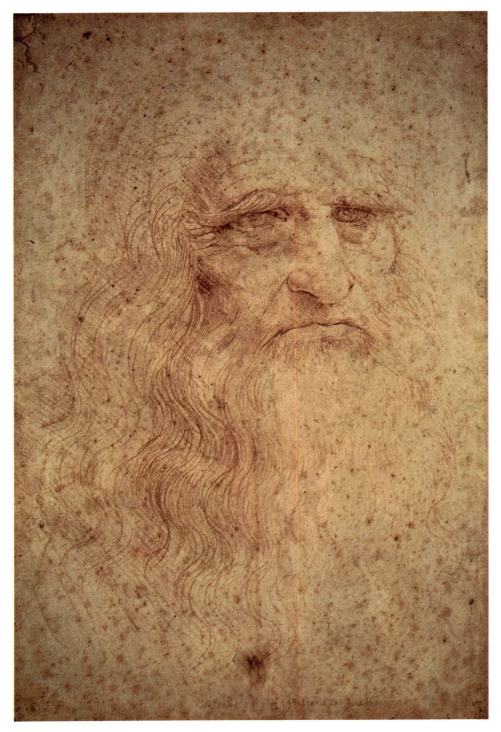

Leonardo da Vinci
*Self-Portrait*
Sanguine; 13⅛ × 8⅜ in. (333 × 213 mm.)
Provenance: Volpato; Carlo Alberto (1840)
Turin, Biblioteca Reale, inv. 15571

This very famous drawing in sanguine is the
only authentic self-portrait of Leonardo and
is datable to between 1512 and 1516. It was
executed just before his departure for
France. The soft, painterly line, which is to
be seen in so many of the artist's works,
shows up well even in this folio in which the
master – only a little over sixty years of age
– has used it to produce an idealized portrait
of himself looking like a philosopher of
Antiquity.
*Bibliography*: Bertini, 1958, no. 229;
Popham, 1963, no. 154; Pedretti, 1975, no. 1

Michelangelo (Caprese 1475–Rome 1564)
*A Head in Profile*
Sanguine; 8 × 6½ in. (205 × 165 mm.)
Provenance: the Buonarroti family; Wicar;
Ottley; Lawrence; Woodburn
Oxford, Ashmolean Museum

This 'Head' has been given several datings
and in the past been identified with some of
the figures in the Sistine Chapel ceiling
(1508–12), mainly because of certain
similarities. Now, however, it has become
linked with the group of so-called 'finished
drawings', datable to around 1522. In these
sheets the draughtsmanship is so complete as
to justify each one being regarded as a work
of art in its own right. They were probably
executed by Michelangelo as gifts to be
presented to his admirers.
*Bibliography*: Parker, 1956, no. 315; Hartt,
1971, no. 363; Pignatti, 1976, no. 20

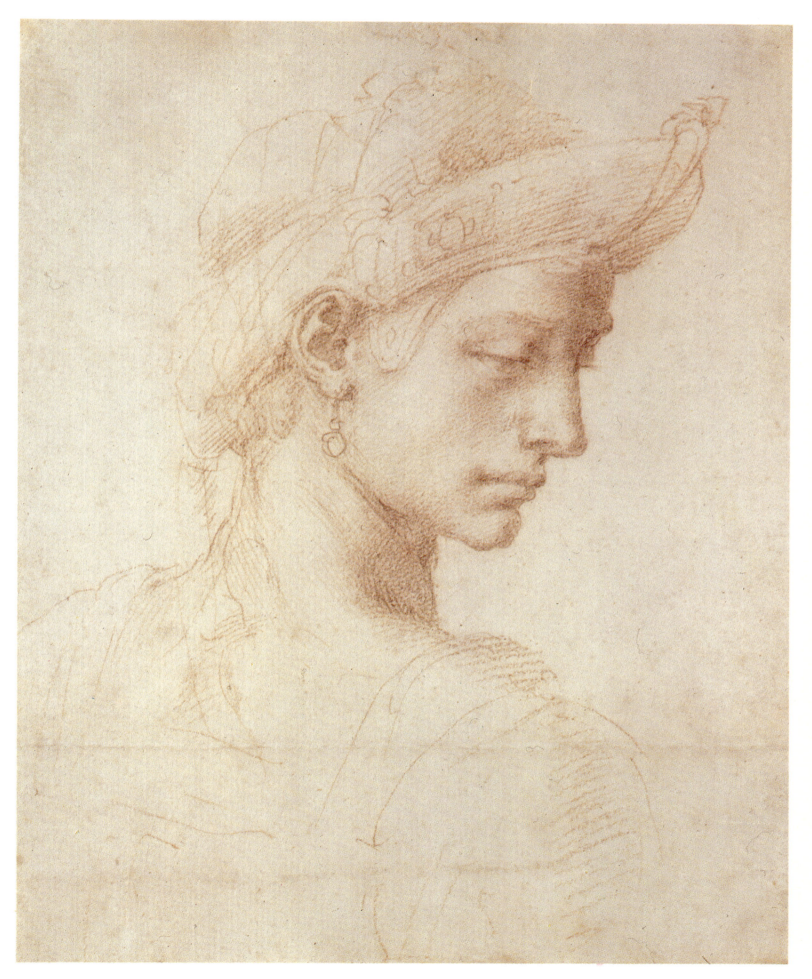

111

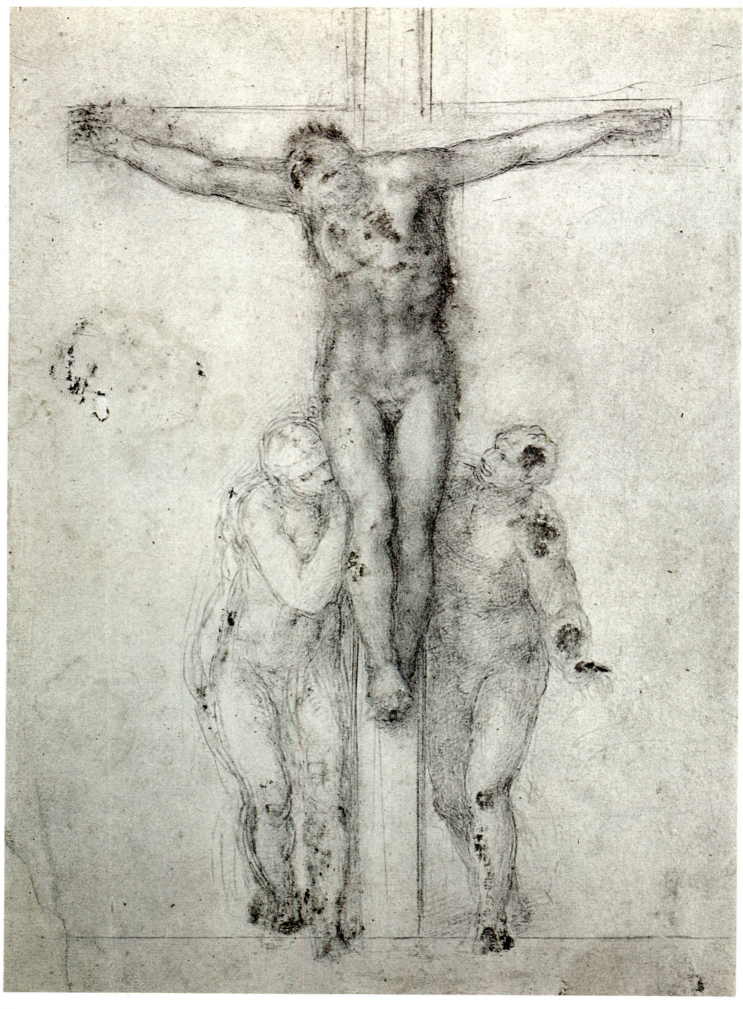

Michelangelo
*Crucifixion*
Black chalk and opaque white-lead pigment;
16¼ × 11 in. (412 × 279 mm.)
London, British Museum, inv. W.82

This study for a 'Crucifixion' is probably the
last of a series of six associated with the later
phase of Michelangelo's work, between
about 1550–5. The religious sensibility of the
artist shows itself in the feeling of pathos
and tension of line that he achieves through
the complex readjustments of the figures,
both in going over the outlines again and in
using the white heightening agent to cover his
*pentimenti* and create emphasis.
*Bibliography*: Wilde, 1953, no. 82; Hartt,
1971, no. 429

Raphael (Urbino 1483–Rome 1520)
*St Catherine of Alexandria*
Charcoal heightened with white;
23⅛ × 13⅝ in. (587 × 346 mm.)
Provenance: Jabach; Cabinet du Roi (1671)
Paris, Musée National du Louvre, inv. 3871

The large size of this sheet, which is made up
of four pieces joined together, and the
pricked outlines for transfer indicate that
this was a preliminary cartoon for the *St
Catherine of Alexandria* in the National
Gallery, London. The classicism of the figure
of the Saint recalls the style of the female
figures in the Stanza della Segnatura in the
Vatican as well as of other works from
Raphael's Roman period.
*Bibliography*: Fischel, IV, 1923, no. 207;
Bacou-Viatte, 1975, no. 62

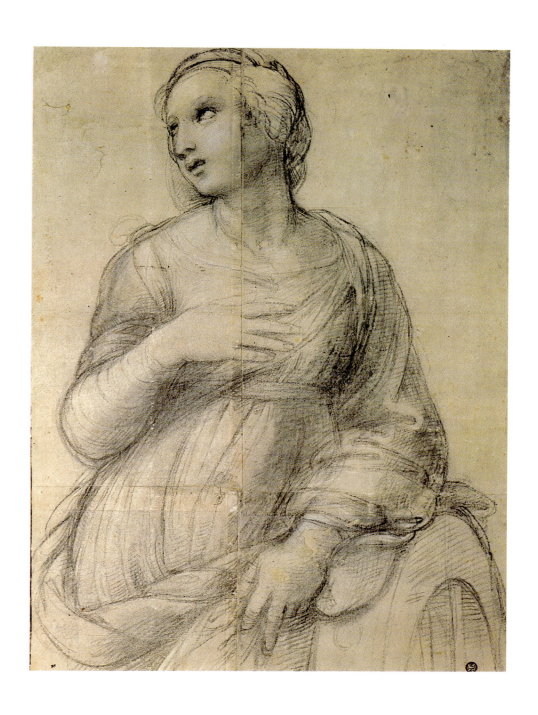

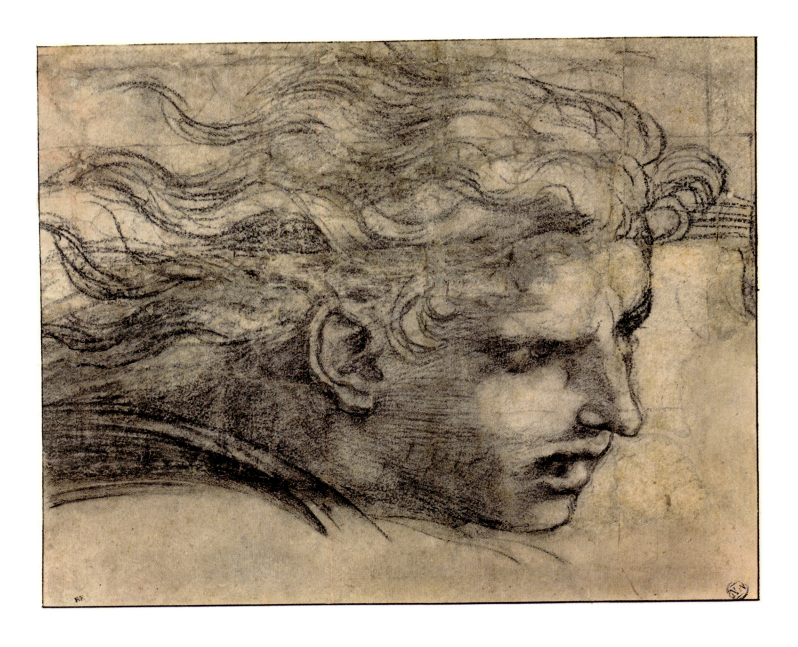

Raphael
*Head of an Angel*
Charcoal heightened with white on light
brown paper; $10\frac{1}{2} \times 13$ in. ($268 \times 329$ mm.)
Provenance: Crozat; Mariette; Cabinet du
Roi
Paris, Musée National du Louvre, inv. 3853

This drawing may well have been part of a
cartoon which Vasari mentions as having
been in the house of Francesco Massini in
Cesena. The subject refers to one of the two
angels who are expelling Heliodorus from
the Temple in Jerusalem (1511), depicted in
fresco in one of the Vatican's Stanze. The
dramatic effect of the windswept hair is
evidence of the extent to which Raphael was
influenced by the Michelangelesque pathos.
*Bibliography*: Oberhuber, IX, 1972, no. 401;
Bacou-Viatte, 1975, no. 64

Raphael
*Woman Reading to a Child*
Metalpoint heightened with white on
prepared grey-tinted paper; $7 \times 5\frac{1}{2}$ in.
($190 \times 140$ mm.)
Provenance: Lely; Duke of Devonshire
Chatsworth, Devonshire Collection, inv. 728

The theme of 'Mother and Child' is seen
here in an intimate, everyday context. The
drawing relates stylistically to the period
when Raphael was working on the
*Miraculous Mass of Bolsena*, and its
particularly finished quality enabled
Raimondo – or one of his pupils – to
transpose it into an engraving.
*Bibliography*: Fischel, VIII, 1942, no. 375;
Wragg, 1962–3, no. 57

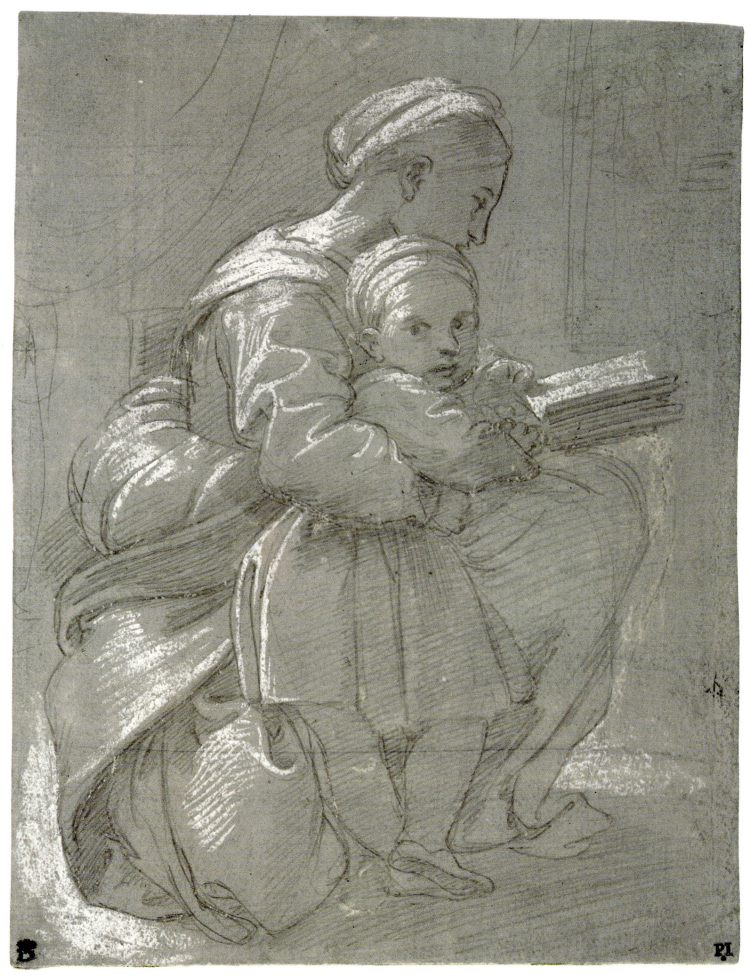

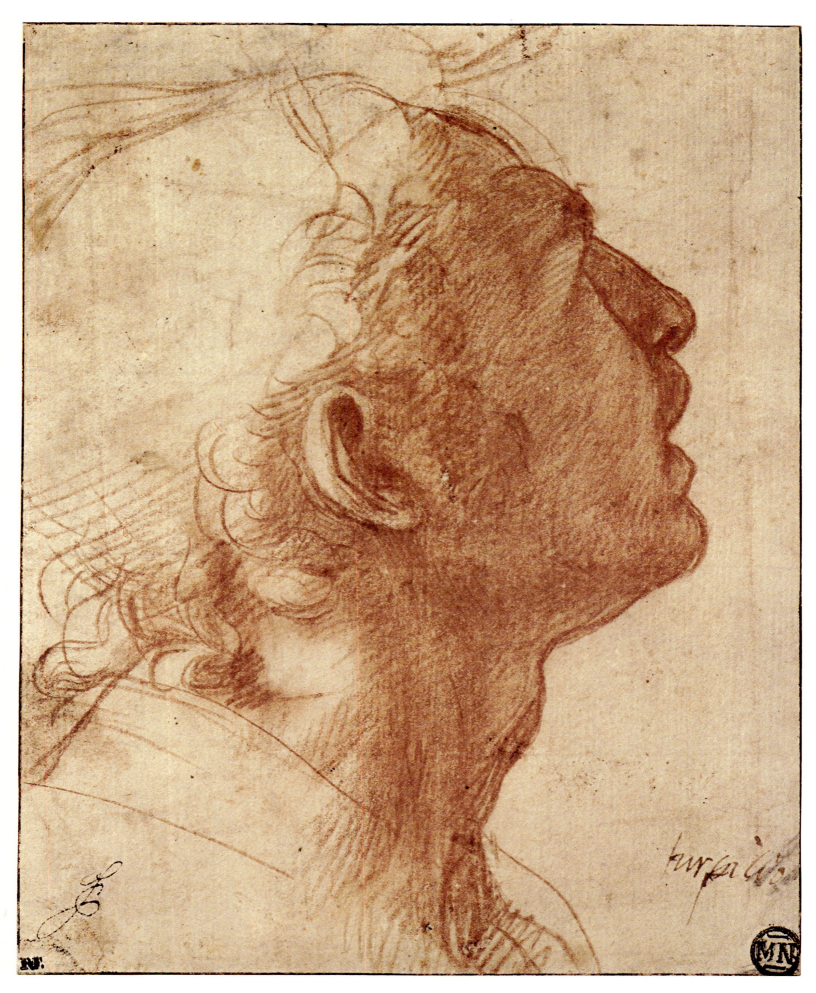

116

Andrea del Sarto (Florence 1486–1531)
*Profile of a Head*
Sanguine; 7⅜ × 6⅛ in. (195 × 156 mm.)
Provenance: Cabinet du Roi
Paris, Musée National du Louvre, inv. 1685

The blend of Raphaelesque harmony with
the soft effect of the *sfumato* lines is the main
stylistic feature of this study, which was used
by the artist for two paintings. In one the
head corresponds to that of Joseph in del
Sarto's *Madonna of the Stairs* (Prado,
Madrid), datable to 1522–3, and in the other
to an Apostle in his Panciatichi *Assumption*
in the Palazzo Pitti, Florence. These
discoveries have made it possible, therefore,
to date this drawing to an earlier phase of
the artist's working life instead of as had
previously been believed, to his later years.
*Bibliography*: Berenson, 1961, no. 149;
Freedberg, 1963, pp. 110, 118; Shearman,
1965, I, p. 158; II, pp. 252, 374; Bacou-
Viatte, 1975, no. 68

Fra Bartolommeo (Florence 1475–Pian di
Mugnone 1517)
*Head of an Elderly Man*
Charcoal; 14⅞ × 10⅜ in. (378 × 264 mm.)
Munich, Staatliche Graphische Sammlung,
inv. 2167 (*r*)

This drawing is characterized by the
markedly plastic quality of the fifteenth-
century Florentine tradition combined with
a soft *sfumato* effect which shows clearly the
influence of Leonardo da Vinci. The artist's
special skill as a draughtsman is clearly in
evidence. In addition to the pen, charcoal
was one of Fra Bartolommeo's favourite
media for his numerous studies; most of his
more successful experimental sketches were,
in fact, executed in charcoal.
*Bibliography*: Gabelentz, 1922, II, p. 139;
Berenson, 1961, no. 449; Degenhart-Schmitt,
1967, no. 11

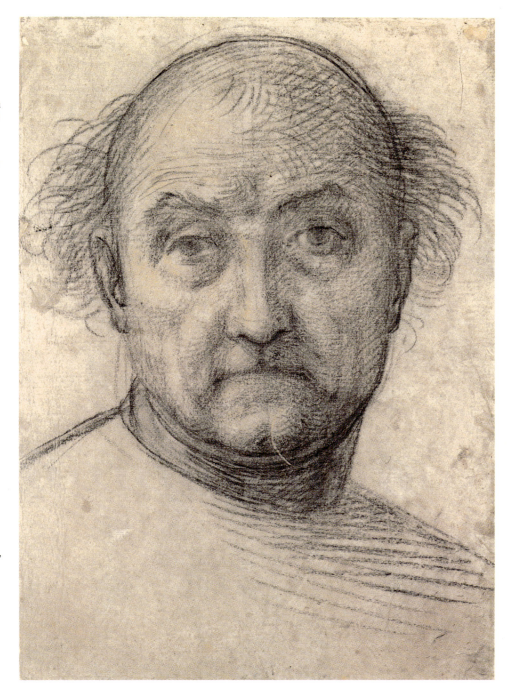

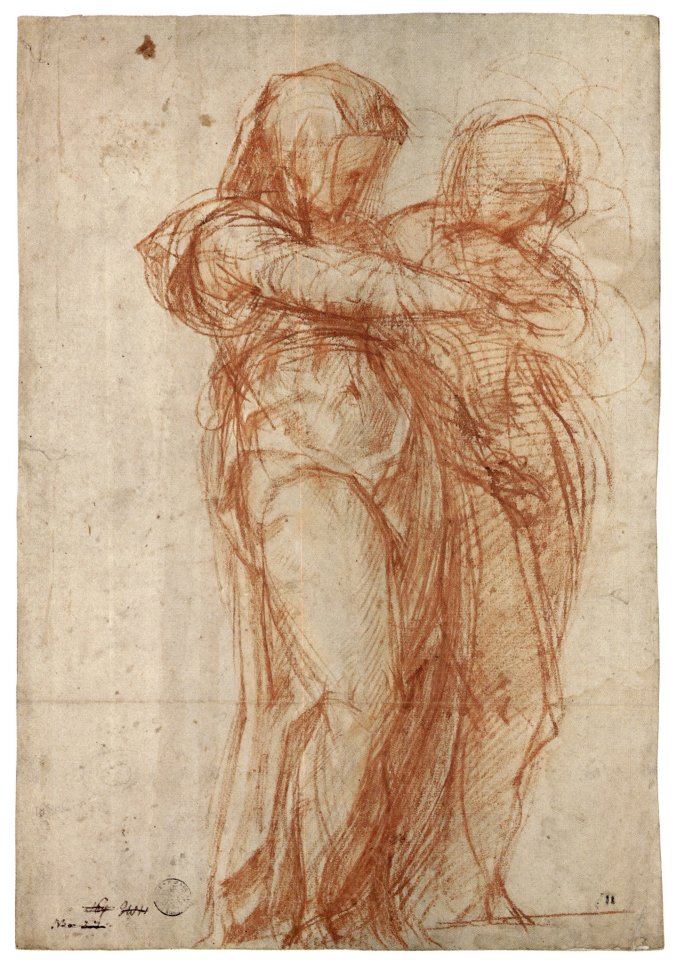

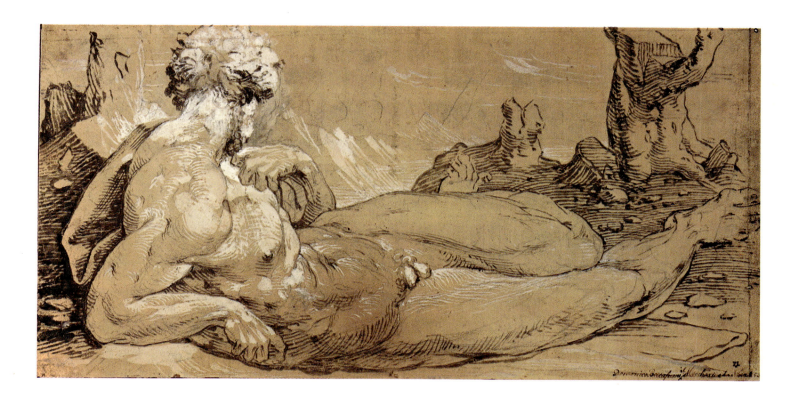

Jacopo Pontormo (Pontormo
1494–Florence 1556)
*Two Veiled Women*
Sanguine; $15\frac{1}{2} \times 10\frac{1}{8}$ in. (391 × 260 mm.)
Provenance: entered in 1822
Munich, Staatliche Graphische Sammlung,
inv. 14042 (*r*)

This drawing may have been a study for a
'Visitation' and belongs to the youthful
period of Pontormo's activities, under the
direct influence of his master, Andrea del
Sarto, to whom the picture was at one time
attributed. The vigorous, flowing strokes
with which the artist has sketched the two
female figures are already typical of the
Mannerist style.
*Bibliography*: Cox Rearick, 1964, no. 17;
Degenhart-Schmitt, 1967, no. 62

Domenico Beccafumi
(Montaperti *c.* 1486–Siena 1551)
Reclining Nude
Black pencil, brush and bistre, highlighted
with opaque white-lead pigment, and sharply
outlined with a stylus; $8\frac{3}{4} \times 17$ in.
(222 × 431 mm.)
Provenance: van Amstel; Albert von
Sachsen-Teschen
Vienna, Graphische Sammlung Albertina,
inv. 276

The pose adopted by this powerful male
figure, which strongly reveals the influence of
Michelangelo, suggests that it represents a
river deity. This drawing, so stylistically
similar to the cartoon of *Moses on Mt Sinai*,
was executed by Beccafumi for the floor of
Siena Cathedral and has a technical affinity
to his chiaroscuro prints which are datable
to the 1530s.
*Bibliography*: Stix-Fröhlich Bum, 1932,
no. 205; Samminiatelli, 1967, no. 122;
Koschatzky-Oberhuber-Knab, 1971, no. 33

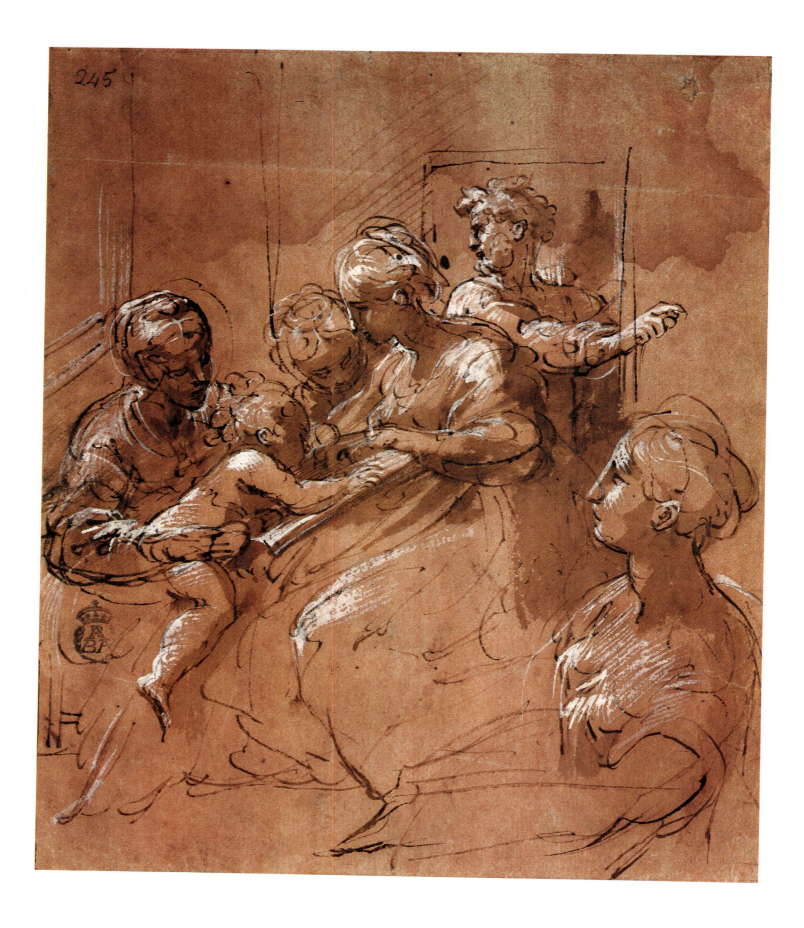

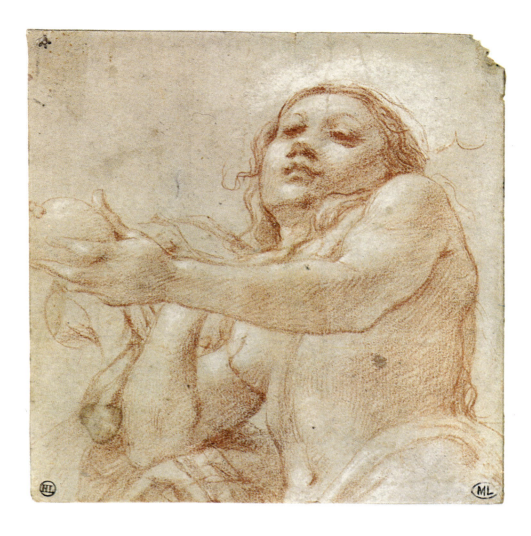

Parmigianino (Parma
1503–Casalmaggiore 1540)
*The Mystical Marriage of St Catherine*
Pen and brown ink, with sepia wash,
highlighted with opaque white-lead pigment
on pink-tinted paper; 8⅝ × 7 in.
(219 × 178 mm.)
Provenance: Philip V of Spain; monastery of
Valparaiso
Madrid, Real Accademia de Bellas Artes de
San Fernando, inv. 158

Here the artist has sought to achieve
painterly and chromatic results through the
contrasting effects of watercolour wash and
white bodycolour on the tinted page. The
sheet is datable to Parmigianino's Roman
period or a little after (1525–7). His elegant
Raphaelism combined with the natural
Correggesque influence have created a
composition in which reality and humanity
give way to a calculated and complex
artificiality.
*Bibliography*: Pérez Sánchez, 1967, no. 115;
Popham, 1971, no. 279; Pérez Sánchez,
1977, no. 4

Antonio Correggio (Reggio Emilia *c.*
1489–1534)
*Eve*
Sanguine heightened with white; 4½ × 4⅛ in.
(116 × 104 mm.)
Provenance: Lanière; de la Salle; acquired in
1878
Paris, Musée National du Louvre,
inv. RF 499

This study refers to the figure of Eve in the
frescoes in the dome of Parma Cathedral,
painted by Correggio between 1526 and
1528. It is characterized by a daring
foreshortening effect of *sotto in sù* (an angle
of perspective whereby objects seen from
below actually appear to be floating in
space.) Correggio used his favourite graphic
medium, sanguine heightened with white, for
this drawing in which the draughtsman has
achieved an extraordinary softness in its
painterly quality.
*Bibliography*: Popham, 1957, no. 53; Bacou,
1964, no. 17; Bacou-Viatte, 1968, no. 38

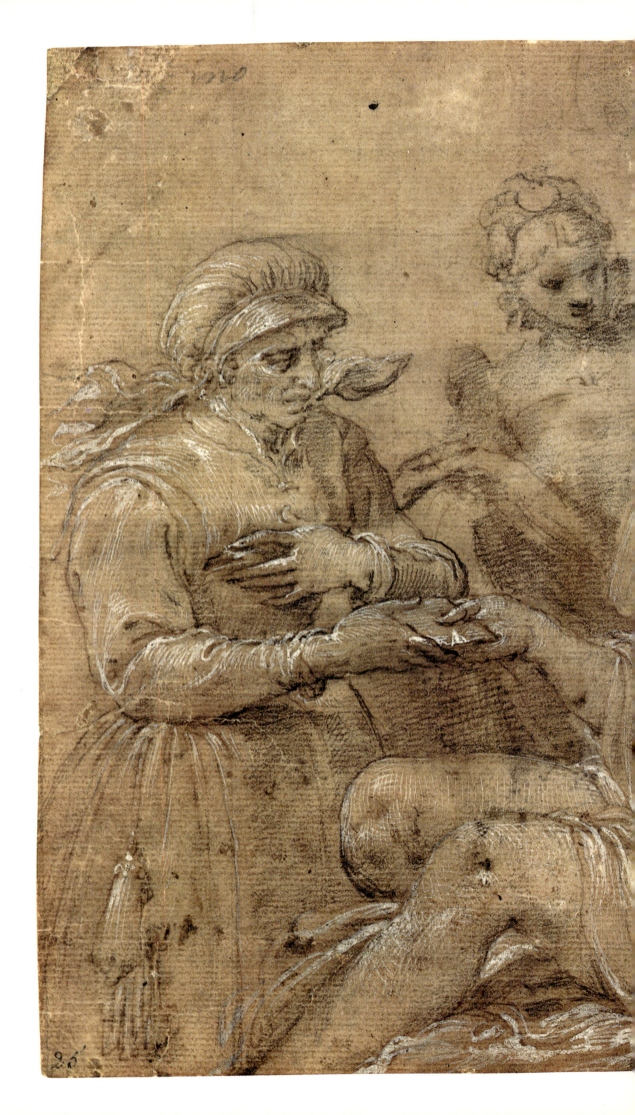

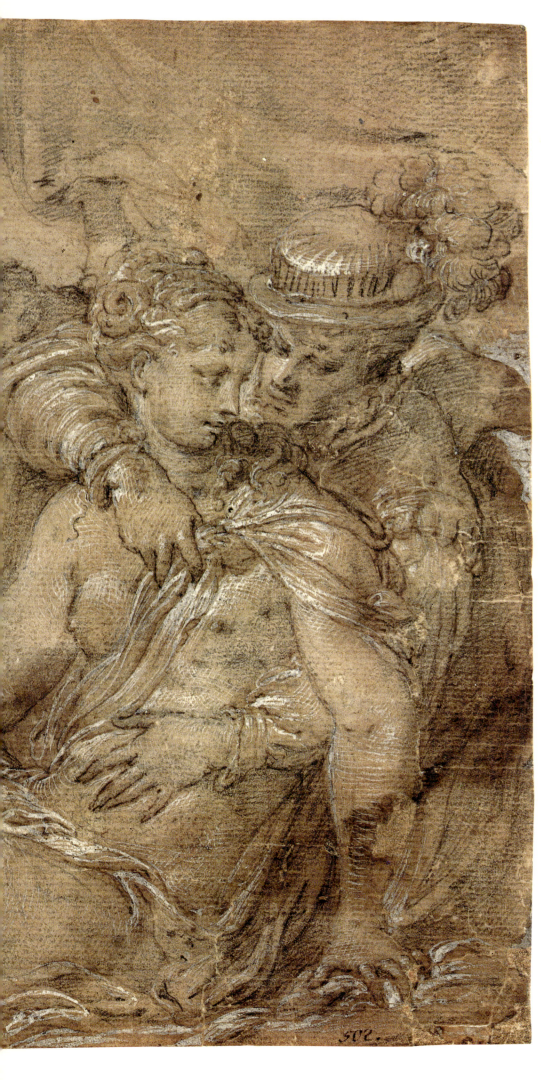

Niccolò dell'Abbate
(Modena *c.* 1509–Fontainebleau 1571)
*Young Man Embracing a Naked Woman*
Pen and bistre with white highlighting on
light brown paper; $7\frac{7}{8} \times 8\frac{5}{8}$ in
(199 × 220 mm.)
Provenance: Mannheimer
Munich, Staatliche Graphische Sammlung,
inv. 2250

This drawing was at one time believed to
belong to the artist's youthful period, but it
has recently been redated to his more mature
phase (1565–70). This decision has been
made both on considerations of stylistic
order and on the dress of the characters.
Typically Mannerist in composition, it
moves on different planes. This folio made a
considerable impact on the genre scene in
France.
*Bibliography*: Halm-Degenhart-Wegner,
1958, no. 70; Béguin, 1969, no. 64

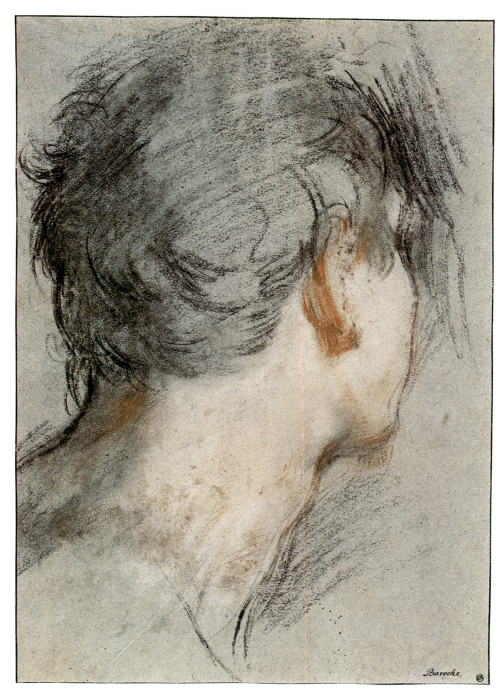

Luca Cambiaso (Moneglia
1527–Madrid 1585)
*Venus Detaining Adonis*
Pen and brown ink on white paper;
$13\frac{3}{4} \times 9\frac{7}{8}$ in. (350 × 250 mm.)
Provenance: Biggal; Chancey; acquired in
1901
Florence, Museo Horne, inv. 5580

Venetian and Correggesque influences,
echoes of **Raphael** and a tension already
presaging the Baroque style are all fused into
the art of Luca Cambiaso. His drawings,
with their 'cubistic' style characterized by
broken, vigorous lines and a remarkable
dynamism, are indicative of the artist's
interest in trying to capture the movement of
figures within the spatial limitations of a
piece of paper or canvas.
*Bibliography*: Ragghianti Collobi, 1963, no.
99

Federico Barocci (Urbino 1528–1615)
*Head in Profile*
Three coloured chalks (the technique known
as *'aux trois crayons'*) on azure paper;
$14\frac{3}{8} \times 10$ in. (365 × 254 mm.)
Provenance: Chechelsberg; Crozat; Tessin;
Kongl. Biblioteket; Kongl. Museum
Stockholm, Nationalmuseum, inv. 462/1863

The contrasting effects in this drawing of the
coloured chalks on azure paper seem to be
striving to achieve the plasticity of the
Roman tradition. It is a preliminary study
for the head of the shepherd who can be
seen on the left of the *Circumcision* of 1590 –
now in the Louvre, Paris – painted by
Barocci for the Compagnia del Nome di
Gesù in Pesaro.
*Bibliography*: Sirén, 1917, no. 165; Olsen,
1962, p. 186, (lower) no. 43; Bjurström,
1970–1, no. 17

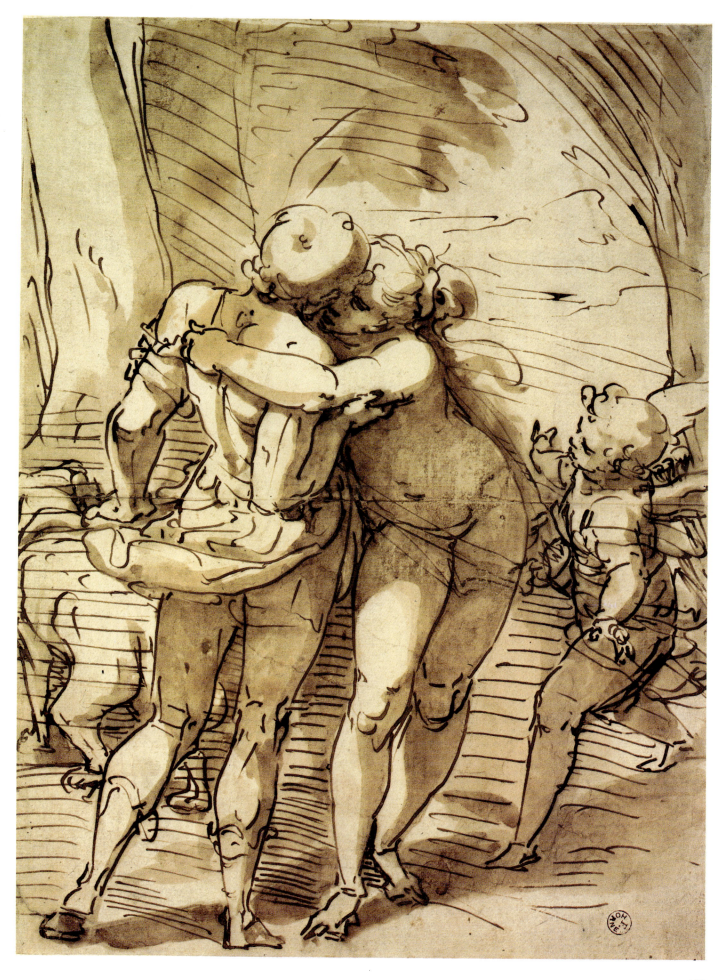

# The Sixteenth Century in Venice

**Giorgio da Castelfranco, known as Giorgione** (Castelfranco Veneto 1477?–Venice 1510). Giorgione became associated with the Bellini workshop at the age of twenty. To it he brought – through his own innovative talent – a lyrical naturalism which was, at the same time, in tune with the humanistic atmosphere of the early sixteenth century. Very few documented works remain to us: the *Tempest* in Venice, the *Venus* in Dresden, the *Three Philosophers* (or *Three Magi*) in Vienna, and several portraits. Stricken with the plague when only about thirty-three years old, he nevertheless succeeded, in his short working life, in bringing about some fundamental revolutionary changes in the artistic theme. These can be seen in the thematic, linguistic and technical differences in painting before and after his influence had made itself felt. He introduced the principles of a lyrical and naturalistic approach to art and emphasized the tonal effects of colour, preparing the way for the very much freer style that was to characterize sixteenth-century Venetian painting as the use of oils came to be better understood and enjoyed. Drawings by Giogione are few and those there are relate mainly to graphic work for Giovanni Bellini's paintings. This rarity may well be due to the eminently painterly nature of his pictures.

**Lorenzo Lotto** (Venice 1480–Loreto 1556). Lotto received his training under the Bellini brothers, then at the age of twenty-three went to Treviso. During his four-year stay in this Veneto town, his development was complicated by influences from Lombardy and Northern Europe; his youthful works were particularly inspired by the realism of Dürer, as seen in his *Bishop de'Rossi*, in Naples, and his Asolo altarpiece of 1506. He completed the great altar at Recanati in 1508 before going to Rome, where his style underwent a complete transformation from his having seen the work of Raphael. He left Rome for the Marches, living from 1513 to 1526 in Bergamo, where he painted altarpieces for the churches of San Bartolomeo and San Bernardino, and produced designs for the intarsia-work in the Cathedral. After a short stay in Venice, where his altarpiece *St Nicholas of Bari in Glory* for the church of Santa Maria del Carmelo (1529) was badly received by the critics, he wandered between Treviso and the Marches in search of commissions but met with little success. He recorded this part of his life in a strange little book which he called *Libro di spese diverse*

('Book of various expenditures'). When he was seventy-two he entered a monastery in Loreto, where he died four years later. A solitary artist, unfortunate in the lack of understanding the revolutionary nature of his painting met with, Lotto is recognized today as a portraitist of outstanding quality and stylistically the precursor of Mannerist disquietude. A great many of Lotto's drawings are extant, mostly taken from life, which show that he had an unusual talent for illustration.

**Sebastiano Luciani, called del Piombo** (Venice *c.* 1485–Rome 1547). This artist spent his early working years in Venice, under the influence of Giorgione. During this period (1508–11) he completed two paintings for the organ of San Bartolommeo a Rialto and an altarpiece for the high altar of San Giovanni Crisostomo. He then moved to Rome where he assisted in the decoration of the Villa Farnesina, in the stylistic range of Raphael and Michelangelo. In 1529 the title of the Papal Seal was conferred on him, hence the name by which he was known, *del piombo* ('of the leaden seal'). From that moment he never moved out of Rome again, and indeed died there eighteen years later. He was above all a great portraitist. He revived the principles of design used by Raphael, combining them with the rich colouristic effects of the Venetians.

**Tiziano Vecellio, known as Titian** (Pieve di Cadore *c.* 1490–Venice 1576). Having been brought up in Venice, Titian spent his artistically formative years under the guidance of the Bellini brothers and Giorgione. Some of his work bears a close resemblance to that of the latter, especially his *Concert Champêtre* (or *Pastorale*) in the Louvre. He also put the finishing touches to a number of Giorgione's works after the latter's rather sudden death. One of these was the *Venus* now in the Gemäldegalerie, Dresden. Titian then reigned supreme among the Venetian painters and his position was left in no doubt when he was commissioned to paint the *Assumption* altarpiece for the church of Santa Maria Gloriosa dei Frari, which he completed between 1516 and 1518. He was then summoned to the castle of Ferrara to decorate the Camerino di Alabastro for Duke Alfonso, the pictures for which are now in Madrid and London. Titian was appointed to the office of Painter to the State, which included the privilege of being the

official portraitist of the Doges. He also executed a number of works, one of which was another altarpiece for the Frari, the *Madonna of the Pesaro Family*; this was nominally intended as an expression of thanksgiving, but was in fact a means of glorifying the donors. It was completed in 1526. In 1530 Titian met the Holy Roman Emperor, Charles V, in Bologna, where he was made a Knight of the Empire as a token of imperial appreciation of a series of portraits. By 1545 he was in Rome as a guest of the Farnese family; while there, he painted the elderly Pope Paul III, both as sole subject and with his two nephews. Michelangelo praised Titian's masterly handling of colour but regretted the lack of interest Venetian artists showed in *buon disegno* by which he meant both drawing and design in the sense of composition, this last including a meaning that developed in Mannerist Italy *c.* 1540–1600 under the influence of Neoplatonism and the notion of the Platonic Idea – that of the ideal vision or *disegno interno* the artist had of his work before beginning it. The term had mystical overtones: an analogy was drawn between the activity of the artist and that of the Creator which found expression in the anagram *Disegno, segno di Dio*, 'Design is the sign of God'. Having returned to the Imperial Court of Augsburg in 1548, Titian painted a portrait of the Emperor and of his son who, when Charles V abdicated about eight years later, became Philip II of Spain. Titian had become his favourite artist and devoted himself almost entirely to working for the Spanish king. In the last years of his life Titian changed his style, as can be seen from his *Pietà*, which remained unfinished due to the artist's death from the plague in 1576. During these final years he executed his pictures without contours, moulding shapes with patches of colour and tortuous effects of light in a kind of 'magical impressionism' which only serves to emphasize his amazing imaginative capacity. Titian was deeply interested in the graphic element in art, whether producing his own xylographs (i.e. an early type of wood-engraving in which the woodcut produced a design in white lines on a predominantly black ground) or looking at reproductions of his pictures made by other engravers. There are about fifty of his drawings extant which can be closely related to the stylistic development of his painting.

**Domenico Campagnola** (Venice 1500–Padua 1564). Domenico was a follower of Giulio Campagnola, from whom he learnt to use the engraving technique that had gained so much popularity as it spread southwards from the Germanic States. He then developed a style that so closely resembled that of Titian that their work was often confused. He in fact co-operated with Titian on the frescoes in the Scuola del Santo in Padua, as well as on other frescoes in the same city. In later life Domenico Campagnola returned largely to graphic work, especially landscape compositions in which he developed, albeit somewhat rigidly, a number of Titian's motifs.

**Giovan Antonio de'Sacchis, known as Pordenone** (Pordenone *c.* 1484–Ferrara 1539). Having remained in Venice for some time under the influence of Giorgione, Pordenone painted his first major work, the *Madonna della Misericordia*, in the town of his birth. He then moved on into central Italy and Rome, where he found himself irresistibly fascinated by the work of Michelangelo. On leaving Rome, he returned to Venice, dividing his time between that city and Ferrara (1520), where he performed the task of an innovator by introducing the Tuscan-Roman culture into his own area, to an extent that even impressed Titian. Pordenone's numerous preliminary drawings, especially those for Cremona Cathedral (1522) demonstrate clearly the close linguistic link between his work and that of Michelangelo. He remained in Emilia for quite a long time, working on frescoes at Cortemaggiore and Piacenza, gradually adopting much of the Mannerism of Correggio. Towards the end of his life, Pordenone returned to Venice, where he executed two major works. One was in the Sala dello Scrutinio (no longer extant) in the Doge's Palace. The other is his *Annunciation*, completed in 1537, for the church of Santa Maria degli Angeli on Murano. His last days, however, were spent in Ferrara.

**Andrea Meldolla, known as Schiavone** (Zadar *c.* 1520–Venice 1563). From his earliest working days as an artist, Schiavone found himself in tune with Mannerism through the prints of Parmigianino. He therefore devoted a great deal of his own talents to engraving and his drawings are numerous. Having left his native land of Dalmatia when quite young, he first made a name for himself by painting large *cassoni*. He is better remembered, however, for such works as those in the Old Library of St Mark's, painted in 1556, in which the style is elegantly Mannerist. Towards the end of his brief life, Schiavone seems to have returned to his fascination for Titianesque emphasis on colouristic effects, while still maintaining his linear accentuation.

**Jacopo da Ponte, known as Bassano** (Bassano *c.* 1517–1592). Having spent his pupilage in Venice under the guidance of Bonifacio dei Pitati, in about 1540 Jacopo returned to his birthplace, Bassano, never to leave it again. He nevertheless succeeded in retaining close cultural links with Venice, where he ranked among the best artists of his day. His most interesting phase occurred while he was developing a feeling for Mannerism, through the prints of Parmigianino (*The Beheading of the Baptist, c.* 1550, Copenhagen). His thematic material developed a particularly rustic flavour, with considerable importance given to landscape, as in his various 'Adorations' of the Magi and of the shepherds, which almost established the basic requirements for an autonomous category. The later works by Bassano, such as the *Baptism of St Lucille* (1581), contain a strange luministic quality, especially the nocturnal effects. Such a large output of paintings implies considerable graphic preparation, and numerous examples of this survive. There is some discussion, still unresolved, as to which of these were the real preliminary 'cartoons' and which the 'records' made purely to be distributed among the various workshops run by the artists' sons and nephews.

**Jacopo Robusti, called Tintoretto** (Venice 1518–1594). The most important of the Venetian Mannerists, Tintoretto from his earliest days drew heavily for his style on the work of Michelangelo and Parmigianino, achieving a dynamic quality and linear skill heightened by effects of light and changing chromatic values that to the Venetian eye were strangely 'modern'. This was especially true of his *Miracle of St Mark Rescuing a Slave* which caused quite a scandal when it was first revealed in 1548. It soon came to be accepted, however, and paved the way for several commissions for the Confraternities (*scuole*) such as the Scuola di San Marco (1560) and the Scuola di San Rocco (1564–87). The poetic instinct in Tintoretto led him to represent his religious motifs with dramatic exultation in a popular and pro-

foundly emotive way. His painting technique was rapid and confident, but to achieve this he worked out the details in a number of preliminary drawings, for which he would even use artificially lit lay figures. His greatest works, the *Battle of Zadar* and the *Paradise*, were painted in the Doge's Palace in about 1590, while the *Last Supper* in the church of San Giorgio Maggiore was executed in the last year of his life.

**Domenico Tintoretto** (Venice *c.* 1560–1635). The son of Jacopo, and his father's most faithful collaborator, he frequently kept the more realistic and descriptive parts – including the landscape – to do himself. His style can best be seen in the numerous sheets of drawings, executed in brush-blobs of ink and heightened with white bodycolour, especially in rustic themes taken from life.

**Domenikos Theotocopoulos, known as El Greco** (Candia 1541–Toledo 1614). Trained from 1560 onwards among the *madonneri* of Venice, the modest, anonymous producers of images of the Madonna, El Greco was greatly influenced by the work of Michelangelo, seen on a visit to Rome in 1569. In 1577 he went to Spain and remained in Toledo for the rest of his life. El Greco used colours much as he had seen them used in Venice to express the highly emotional religiosity of Catholic and anti-reformist Spain. His major works were inspired by a disturbing mysticism, for example the *Disrobing of Christ*, painted in 1579 and now in Munich, and the *Burial of Count Orgaz*, painted in 1596 for the church of Santo Tomé in Toledo. They seem to represent a hallucinated humanity reaching out towards visions of a celestial world. The few drawings that are attributed to him are notable for their dependence on Tintoretto – whose work El Greco followed closely as a young man – and their relationship to his paintings.

**Jacopo Negretti, known as Palma Giovane ('the Younger')** (Venice 1544–1628). Great-nephew of Palma Vecchio ('the Elder'), Jacopo received his youthful training in Urbino and Rome, thus ensuring his development along Mannerist lines. At the age of twenty-six, he returned to Venice as an assistant to Titian and found himself called upon to do all kinds of painting, as there were no longer any great masters available. He worked in the Doge's Palace, the Oratorio dei Crociferi (1583–91), the Scuola di San Fantin (*c.* 1600) and innumerable other religious buildings. He was a tireless painter and thousands of his drawings are extant, often bound as notebooks (preserved in Munich and London), all of them having served as studies and preliminary work for his paintings.

**Paolo Caliari, known as Veronese** (Verona 1528–Venice 1588). Having spent his formative years in Verona, he had been vulnerable to the Mannerist influences of nearby Mantua, where Giulio Romano was painting, and of Parma, where Correggio and Parmigianino had their workshops. He soon moved to Venice and in 1551 painted the altarpiece for the church of San Francesco della Vigna. After working for about a year (1553–4) in the Doge's Palace, he executed some very successful paintings in the Old Library of St Marks (1556). He had in the meantime begun the decoration of the church of San Sebastiano, which he completed in 1570 after fifteen years' work with canvases and frescoes. This undertaking became one of his masterpieces. During the years 1559 to 1560, Veronese was working on his wonderful frescoes in the Villa Barbaro (now Villa Volpi) designed by Palladio on the mainland at Maser. His colouristic effects reached their peak of perfection here, with colour and draughtsmanship coming together to provide a happy combination of luminosity. He spent his later years repainting some of the Doge's Palace after the great fire. In the Sala del Collegio he painted the ceiling and also a huge canvas celebrating Venice's victory over Lepanto (1576–7), and nine years later completed his *Triumph of Venice* in the Sala di Maggior Consiglio. Veronese had a large workshop and could therefore call upon the collaboration of several assistants in the execution of his huge projects. As a result, the graphic aspect of his work was very important, as it was necessary to have patterns, cartoons for frescoes and records of completed work. There is thus a wide range of techniques in the drawings, ranging from lightning pen-sketches to elaborate chiaroscuro brushwork on tinted paper and large figure sketches in pastels.

**Carletto Caliari** (Venice 1570–96). The son of Paolo, Carletto was also one of his assistants, along with his brother Gabriele and his uncle Benedetto. Besides the few paintings identified as his, Carletto is notable for a series of portraits executed in different shades of pastel. It is these that reveal his careful, detailed style, similar to that of Bassano whose pupil he was.

**Federico Zuccari (Zuccaro)** (Sant'Angelo in Vado *c.* 1540–Ancona 1609). Younger brother of the better-known Taddeo Zuccari, Federico was an architect and treatise writer as well as a fine painter. He can be categorized as a late Roman Mannerist; the main characteristics of his work are the importance of the drawing and the surprising contrasts of his changing colours. After working with his brother on the frescoes of the Palazzo Farnese and of the Sala Regia in the Vatican, he completed the dome (started some years before by Vasari) of the cathedral of Santa Maria del Fiore in Florence. After working for some time in Spain and England, he returned to Rome, where in 1593 he established the Accademia di San Luca and where, five years later, he was made a prince.

Giorgione (Castelfranco 1477?–Venice 1510)
*A Shepherd Boy*
Sanguine on yellowed paper; $8 \times 11\frac{1}{2}$ in.
($203 \times 290$ mm.)
Provenance: Resta; Böhler; Koenigs
Rotterdam, Museum Boymans-van
Beuningen, inv. I-485

The fine hatching of this drawing, which is
still in the Bellini tradition, blends in with
the meticulously clear-cut depiction of the
landscape, with its distinct German
derivation. The scenery is stylistically akin to
that of the *Madonna* in Leningrad, while the
figure of the shepherd in the foreground
bears a distinct resemblance to the figures in
the *Tramonto* ('Sunset') in London. The
sheet has been damaged due to an unwise
attempt by Resta to clean it with warm
water.
*Bibliography*: Tietze, 1944, no. 709;
Haverkamp Begemann, 1957, no. 38;
Pignatti, 1978, no. 15

Lorenzo Lotto (Venice 1480–Loreto 1556)
*Head of a Woman*
Silverpoint, brushwork in opaque white-lead
pigment on pale blue paper; $8\frac{3}{8} \times 5\frac{1}{2}$ in.
($211 \times 138$ mm.)
Provenance: Bossi
Venice, Gallerie dell'Accademia, inv. 114

A realism which is typical of Lotto
characterizes this 'Head' so delicately
sketched in silverpoint. The marked
influence of Dürer in the clear-cut
representation of the features contrasts
strongly with the Bellini tradition within
which Lotto spent his formative years; it
would seem, therefore, that this drawing
belongs to his more youthful phase, and is to
be dated to about 1506 when he was
painting such pictures as his *Ritrattino*
('Little Portrait') in Bergamo.
*Bibliography*: Tietze, 1944, no. 324; Pignatti,
1973, no. 9; *Giorgione a Venezia*, 1978, p. 76

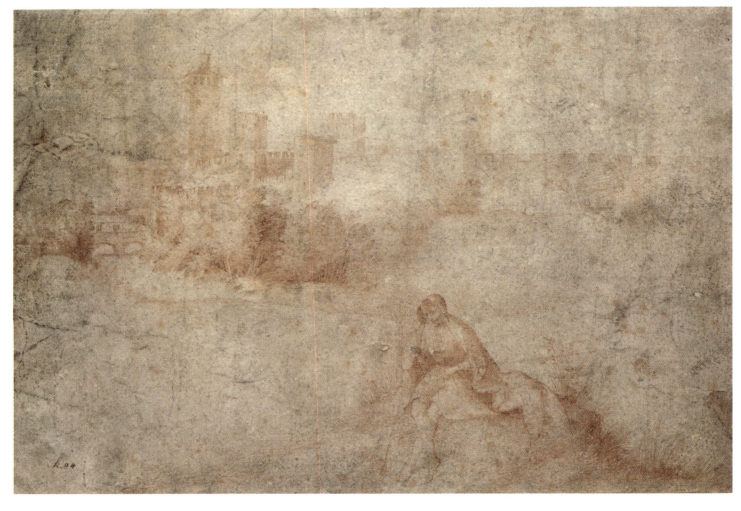

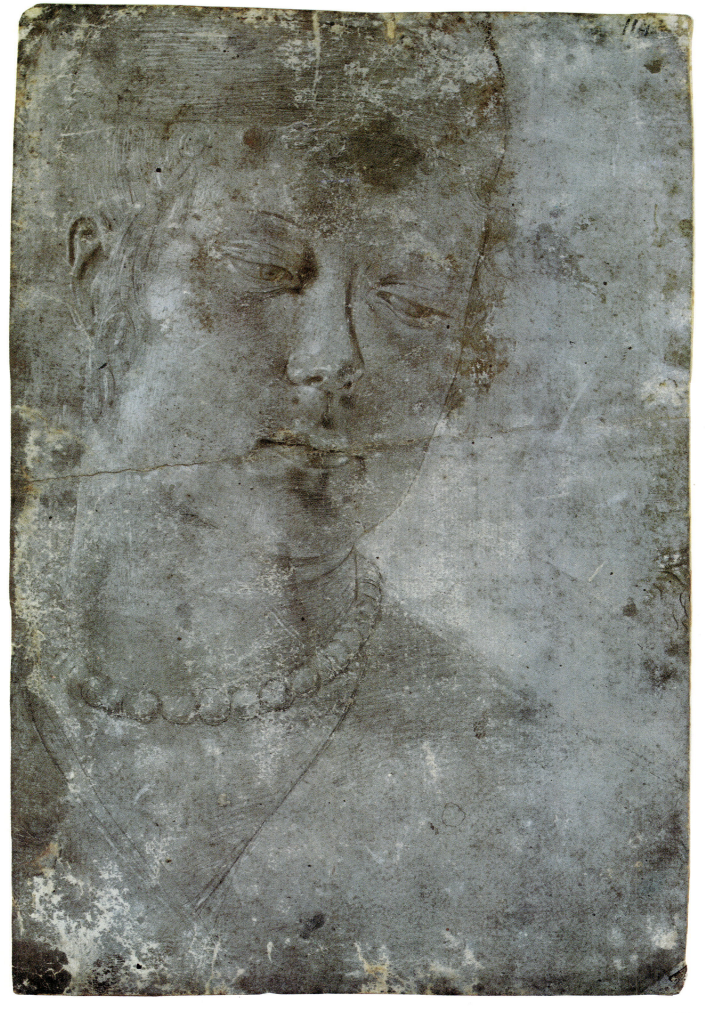

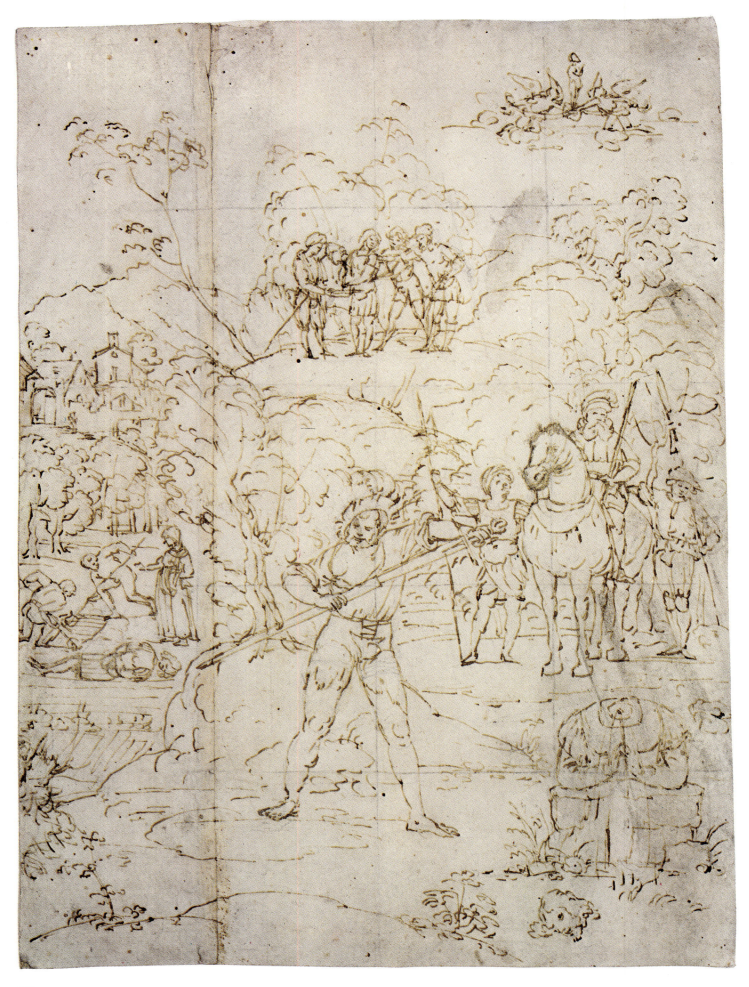

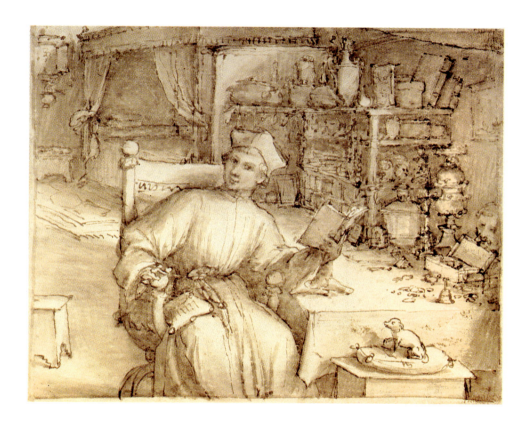

Lorenzo Lotto
*Martyrdom of Saint Alexander of Bergamo*
Pen and brown ink, squared in black chalk;
$10\frac{5}{8} \times 7\frac{3}{4}$ in. (271 × 197 mm.)
Provenance: Calmann
Washington, DC, National Gallery of Art,
Ailsa Mellon Bruce Fund, inv. B-25, 789

The stylistic similarity of these sketches to
two known studies for the intarsia-work in
Bergamo Cathedral make it possible to date
this folio – probably part of a sketchbook
long since lost – to the 1520s, when Lotto
was working in Bergamo. The fable-like
narrative tone and meticulous portrayal of
character which stamp the frescoes executed
in 1524 in the Villa Suardo, Trescore, can be
seen reflected in this sheet, whose subject
matter is drawn from the same source.
*Bibliography*: [Overhuber], 1974, p. 64;
Pignatti, 1974, no. 12; Robison, 1978, no. 41

Lorenzo Lotto
*Prelate in His Study*
Pen, brush and brown ink highlighted with
opaque white-lead pigment; $6\frac{3}{8} \times 7\frac{3}{4}$ in
(162 × 198 mm.)
Provenance: Phillips; Fenwick
London, British Museum, inv. 1951-2-8-34

The lively and detailed portrayal of indoor
domestic objects is one of the more
outstanding features of Lotto's work. This
can be seen particularly in paintings from
about 1525, such as his *Annunciation* in
Recanati. The fragmentary lines and
emphasis on the play of light suggest that
this folio belongs to the artist's mature
phase.
*Bibliography*: Popham, 1951, p. 72;
Pouncey, 1965, p. 15; Pignatti, 1970, pl. XIII

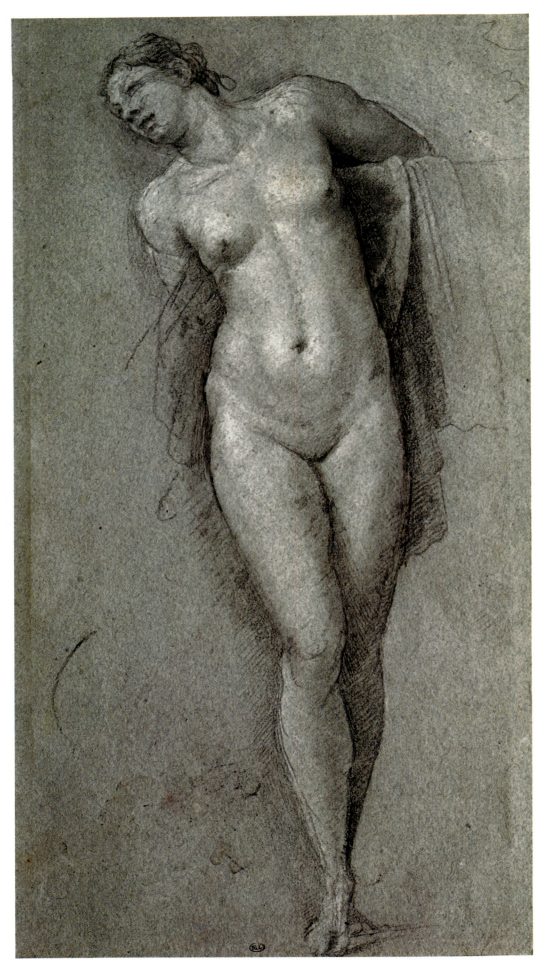

Sebastiano del Piombo (Venice *c.* 1485–Rome 1547)
*Nude Woman Standing*
Black chalk heightened with white on azure paper; 14 × 7⅞ in. (353 × 189 mm.)
Provenance: Jabach; Cabinet du Roi (1671)
Paris, Musée National du Louvre, inv. 10.816

This female nude can be related, with a few changes, to the figure of the saint herself in the *Martyrdom of St Agatha* (Pitti Palace, Florence), painted in 1520. During this period of his work, Sebastiano achieved his three-dimensional quality – which he had derived from Michelangelo – by means of a particularly painterly representation which is typically Venetian in style, as is the technique of using black chalk heightened with white on azure paper.
*Bibliography*: Pouncey, 1952, p. 116; Berenson, 1961, no. 2497 c; Bacou-Viatte, 1975, no. 69

Titian (Tiziano Vecellio) (Pieve di Cadore *c.* 1490–Venice 1576)
*Portrait of a Young Woman*
Black chalk heightened with white chalk on yellowed sky-blue paper; 16½ × 10⅜ in. (419 × 264 mm.)
Provenance: Fondo Mediceo-Lorenese (?)
Florence, Galleria degli Uffizi, inv. 718E (*r*)

This drawing is a fine example of Titian's preference for black chalk or charcoal on azure paper for his figure studies. Stylistically, it is very similar to the dense brushwork of his Paduan frescoes, which were completed in 1511. Even in this youthful work, Titian was striving to achieve that soft, painterly quality that was to typify his more mature drawings.
*Bibliography*: Tietze, 1944, no. A1899; Rearick, 1976, no. 16; Pignatti-Chiari, 1979, pl. XII

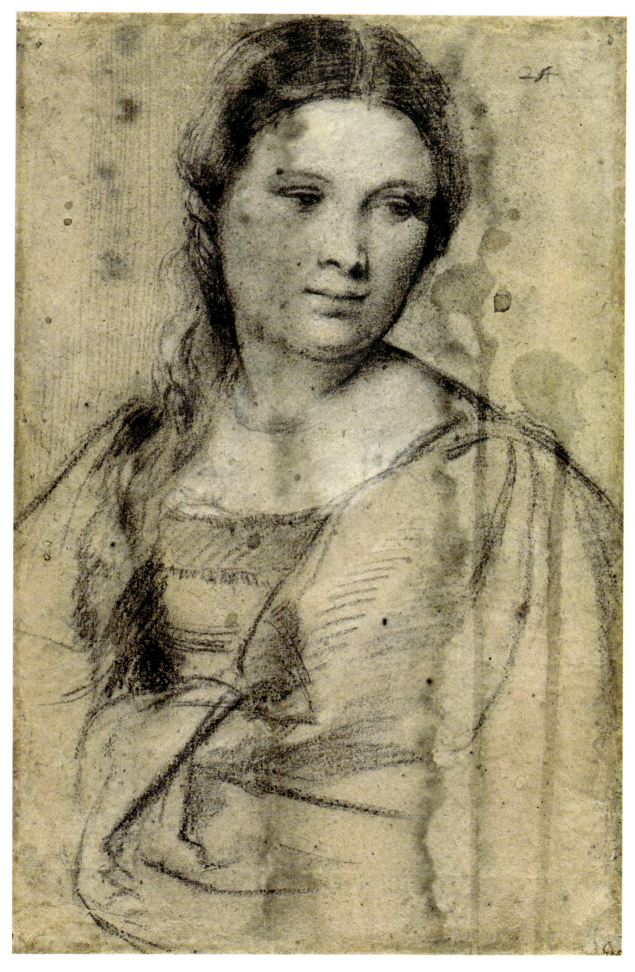

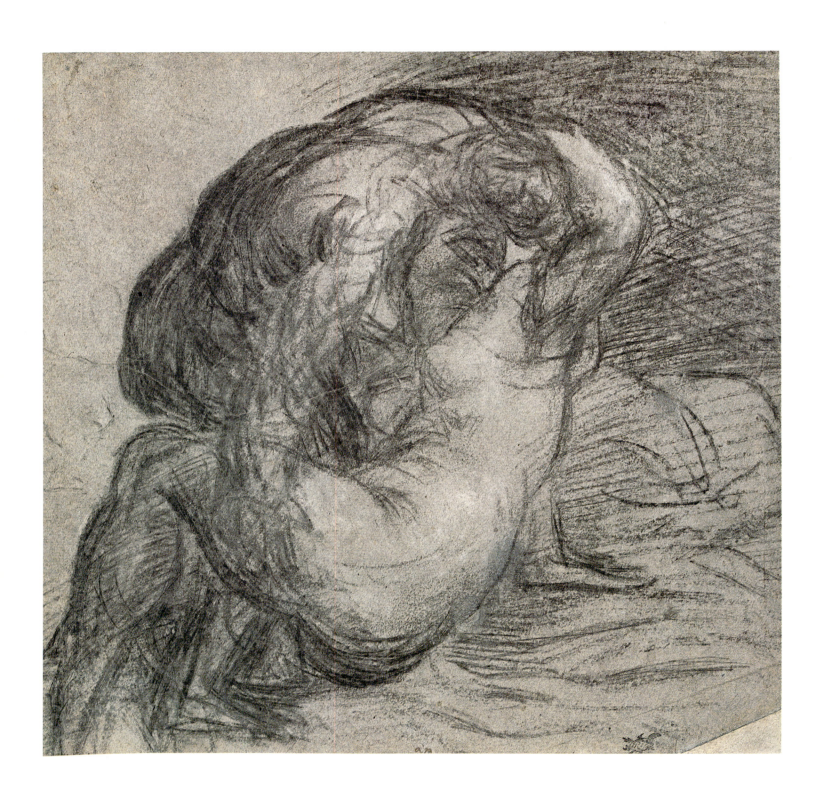

136

Titian (Tiziano Vecellio)
*Mythological Couple Embracing* sometimes
called *Jupiter and Io*
Charcoal highlighted with opaque white-lead
pigment on azure paper; 9¾ × 10¼ in.
(252 × 260 mm.)
Provenance: Richardson; Ricketts; Shannon
Cambridge, Fitzwilliam Museum, inv. 2256

The significance of this scene remains a
mystery, as does the relationship of the
drawing to any specific work by Titian. It

undoubtedly belongs to his late phase, as is
clear from the vigorous strokes and violent
shafts of light and shadow which emphasize
the vitality of movement. In the 1550s, when
he was already well over sixty, he tended
towards an increasingly painterly style in his
graphic work, the plastic form dissolving
into pure effects of light.
*Bibliography*: Tietze, 1944, no. 1886;
Oberhuber, 1976, no. 43; Pignatti-Chiari,
1979, pl. XLIV

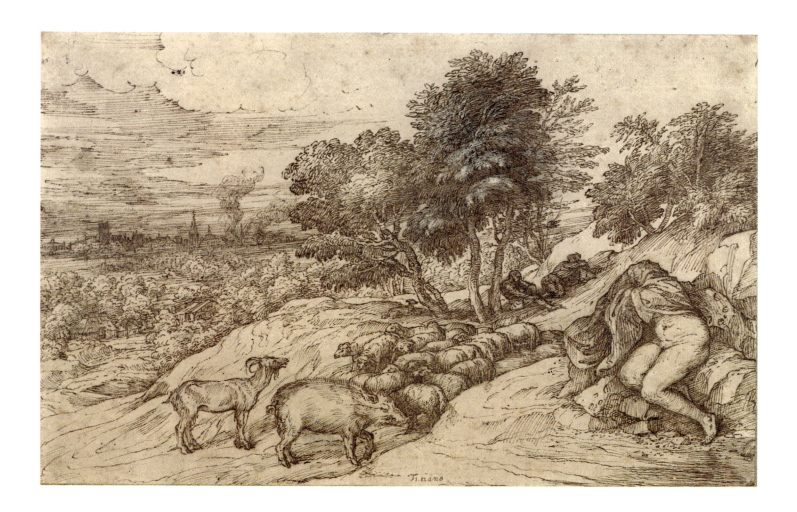

Titian (Tiziano Vecellio)
*Pastoral Landscape with Nude Woman
Asleep*
Pen and brown ink highlighted with opaque
white-lead pigment; 7⅝ × 11¾ in.
(195 × 298 mm.)
Chatsworth, Devonshire Collection, inv. 64

The broad, open-air feeling of the
composition, combined with a carefully
descriptive representation of Nature, are the

fundamental characteristics of a series of
landscape scenes drawn by Titian and
datable to the 1560s. The artist had long
since abandoned the Germanic graphic style
that had influenced him as a young man and
in this late stage of his life was concentrating
on essentially painterly effects with skilful
balance of warm lights and deep shadows.
*Bibliography*: Byam Shaw, 1969, no. 68;
Oberhuber, 1976, no. 46; Pignatti-Chiari,
1979, no. LIII

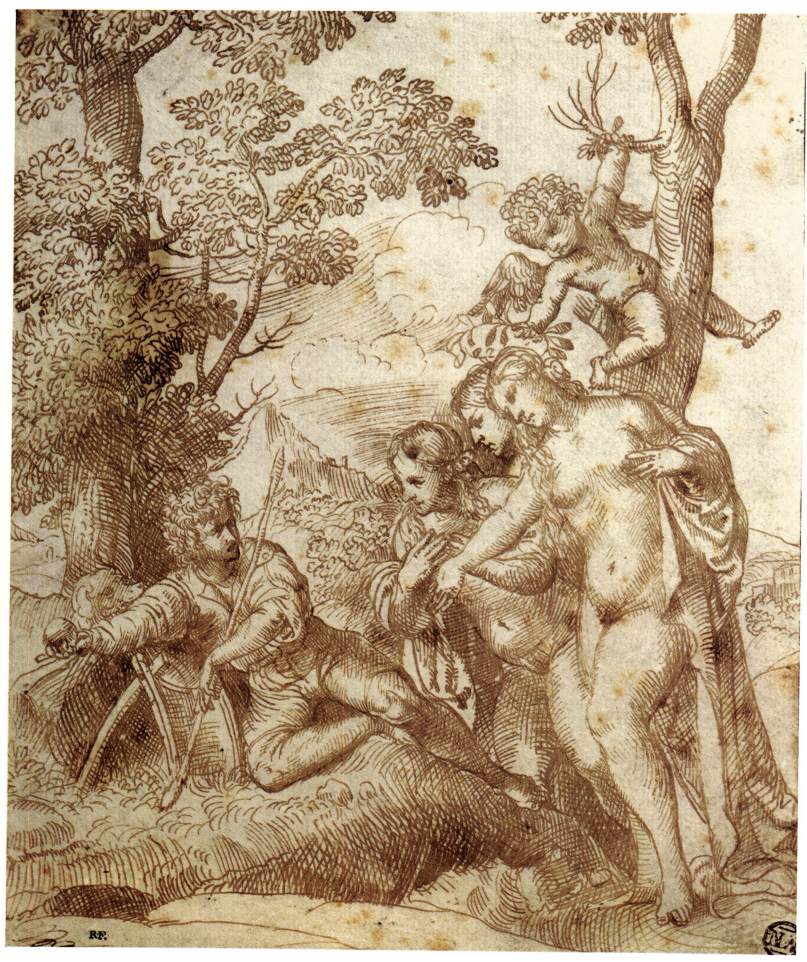

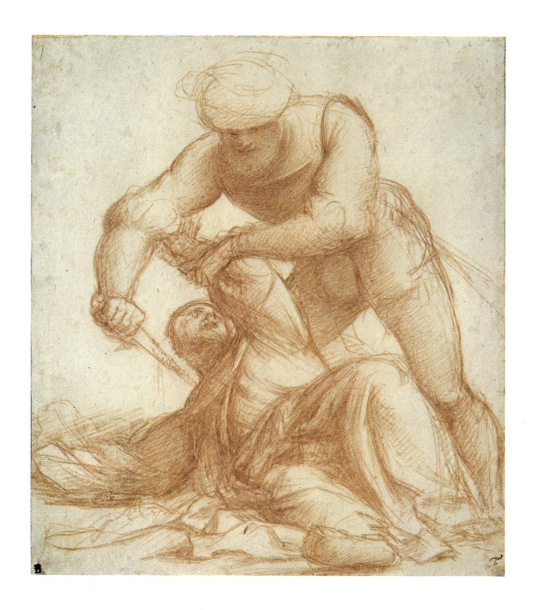

Domenico Campagnola
(Venice 1500–Padua 1564)
*The Judgement of Paris*
Pen and brown ink; $9\frac{3}{4} \times 7\frac{7}{8}$ in.
($248 \times 200$ mm.)
Provenance: Jabach; Cabinet du Roi (1671)
Paris, Musée National du Louvre, inv. 5519

This work by Domenico Campagnola was
for a long time attributed to Titian. Apart
from certain Northern characteristics, with
particular echoes of Dürer, it displays
uncertainties in anatomical construction and
lack of plasticity typical of the
draughtsmanship of a young man who was
still influenced by the production of
engravings in 1517 to 1518, although his
graphic style is demonstrably more free. He
had already begun to sketch in a
background landscape, and this was to
become a fundamental element in his
subsequent graphic work.
*Bibliography*: Tietze-Tietze Conrat, 1939,
pp. 451–3; Tietze, 1944, no. 537; Bacou-
Viatte, 1968, no. 47

Pordenone (Pordenone
*c.* 1484–Ferrara 1539)
*Martyrdom of St Peter, Martyr*
Sanguine; $9\frac{5}{8} \times 8\frac{1}{8}$ in. (244 × 207 mm.)
Provenance: Flinck; William, 2nd Duke of
Devonshire
Chatsworth, Devonshire Collection, inv. 746

This drawing, with its clean-cut lines in
sanguine, is given a painterly effect by means
of heavily hatched shadows. It is associated
with the *modello* (i.e. a small version of the
proposed final work) which Pordenone
entered for the competition promoted by the
church of San Zanipolo in Venice (1526–8)
for a painting on the subject of 'St Peter,
Martyr'. Titian actually won. Drawings such
as this were typical of Pordenone's creative
process; he not only studied the
relationships between masses but also
stressed any foreshortenings, light and
details of costume. He was the first artist to
introduce the principles of Mannerism into
the Venetian area.
*Bibliography*: Strong, 1902, no. 24; Wragg,
1962–3, no. 51; Cohen, 1980, p. 66

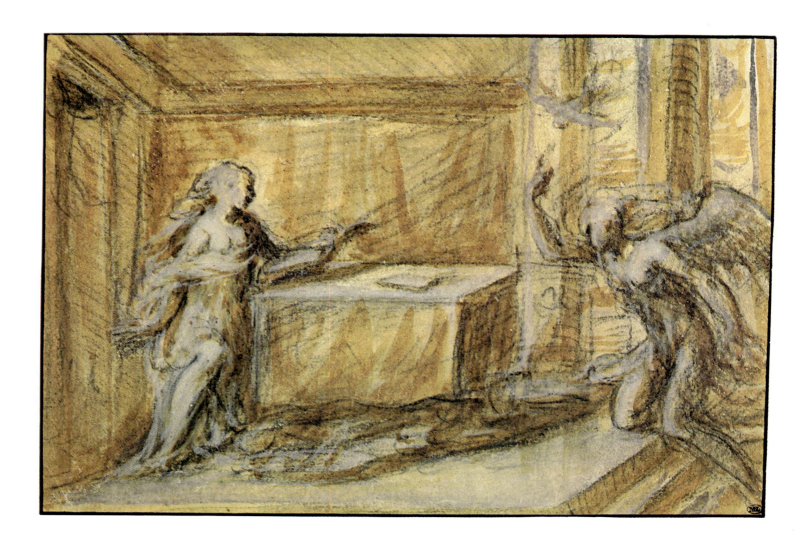

Andrea Schiavone
(Zadar *c.* 1520–Venice 1563)
*The Annunciation*
Black chalk, brush and light brown ink
heightened with white on yellow paper;
6⅝ × 9⅝ in. (170 × 246 mm.)
Provenance: entered during the Revolution
Paris, Musée National du Louvre, inv. 9954

The typical flowing line achieved by
Schiavone in his late Mannerist phase,
illustrated in this drawing, can be related to
the paintings he executed in 1550 for the
chancel of the church of Santa Maria del
Carmelo, which includes an 'Annunciation'.
The use of charcoal and watercolour on
yellow paper gives the impression of painting
*en camaïeu* (or *grisaille*), a feature which can
be seen in many of the drawings he executed
on coloured paper in the latter part of his
life.
*Bibliography*: Bacou, 1964, no. 102; Bacou-
Viatte, 1968, no. 62

Jacopo Bassano (Bassano *c.* 1517–92)
*Head of a Woman*
Brush and brown, grey, red and white oils
on brownish paper; 14 × 9⅞ in.
(353 × 249 mm.)
Provenance: de Ligne; Albert von Sachsen-
Teschen
Vienna, Graphische Sammlung Albertina,
inv. 17656

The plastic force and interest in the
psychological aspect are the main
characteristics of this expressive portrait of a
woman, executed in a particular brush-and-
oil technique on brownish paper which
provoked doubt as to the correct attribution.
It nevertheless remains one of the
masterpieces among Bassano's vigorous and
expressive graphic works.
*Bibliography*: Stix-Fröhlich Bum, 1926,
no. 71; Arslan, 1960, p. 380; Koschatzky-
Oberhuber-Knab, 1971, no. 65

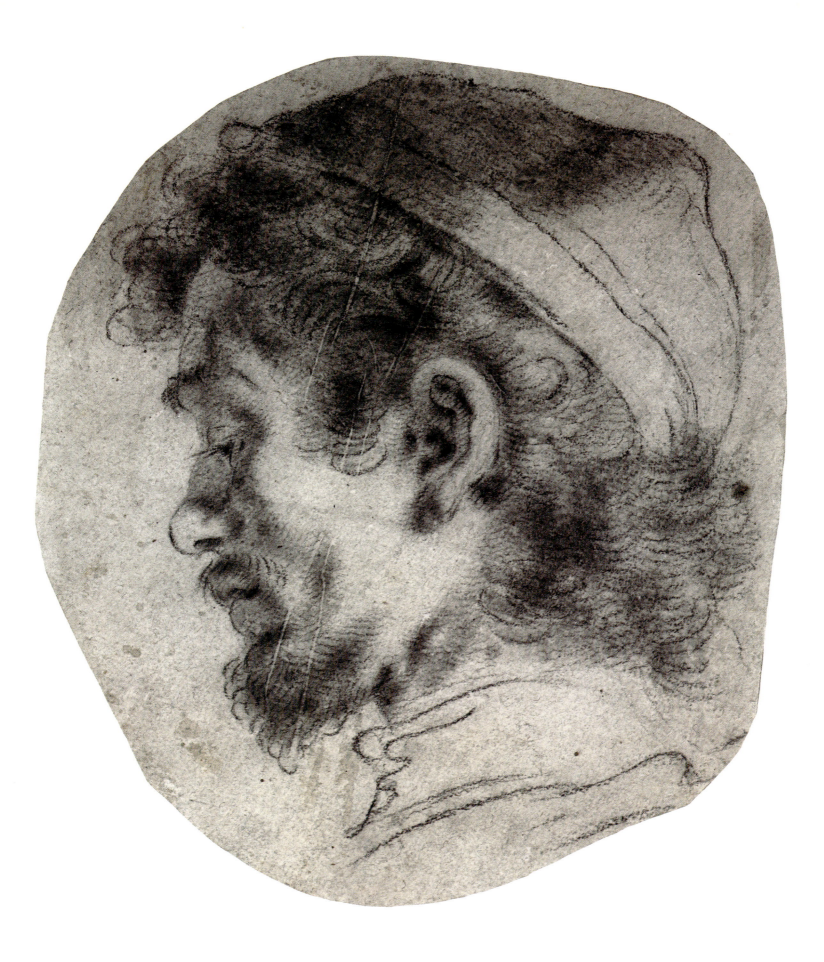

205

Grechetto (Genoa 1616–Mantua 1665)
*Rachel with Jacob's Children and his Animals*
Brush, turpentine and oil on paper;
14¾ × 21 in. (375 × 532 mm.)
Provenance: Mariette
Vienna, Graphische Sammlung
Albertina, inv. 14419

The biblico-pastoral scene was very dear to Grechetto. In it he succeeded in combining a religious subject with a genre scene, and the drawing in brush and oil illustrated here is typical of this. Similar sheets by this artist, in which a few colours have been used to produce a chiaroscuro effect, seem to be complete, independent works of art. He invented the monotype process.
*Bibliography*: Delogu, 1928, p. 59, no. 31; Stix-Spitzmüller, 1941, no. 514; Benesch, 1964, pl. IV

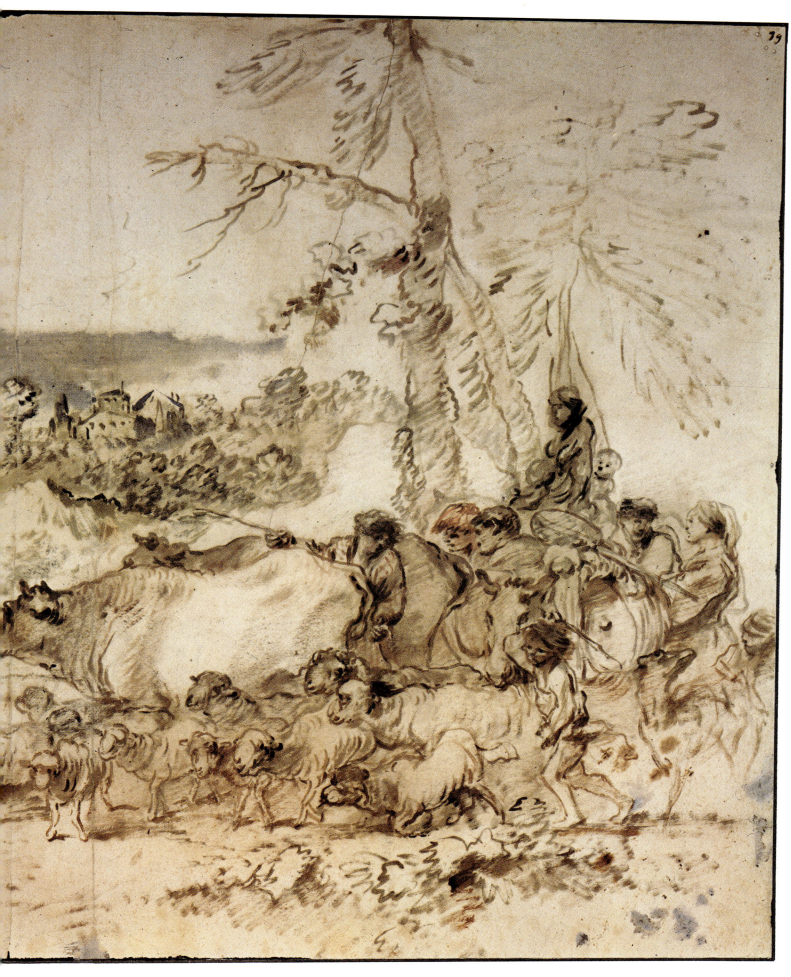

# The Seventeenth Century in the Low Countries, France and Spain

**Pieter Paul Rubens** (Siegen 1577–Antwerp 1640). Rubens was born in Germany of Flemish parents who returned to Antwerp when he was about twenty. There, in 1590, he began to study painting. In 1600 he set off on a long tour of Italy, visiting Venice, Rome, Mantua, Genoa and Florence. Eight years later he returned to Antwerp, where he married and began work on his famous canvases for the Cathedral. A great favourite in Flemish high society, he brought a rich, festive atmosphere into the hitherto rather solemn Flemish school. His work reached its peak in its portraits and large decorative paintings like those he produced in 1621 for Marie de' Medici for the Palais de Luxembourg, Paris (now in the Louvre). His wife having died in 1626, he remarried four years later to begin a final, very happy phase of his life. Among other countries, he went to England where he did some fine paintings before returning to Antwerp for the last time. He was as tireless in his graphic work as he was in his painting, all his preliminary drawings being taken from life.

**Jacob Jordaens** (Antwerp 1593–1678). As did Rubens, Jordaens drew his inspiration from the school of Caravaggio and from the strong feeling for colour of the Venetians. There was, however, added stress on the corporeity of his subjects and a totally objective thematic veracity, a fine example of this being his *Peasant with a Satyr*, now in Munich. From among his vast output, his most remarkable works are those painted around 1630 when he was experimenting with the effects of light, as in his *Fertility of the Earth* in Brussels.

**Anthony van Dyck** (Antwerp 1599–London 1641). A pupil of Rubens in 1618, van Dyck toured Italy from 1621 to 1627, during which time he visited Rome, Bologna and Venice. Returning to Antwerp, he became Court Painter to the House of Orange, working particularly as a portraitist. At the age of thirty-three he went to England, where he remained almost uninterruptedly until his death only nine years later. Van Dyck's sketchbooks have been preserved in the British Museum, London. From them can be seen how carefully he studied all the great masters of the past. He was especially drawn to the Venetian artists, on whose delicate handling of changing colour he based his own artistic language.

**Rembrandt Harmenszoon van Rijn** (Leyden 1606–Amsterdam 1669). It was through his fellow artists returning from Rome that Rembrandt became familiar with the achievements of the Caravaggio school. From his earliest working days, he developed a realistic style in which the modelling was largely created by the effects of light. In 1631 Rembrandt moved to Amsterdam, where he set to work on a grand scale, mainly as a portraitist and painter to the Guilds. His masterpiece during this phase was his so-called *Night Watch* – originally entitled *The Militia Company of Captain Frans Banning Cocq* – which he painted in 1642. He was a prolific engraver and an outstanding draughtsman, his sheets of drawings running into thousands. The final period of Rembrandt's life was sad. He had become the victim of an increasing lack of understanding and this, combined with some unfortunate family problems, reduced him to a state of solitude and poverty. His work was to be admired and emulated for centuries to come, however, not only for its technical qualities but for its tragic search for truth and lofty moral conscience.

**Leonard Bramer** (Delft 1596–1674). Bramer owed his formation as an artist to his experiences during a long tour of Italy undertaken between 1614 and 1616. He remained in Rome for a few years, working with Adam Elsheimer, from whom he learnt to produce dramatic contrasts of light and shade, apparent even in his drawings. At the age of thirty-three he returned to Delft, where he was commissioned to paint the ceiling of the castle. So far as his graphic work is concerned, Bramar left a number of sketchbooks, such as his preparatory drawings for his *Lazarillo de Tormes* and *Passion of Christ*. He was also an outstanding engraver.

**Adriaen van Ostade** (Haarlem 1610–85). A pupil of Frans Hals, van Ostade devoted his work mainly to themes relating to the life of country foik. His style was very painterly and the influence of Rembrandt gradually becomes more apparent with maturity. He also learnt a great deal about the effects of light through Rembrandt's engravings, a medium van Ostade himself also employed.

**Aelbert Cuyp** (Dordrecht 1620–91). The son and pupil of the portraitist Jacob Gerritsz, Cuyp concentrated mainly on bucolic scenes

into which he introduced peasant figures and animals with effective realism.

**Hendrick Avercamp** (Amsterdam 1585–Kampen 1634). Avercamp is the Dutch master whose work most closely resembles that of Bruegel the Elder in the rendering of landscape animated by small figures. The whole picture, however, is depicted in a suspended atmosphere that enables the artist's meticulous and precise graphic work to be seen to its best advantage.

**Francisco de Zurbarán** (Fuente de Cantos 1598–Madrid 1664). From 1629 Zurbarán worked mainly in Seville, where he acted as an artistic interpreter of the austere religiosity of the time. He decorated the Buen Retiro Palace (1634–6) in Madrid, the monastery of Guadalupe and the Carthusian monastery in Jerez with paintings of impressive solemnity. In the latter part of his life, Zurbarán worked almost exclusively for churches and monasteries in Latin America.

**Charles Le Brun (Lebrun)** (Paris 1619–90). Having spent his formative years in Rome under the guidance of Simon Vouet and Nicolas Poussin, Le Brun became the most important artist in the France of Louis XIV, the Sun King. His rhetorical, classicized art had its greatest scope for expression in the palace of the Tuileries and at Château de Versailles. A fine example of his work in this connection is his *Chancellor Séguier*, painted in 1660 and now in the Louvre. Le Brun held a number of high administrative offices and was President of the French Academy of Painting and Sculpture from 1663 to 1690, Director of the Gobelins' tapestry factory and impresario for royal ceremonies.

**Jacques Callot** (Nancy 1592–1635). Callot received his training in Italy, partly in Rome and partly in Florence, from 1609 to 1612. His chief skill was as an etcher and he held such a unique position in this field that it has never been challenged. In his *Caprices* of 1617, he illustrated some of the strange and grotesque aspects of the life of the people. Later, having returned to France, at the age of forty-one he etched his masterpiece, *Les Grandes Misères de la Guerre*. This was etched in a serpentine style with whiplash, sweeping lines for which Callot had prepared a number of impressive drawings in pen and brush.

**Jusepe de Ribera, called Spagnoletto** (Játiva de Valencia 1591–Naples 1652). Ribera was in Naples in 1616 and found the style of Caravaggio very much to his taste. He adopted a *tenebroso* style of painting – deeply shadowed and low-keyed – which soon spread throughout Sicily and the south of Italy. Ribera's paintings are full of expressive verism through themes that are often rough and vulgar, such as his *Silenus* in Naples. His last works were all executed for Naples, one of the most important being the *Communion of the Apostles* in the Carthusian monastery of San Martino.

Pieter Paul Rubens
(Siegen 1577–Antwerp 1640)
*Three Caryatids*
Sanguine, brush and red ink, highlighted
with opaque white-lead pigment; 10½ × 10 in.
(269 × 253 mm.)
Provenance: Happaert; Lankrink; Koenigs
Rotterdam, Museum Boymans-van
Beuningen, inv. V-6

Profoundly influenced as a young man by
Italian art, Rubens made numerous copies
and free interpretations of various of its
aspects, including this drawing whose subject
is related to a work by Primaticcio. His use
of sanguine, delicately brushed over with red
ink, already determined the plastic effect that
was to characterize his style.
*Bibliography*: Burchard-d'Hulst, 1956, no.
100; Haverkamp-Begemann, 1957, no. 28;
Eisler, 1964, pl. 40

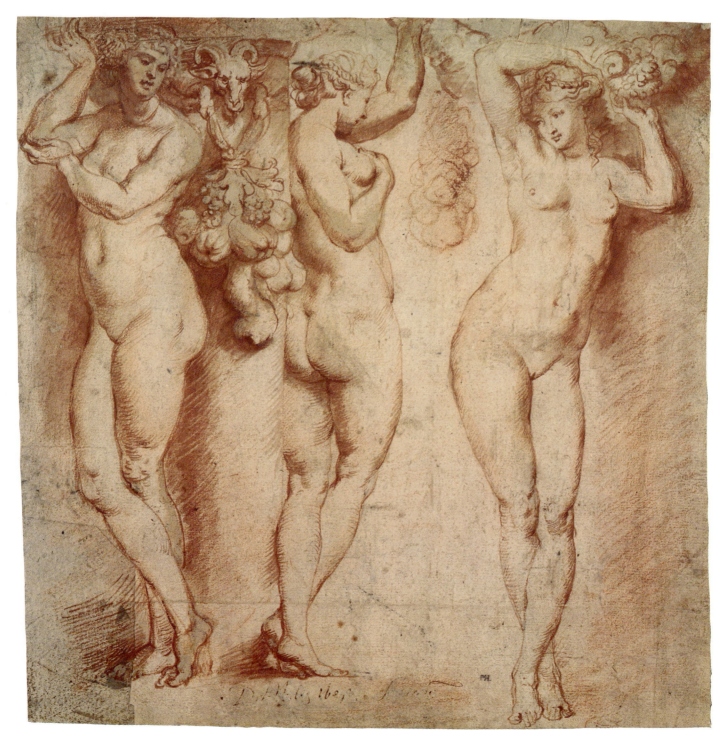

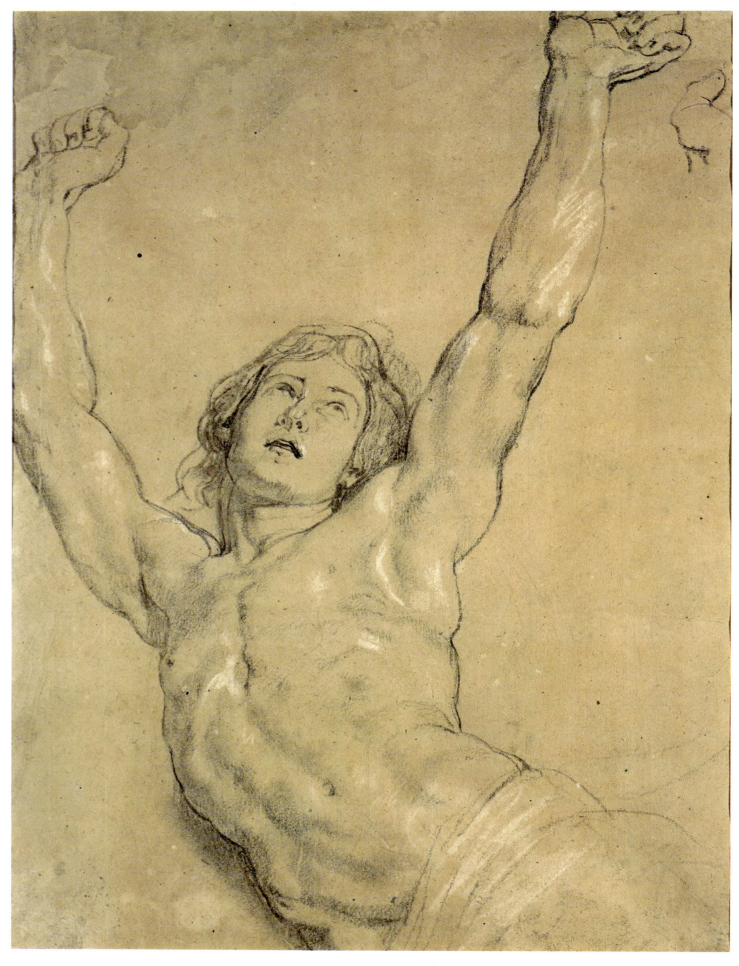

212

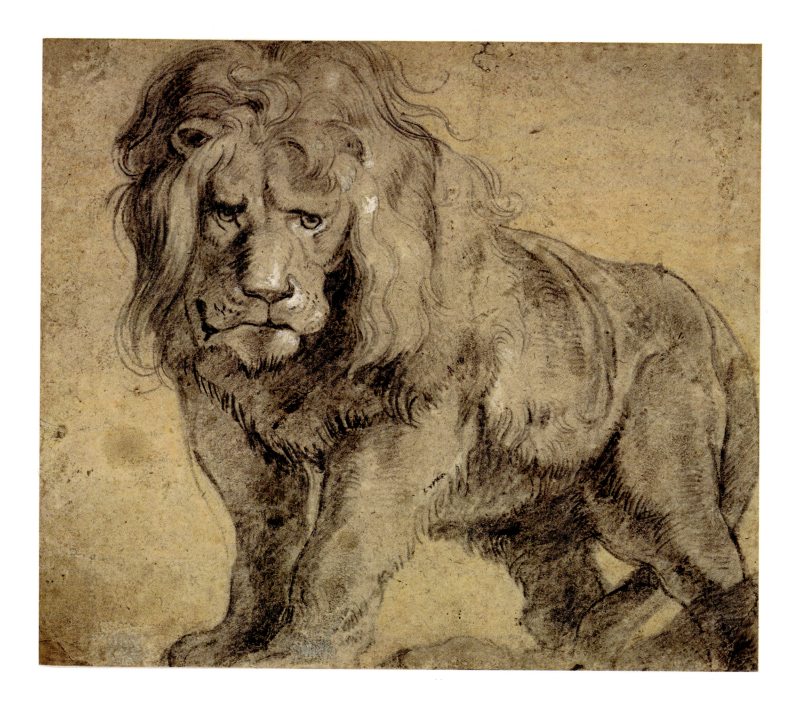

Pieter Paul Rubens
*Study for Christ Raising the Cross*
Black chalk heightened with white on pale
yellow paper; $15\frac{3}{4} \times 11\frac{3}{4}$ in. (400 × 298 mm.)
Provenance: de Wit (?); Böhm; Weisbach;
Sachs
Cambridge, Mass., William Hayes Fogg Art
Museum, Gift of Meta and Paul J. Sachs,
inv. 1949.3

This preliminary study from life for the
figure of Christ in the *Raising of the Cross*
which Rubens painted for Antwerp
Cathedral (1610–11), reveals the direct
influence of the Classicism of the school of
Carracci, which had fascinated Pieter Paul
while he was in Italy. The figure of Christ, so
rhythmically outlined with a soft line of
black chalk, is enhanced by the vigorous
plasticity of the modelling.
*Bibliography*: Mongan Sachs, 1946, no. 483;
Burchard-d'Hulst, 1963, no. 55

Pieter Paul Rubens
*Lion*
Black and yellow chalks heightened with
white; $10 \times 11\frac{1}{8}$ in. (254 × 282 mm.)
Washington, DC, National Gallery of Art,
Ailsa Mellon Bruce Fund, inv. B-25, 377

The powerful plasticity of this magnificent
figure of a lion is emphasized by the complex
technique employed known as *aux trois
crayons*, which enables three colours of chalk
to be combined – in this case, black, yellow
and white – in the chromatic rendering of
the animal's coat. There are two similar
sheets in the British Museum which relate to
the picture *Daniel in the Lions' Den* – at one
time in the Hamilton Collection – which
were included in a list of paintings sent by
Rubens to Dudley Carleton in 1618. This
seems to justify the dating of this study,
therefore, to between 1615 and 1620.
*Bibliography*: Robison, 1978, no. 63

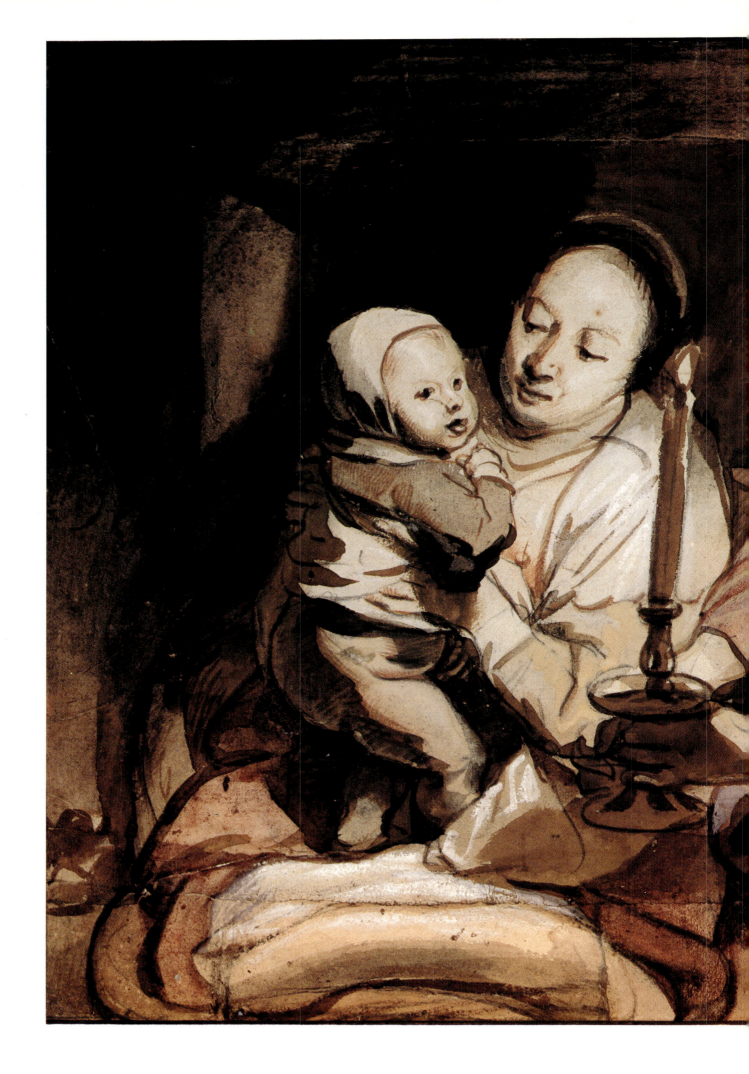

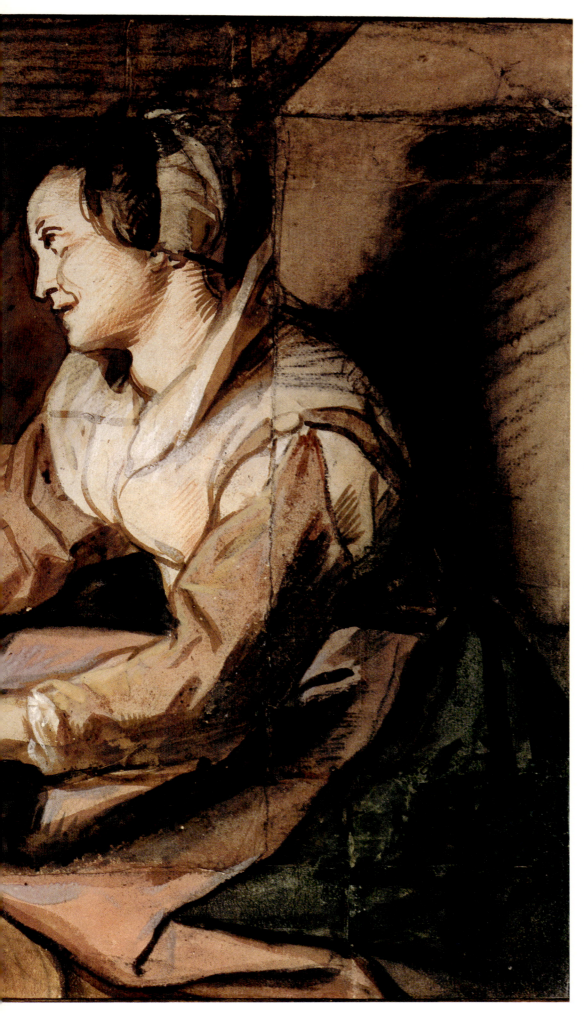

Jacob Jordaens
(Antwerp 1593–1678)
*Two Women and a Child in
Candlelight*
Watercolour, brush and bistre
heightened with white over black
chalk and sanguine; $14 \times 18\frac{7}{8}$ in.
($357 \times 479$ mm.)
Vienna, Graphische Sammlung
Albertina, inv. 15126

One of the major exponents of
Dutch Caravaggism, Jordaens'
realistic themes and his pursuit of
striking effects of light and shade are
the most outstanding features of his
work. In this work, which was
executed in his late twenties, and in a
similar one in the Louvre, he reveals
his fondness for an intimate theme
set in candlelight.
*Bibliography*: Schönbrunner-Meder,
1896–1908, no. 725; d'Hulst, 1956,
no. 32; Benesch, 1964, pl. XV

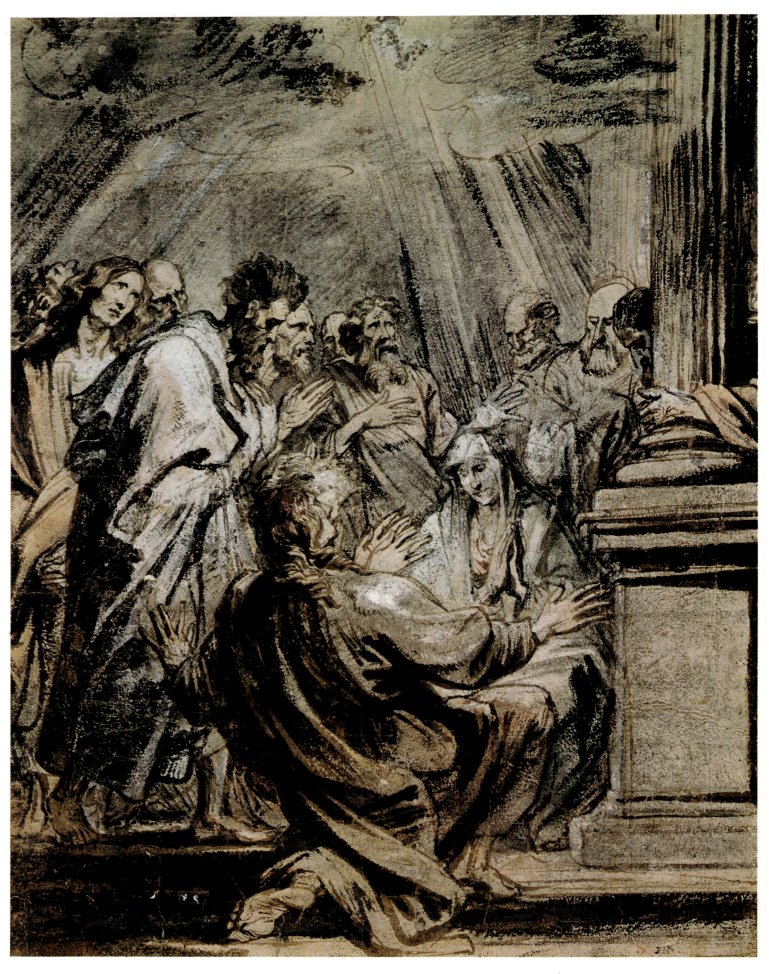

216

Anthony van Dyck
(Antwerp 1599–London 1641)
*Pentecost*
Pen, brush and bistre, watercolour
heightened with white; 13⅜ × 10¼ in.
(340 × 260 mm.)
Provenance: Lankrink
Vienna, Graphische Sammlung Albertina,
inv. 7574

This drawing is signed in the lower left-hand
corner, although nothing is legible except the
word *'fecit'*. It is one of several pen and
brush studies executed by van Dyck, in
addition to some charcoal drawings of
details, for his Potsdam *Pentecost*, datable to
about 1620. The ecstatic attitudes of the
figures, which are thrown into relief by the
strong luministic effects, are characteristic
features of the painter's youthful phase.
*Bibliography*: Meder, 1923, pl. 13; Vey,
1962, no. 66; Benesch, 1964, pl. XIV

Anthony van Dyck
*Portrait of Puteanus*
Black chalk and brown wash; 9½ × 6⅞ in.
(242 × 173 mm.)
Provenance: Hudson, Malcom
London, British Museum, inv. 1895-9-15-
1069

There is a painting in Raleigh, North
Carolina, signed *'van dyck f.'*, which
corresponds to this drawing. The blending of
media in chalk and brush has enabled the
artist to produce an extremely vital and
realistic portrait of a great contemporary of
van Dyck. He was Eerryck de Putte, known
as Puteanus, a historian and philologist.
who lived from 1574 to 1646.
*Bibliography*: Hind, 1923, no. 32; Vey, 1962,
no. 255

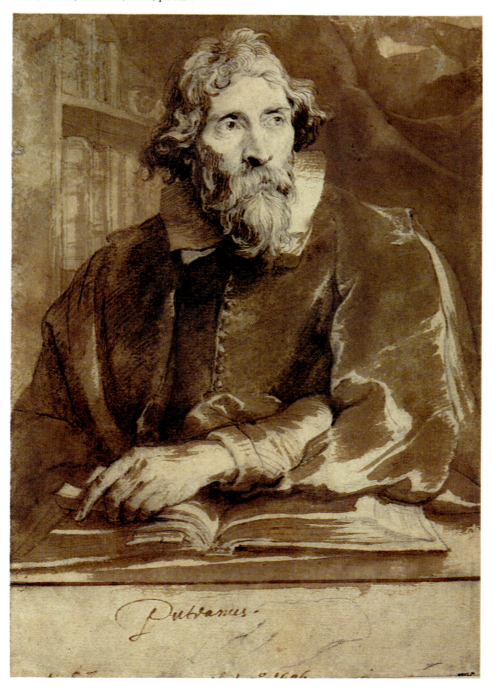

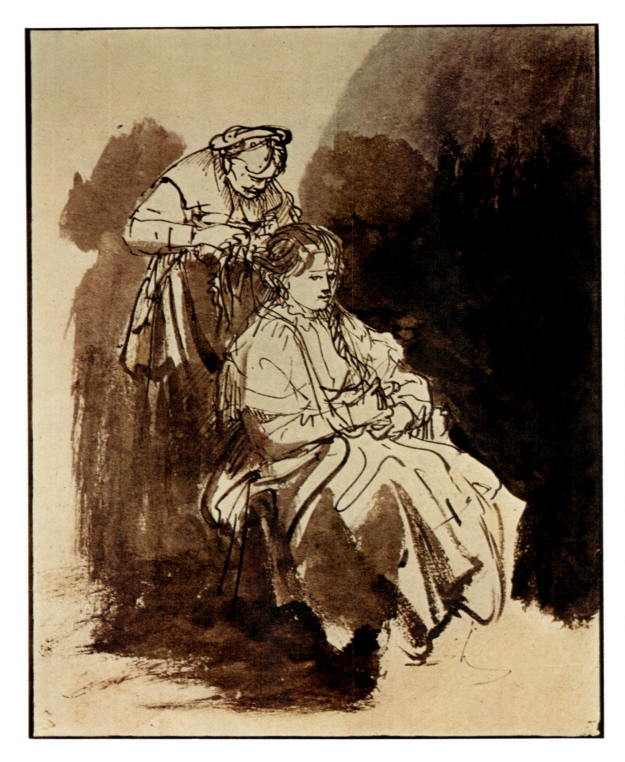

Rembrandt
*Seated Nude Woman*
Pen and brush, bistre,
black chalk and
charcoal; $11\frac{3}{8} \times 7\frac{1}{2}$ in.
(288 × 191 mm.)
Provenance: Spencer;
Russel; Heseltine;
Koenigs
Rotterdam, Museum
Boymans-van
Beuningen, inv. R-2

This drawing is one of a
series of nudes executed
by Rembrandt in the
latter part of his life,
between about 1650 and
1660. His complete
mastery of technique
allowed him to achieve
an exquisitely painterly
quality emphasized by
the marked contrasts of
light, which make the
white, sensual figure
stand out strongly
against the background
darkness. The model
may well be
Rembrandt's second
wife, Saskia.
*Bibliography*: Benesch,
1957, no. 1114

Rembrandt (Leyden 1606–Amsterdam 1669)
*A Woman and Her Hairdresser*
Pen and bistre, with bistre and indian ink
wash; $9\frac{1}{8} \times 7$ in. (233 × 180 mm.)
Vienna, Graphische Sammlung Albertina,
inv. 8825

The play of light and shade, reproduced by
skilful brushwork over a rapidly penned
outline, makes this one of the most
important of all the studies of domestic
subjects executed by Rembrandt in the
early 1630s. This drawing is
probably datable 1632–4 and it is not
unlikely that it provided the inspiration for
his *Bathsheba Bathing*, painted in 1632, now
in the National Gallery of Canada, Ottawa.
*Bibliography*: Benesch, 1954, no. 395; *idem*,
1964, pl. XVII

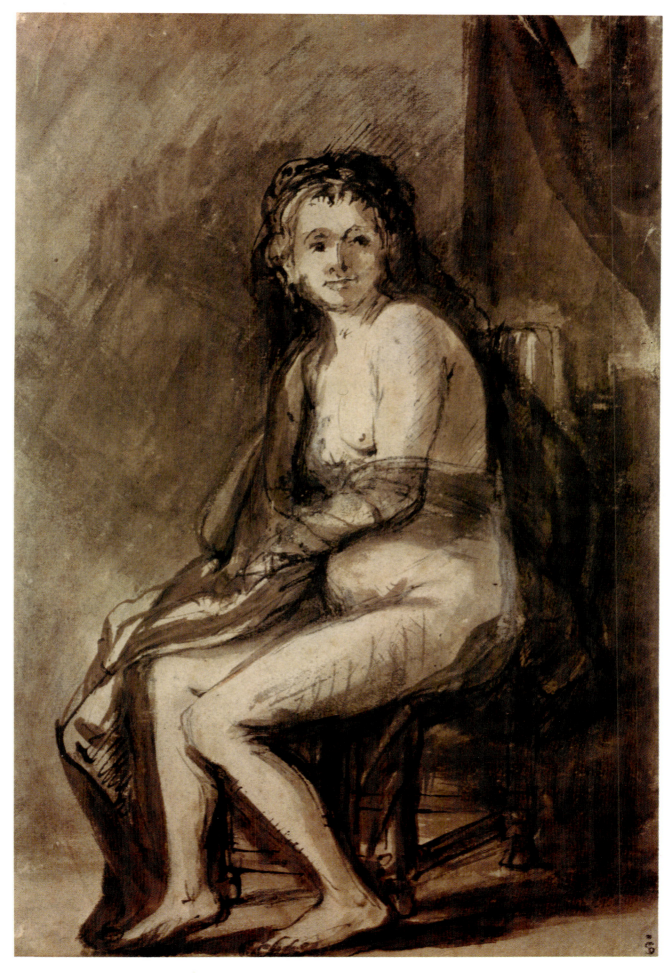

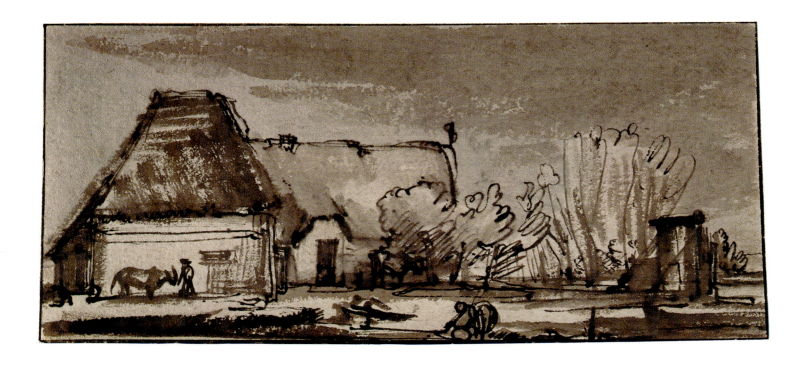

Rembrandt
*Landscape with Farmstead*
Pen and brush with brown ink; $4\frac{1}{4} \times 9$ in.
(108 × 229 mm.)
Haarlem, Teylers Stichting

This is a drawing that relates to
the artist's landscapes painted as a young
man. Here, too, Rembrandt has made use of
the mixed technique of pen and brush to
animate his portrayal of rustic life. The
atmospheric effect is emphasized by the
graduation of expressive energy which
decreases from the forcefulness of the
foreground – drawn in by pen over the ink
brushwork – to the lightly brushed-in trees
in the background.
*Bibliography*: Benesch, 1954, no. 473;
Regteren Altena, 1958, no. 62

Rembrandt
*Pensive Woman*
Brush and brown ink wash with touches of
opaque white-lead pigment; $6\frac{1}{2} \times 4\frac{7}{8}$ in.
(165 × 122 mm.)
Provenance: de Piles (?); Crozat; Tessin,
Kongl. Biblioteket; Kongl. Museum
Stockholm, Nationalmuseum, inv. 2085/1863

The model for this drawing, which is datable
to between 1655 and 1659, is almost
certainly Hendrickje Stoffels, the painter's
companion during his last years. The rapidly
drawn outline, executed with few brush-
strokes – which gives the portrait an
exceptional three-dimensional vigour – was
completely opposed to the analytical
tendency of contemporary bourgeois
realism.
*Bibliography*: Benesch, 1957, no. 1102;
Bjurström, 1970–1, no. 82

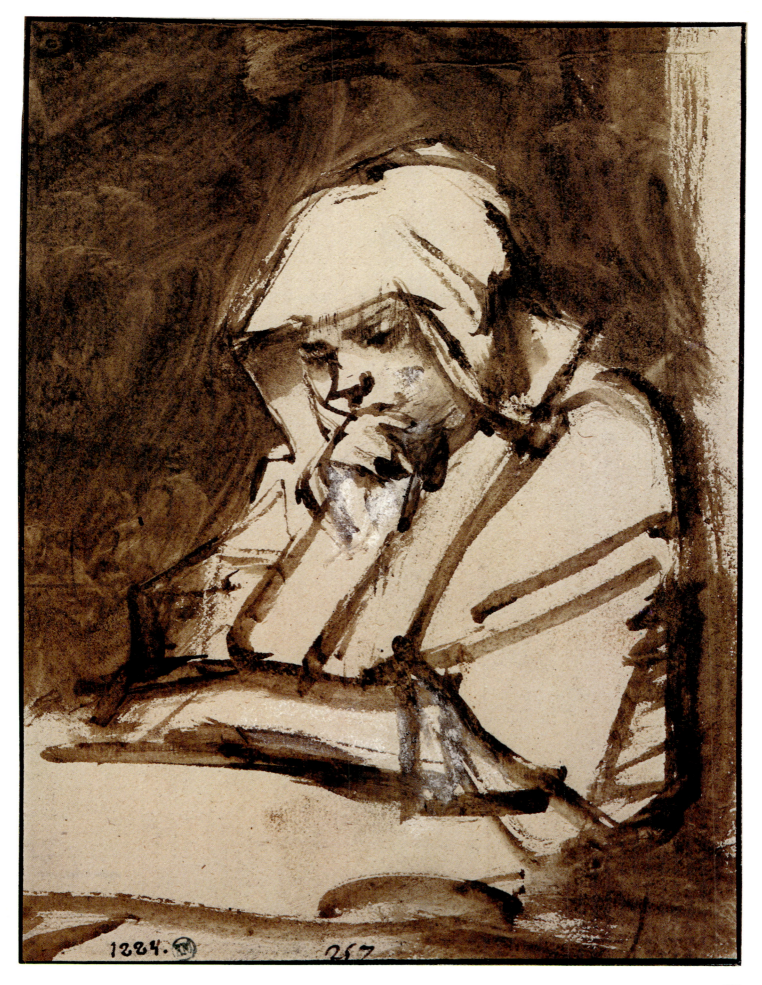

1284. 267

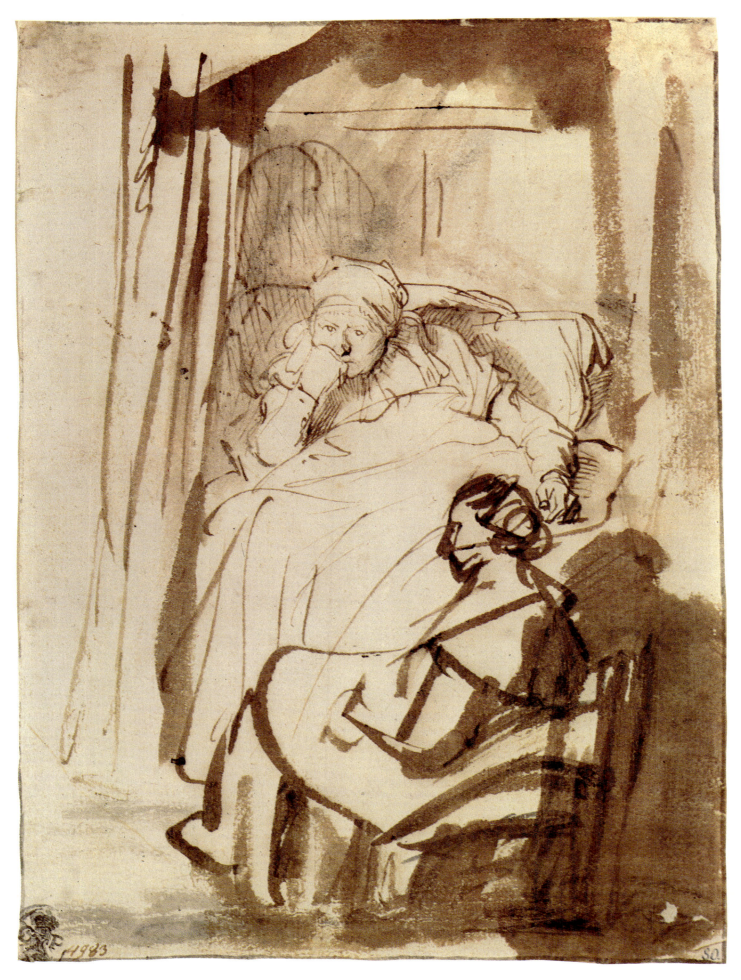

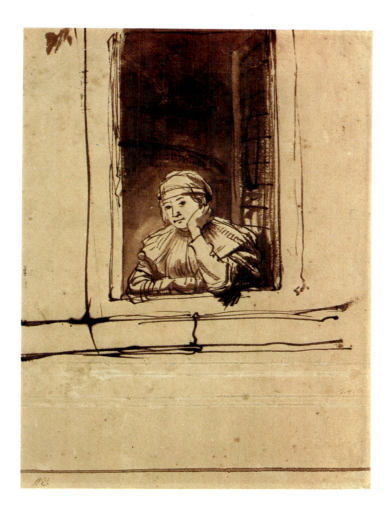

Leonard Bramer (Delft 1596–1674)
*Woman with doll*
Brush with black and grey indian ink,
heightened with white on grey paper;
$8\frac{1}{2} \times 6\frac{3}{4}$ in. (216 × 171 mm.)
Provenance: Gasc; Gigoux; Chennevières
Amsterdam, Prentenkabinet, Rijksmuseum,
inv. 09:16

This sheet, on whose *verso* there is another
study of the same subject, carries the
inscription *'elck heeft sijn eigen/pop'*
('everyone has their doll'). This is
fundamental to an interpretation of the
theme, which alludes to human weakness
and was inspired by a well-known book of
proverbs. The drawing is characterized by a
realistic *intimisme* and executed with broad
strokes of the pen in black and grey ink.
*Bibliography*: Wichmann, 1923, no. 159;
Boon, 1972, no. 21

Rembrandt
*Saskia at the Window*
Pen and brush with brown ink; $9\frac{1}{4} \times 7$ in. (236 × 178 mm.)
Provenance: de Vendè; Dimsdale; Lawrence; Esdaile; Bale;
Heseltine; Bonn; Cate: Koenigs; van Beuningen; entered in 1941
Rotterdam, Museum Boymans-van Beuningen, inv. R-131

A domestic scene, with his wife at the window bathed in sunshine, is
caught with spontaneous immediacy by the rapid strokes of
Rembrandt's pen, making the long white areas stand out against the
background. Saskia, who was married to Rembrandt on 10 June
1634, was to be the favourite model for his extremely lively studies
of everyday life. Indeed, this type of picture seemed to interest
Rembrandt no less than his most important commissions for
religious paintings and for portraits.
*Bibliography*: Benesch, 1954, no. 250; Haverkamp Begemann, 1957,
no. 20; Regteren Altena, 1958, no. 58

Rembrandt
*Saskia in Bed with Pupil-Assistant at the Bedside*
Pen, brush and watercolour, bistre and indian ink; $9 \times 6\frac{1}{2}$ in.
(228 × 165 mm.)
Provenance: Comtes Palatins du Rhin; Mannheimer
Munich, Staatliche Graphische Sammlung, inv. 1402

This scene, which is datable to around 1635, is perhaps the finest of
the family studies from this period because of the well-balanced
composition and the skilful play of light and shadow. The intimate
character of the scene is stressed; the 'Cubist' way in which the
assistant is depicted in a few brush-strokes gives the figure of Saskia
– drawn with such meticulous penmanship – so much more
importance.
*Bibliography*: Benesch, 1954, no. 405; Halm-Degenhart-Wegner,
1958, no. 83

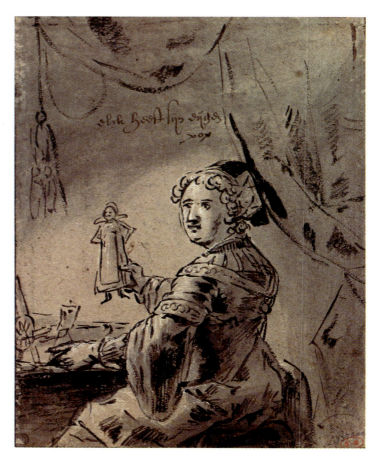

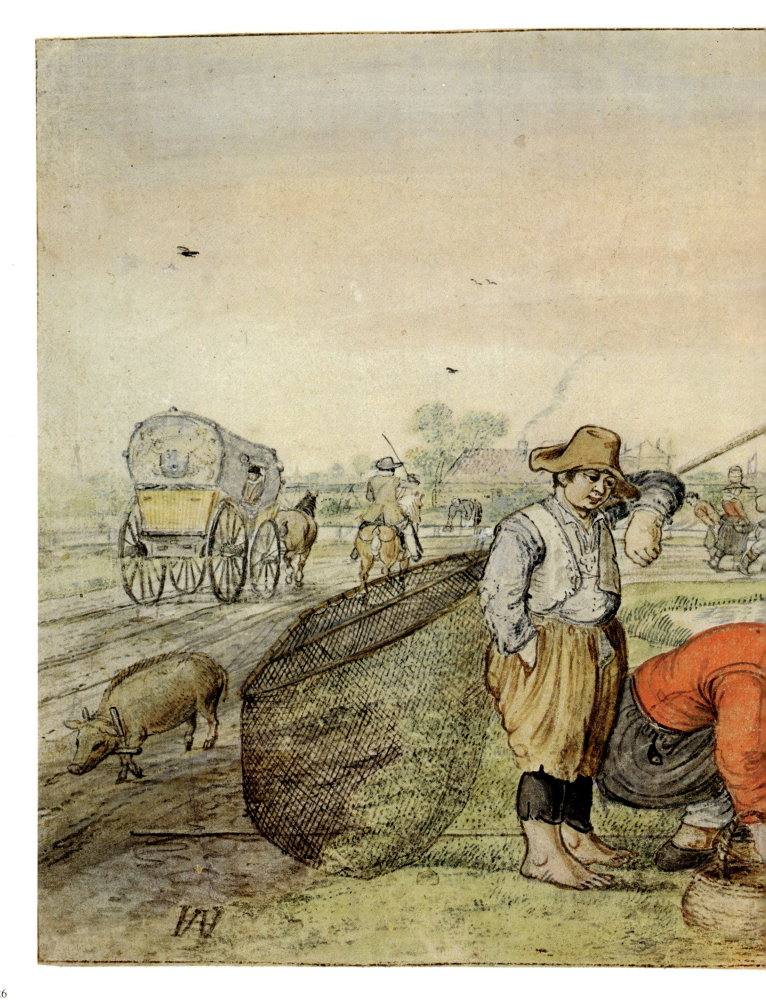

Francisco de Zurbarán
(Fuente de Cantos 1598–Madrid 1664)
*Head of a Monk*
Black chalk and brush with grey ink on pale
yellow paper; $11 \times 7\frac{5}{8}$ in. ($280 \times 194$ mm.)
Provenance: de Madrazo
London, British Museum, inv. 1895-9-15-873

There is something of Caravaggio's influence
in the *Head of a Monk*, although it is
distinguished by a profound realism, so
typically Spanish, as well as by a strangely
expressive force. Zurbarán, by reinforcing
his vigorous black chalk drawing with light
brushwork shading, has tended mainly to
stress the painterly effect by means of strong
chiaroscural contrast.
*Bibliography*: Soria, 1953, no. 34

Charles Le Brun
(Paris 1619–90)
*The Nations of Asia*
Black chalk heightened with white and traces
of sanguine on several sheets of beige paper
joined together; $6\frac{5}{8} \times 9\frac{1}{4}$ in. ($168 \times 235$ mm.)
Paris, Musée National du Louvre, inv. 29976

This drawing is squared up with black chalk
for transference, as it refers to one of the
four *Nations of the World* frescoes executed
by Le Brun on the walls of the *Escalier des
Ambassadeurs* (Great Staircase) at Versailles
between about 1674 and 1679. This was just
one expression of the Sun King's
determination to surround himself and his
Court with as much beauty and magnificence
as possible, thus setting the scene for the
elaborate decoration of nearly all the palaces
in Europe. The staircase was destroyed in
1752, and the working drawings are
therefore of fundamental importance in
gaining any knowledge of how it must have
looked.
*Bibliography*: Guiffrey-Marcel, 1912–13, no.
5747; Bacou, 1974, no. 33

Jacques Callot
(Nancy 1592–1635)
*The Capturing of Christ*
Brush and brown wash over black chalk;
4 × 8½ in. (100 × 215 mm.)
Provenance: Mariette; Duke of Devonshire
Chatsworth, Devonshire Collection, inv. 409

A nocturnal setting with violent contrasts of
light characterize this brush-drawing which,
although one of a series of studies produced
for engraving, was in fact never printed.
Callot's rich graphic output, so remarkable
for its originality of invention and amazing
technical skill, exercised a fundamental
influence on seventeenth-century engravers,
among whom was Stefano della Bella.
*Bibliography*: Ternois, 1961, no. 577; Byam
Shaw, 1969–70, no. 111a

Jusepe de Ribera
(Játiva de Valencia 1591–Naples 1652)
*St Irene* (?)
Sanguine heightened with white on pale
yellow paper; 12¼ × 8⅛ in. (310 × 206 mm.)
Provenance: Guise
Oxford, Christ Church, inv. 1074

Ribera's interpretation of Caravaggesque
realism into a low-keyed tenebrism is typical
of the work of this artist who, although born
in Spain, was active mainly in Naples. This
study in sanguine is characterized by strong
verism. It is signed *'Joseph à Ribera Hisp.ˢ f.'*
and seems to relate to a *St Irene Tending St
Sebastian*, similar in style to the painting of
the same subject in Leningrad.
*Bibliography*: Mayer, 1923, p. 210; Brown,
1972, p. 7, n. 2; Byam Shaw, 1976, no. 1497

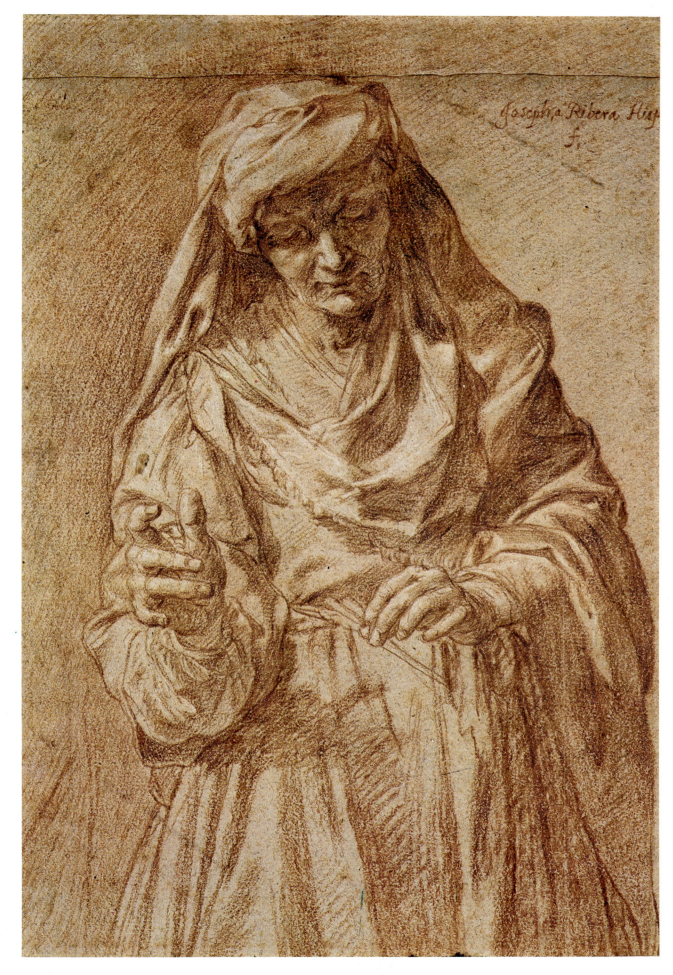

# The Eighteenth Century in Italy

**Sebastiano Ricci** (Belluno 1659–Venice 1734). After a long tour of Italy lasting from 1680 to 1706, during which he followed the path of late Baroque painting from Bologna to Parma, Rome and Florence, Ricci developed an artistic language of his own. This involved the sparing use of colour and a light, airy style of composition – both elements that were to form the basis of the new linguistics of Rococo. From 1712 to 1715 Ricci was working in London; the year 1719 he spent painting in Paris and 1724 saw him in Turin, whence he finally returned to Venice. Such diffuse activity meant that his pictures were influential over a wide area in the formation of a new generation of eighteenth-century artists. Ricci was a prolific draughtsman, and whole albums of his drawings are preserved in Venice and in the Royal Collection, Windsor.

**Gian Antonio Pellegrini** (Venice 1675–1741). In the footsteps of Sebastiano Ricci, Pellegrini also undertook a tour of study in Italy, visiting Florence, Rome and Naples. He soon acquired the expansive graphic style and verve in the handling of colour that distinguished the early Rococo masters, especially Luca Giordano. He carried the message of the new decorative linguistics to England (1708–13), thence to Holland, Germany and Paris (1714–20). He produced a great deal of graphic work on which his paintings were based.

**Gian Antonio Guardi** (Vienna 1699–Venice 1761). Gian Antonio was one of a family of painters which included his two younger brothers, Francesco and Nicolò. His father, Domenico – who lived in Vienna until the end of the seventeenth century – was also an artist, although nothing remains of his work. Once he had moved to Venice, Domenico did not live long, and Gian Antonio took over the responsibility of the studio-workshop, thus becoming master-painter over his two brothers. Under his direction, they began to copy well-known works by Tintoretto, Ricci, Piazzetta, and so on as well as painting family portraits on behalf of the well-known collector, Marshal Schulemburg. By this time, Gian Antonio was in contact with the leading artists of the Venetian Rococo period, especially Sebastiano Ricci, Pellegrini and Gian Battista Tiepolo, who was to marry his sister, Cecilia. From the 1740s Gian Antonio's work developed an individual quality, quite different from that of the other

members of the Guardi workshop. He succeeded in creating some genuine masterpieces in the Rococo idiom which are characterized by the exceptional lightness of their touch and the elusive airiness of their colours. Many of his works were designed to decorate interiors, like luminous tapestries, for example the *Gerusalemme Liberata* in the National Gallery of Art, Washington; on ceilings, paintings such as the *Aurora*, now in the Cini Collection, Venice, radiated dazzling luminosity. His masterpiece, however, will always be the balcony of the organ-loft in the church of the Archangel Raphael executed with sweeping strokes and brilliant colours in a style that seems to herald the radiant palette of Turner. In the meantime, Francesco was pursuing his own artistic career. He was specializing in small views, *vedute*, of Venice and was certainly doing so very successfully, being regarded as a successor to Canaletto. There are about a hundred known drawings by Gian Antonio in existence. Whilst his style was moulded on that of Ricci, he tended towards a much freer Rococo picturesqueness.

**Gaspare Diziani** (Belluno 1689–Venice 1767). Having first worked in Germany, Diziani was active in Venice from 1710 onwards. He adopted the contemporary decorative style led by Ricci and Pellegrini, and produced a great deal of work for the churches of Venice and surrounding areas. He was a prolific draughtsman: there is a vast collection of his drawings in the Museo Correr, Venice. His graphic work can be regarded as among the most outstanding to have been produced in the Rococo style.

**Donato Creti** (Cremona 1671–Bologna 1749). A pupil of the elegant Pasinelli, Creti was considerably influenced by the Carracci, whose work he was able to study in the Palazzo Fava, where he was resident painter to the Fava family. His mature style, which can be seen in the *Dance of the Nymphs* in the Palazzo Venezia, Rome, is a delicate synthesis of classicist refinement and Rococo affectedness. His numerous drawings fully illustrate the complex make-up of this artist and show how he achieved such stylistic charm in his finished works.

**Gian Battista Piazzetta** (Venice 1683–1754). Having first studied under his father, who was a sculptor, Gian Battista was considerably influenced in his early years by the

group of late seventeenth-century Venetian painters, including Zanchi and Langetti, known as the Tenebristi. Piazzetta's feeling for this type of low-key, shadowy style was strengthened after a visit to Bologna, where he came into contact with the work of Guercino and with Giuseppe Crespi. In the early 1720s Piazzetta painted his *Martyrdom of St James the Great* in the church of San Stae and his *Glory of St Dominic* on the ceiling of the church of San Zanipolo, both in Venice. He then formed his own workshop, including among his assistants Angeli, Maggiotto and Cappella. Their work was on traditionalist lines in opposition to the unbridled decorativeness of Rococo and the brilliant compositions of the somewhat younger Giambattista Tiepolo. The master-painter became increasingly academic in his work, a tendency which was furthered by the wide circulation of drawings and engravings from his studio, and in 1750 founded a school of painting which was continued by his followers. The best work by Piazzetta is in the more popular, veristic field, for example his *Fortune-teller* in Venice. Here he had freed himself from the weight of the late Baroque tradition and had begun to point the way to modern Realism.

**Marco Ricci** (Belluno 1676–Venice 1730). Nephew of the great decorator Sebastiano Ricci, Marco from boyhood collaborated with his uncle on stage sets, making scenery and costumes, in particular during a long visit to England with Pellegrini (1708–12). At the same time, he showed a growing interest in monument and landscape painting. He concentrated particularly on these themes during a stay in Rome when he had the opportunity to get to know the work of great seventeenth-century landscapists such as Poussin, Claude Lorraine and Salvator Rosa. Another strong influence in his turning towards landscape painting came when he made the acquaintance of the Genoese artist Alessandro Magnesco. In 1716 Marco returned to Venice, where he concentrated largely on graphic work, drawing and engraving landscapes which had a Romantic flavour and which greatly interested Piranesi, then at the outset of his fascination with etching. In recent times, whole albums of drawings by Marco Ricci have been taken apart and disposed of piecemeal. They contained some of the most natural and impressive of all eighteenth-century landscape drawings.

**Alessandro Magnasco** (Genoa 1667–1749). Although Magnasco painted a number of works with a religious theme during a short stay in Milan, a visit to Florence gave him the idea of trying some popular and dramatic subjects such as had been used by Jacques Callot and were still being used by Giuseppe Crespi. As a result, he specialized in landscape and indoor scenes with satirical motifs, especially on monastic life. In these, his graphic work, which was particularly lively, was combined with strong colours.

**Francesco Zuccarelli** (Pitigliano 1702–Florence 1788). Zuccarelli spent his formative years in Rome under the influence of such landscape artists as Locatelli and such painters of ruins as Pannini, but when his work took him to Venice in 1732 his style underwent considerable modification. His use of colour became more elegant, with delicate pastel shading, and he became the greatest exponent of the pictorial Arcadia now regarded as typical of the mid eighteenth century in Venice. He also worked in England for a number of years, during which time he established himself in the world of art and probably exercised some influence on the English landscapist Richard Wilson. Examples of his landscapes are in the Royal Collection, Windsor, and other important galleries. In his graphic work, Zuccarelli displayed an essentially painterly approach; this is particularly apparent in his sketchbook of the Tassi Counts of Bergamo which has survived almost intact to this day.

**Gian Battista Tiepolo** (Venice 1696–Madrid 1770). Having received his training in Venice with Bencovich and Piazzetta, under Sebastiano Ricci, by the early 1720s Giovanni Battista had already gained for himself the position of master in his own right. He worked mainly in fresco decoration, in Venice (Gli Scalzi), Udine (Archbishop's Palace) and Milan, Bergamo and Vicenza. In about 1747 he decorated the Palazzo Labia, Venice, and between 1750 and 1753 executed what was probably his finest work in the Residenz of the Prince-Bishop of Würzburg. After his return to Venice, he was commissioned to paint various altarpieces and frescoes, but in 1761 he was invited to the Villa Pisani at Strà, on the mainland, where he painted the magnificent ceiling that can still be seen today. Subsequently he went to Madrid, where he decorated the huge ceilings of the royal palace. His death in Spain

heralded the end in Europe of the elaborately decorative Rococo style, which had undoubtedly reached its peak in his work. In executing his frescoes, Gian Battista was supported by several assistants from his workshop; he made a great number of preliminary drawings from which they could work, and many volumes of these have survived the centuries. There are thousands of items altogether, and it is sometimes quite difficult to distinguish the hand of the master from drawings done by his assistants, foremost amongst whom were his two sons, Gian Domenico and Lorenzo. Gian Battista also holds an important place as an engraver, his series of *Capricci* ('Caprices') and *Scherzi* ('Jests') being masterpieces among eighteenth-century etchings.

**Gian Battista Piranesi** (Mogliano Veneto 1720–Rome 1778). Having been in Venice as a youth, where he had been able to study the graphic skills of Marco Ricci and Tiepolo, Piranesi in 1740 moved to Rome, where he was to work for the rest of his life. Apart from a few brief periods when he practised as an architect, Piranesi devoted himself entirely to engraving, depicting mainly the archaeological and architectural landmarks of Rome in several truly remarkable series of etchings. Many of the drawings which relate to this work are extant, executed mostly in pen and ink, apart from some folios from his youth, on which he used pencil for architectural plans and a very few figures. A highly romanticized view of the ruins of Rome emerges from these folios, although they were drawn with the objective precision that already presaged the Neoclassical movement.

**Pietro Longhi** (Venice 1702–85). Although Longhi had trained in the school of Balestra, his youthful work had little merit and shows clearly that he was not attracted towards painting in the rather elaborate decorative style that was then fashionable. A visit to Bologna when he was about twenty-eight, however, brought him into contact with the intimate style and lively touch of Giovanni Crespi. This gave him the spur he needed. He began to concentrate on the 'conversation piece' type of picture, depicting high Venetian society in all its public and private aspects. With an amazing stylistic constancy, his little canvases thus offer a completely faithful account of the contemporary patrician lifestyle. His drawings are extremely

interesting, demonstrating as they do a connection with the international fashion for the *tableau de genre* so popular in France. The majority of these sheets are now in the Museo Correr in Venice, which acquired them direct from the artist's son, Alessandro, himself a painter and portraitist, well-known towards the end of the eighteenth century.

**Antonio Canal, called Canaletto** (Venice 1697–1768). Being the son of a theatrical scene-designer, Canaletto devoted himself entirely to work for the theatre, both in Venice and Rome, until he was twenty-two. From 1720, however, he began to concentrate solely on cityscapes, taking for his theme the topography of his beautiful native city with its festivals and architectural extravagances. At first, he tended to follow Marco Ricci, the painter of ruins, but soon came under the influence of the well-balanced work of Luca Carlevaris with its squared-up perspective. The rich English 'milords', on their Grand Tours of Europe, were enchanted by his *vedute* ('views') and became his main clients. Joseph Smith, a merchant who was to become the English Consul in Venice, acted as his patron and agent, arranging for the sale of paintings in England, including many to King George III which are now in the Royal Collection at Windsor. The Duke of Buckingham and the Duke of Bedford (whose descendants still live at Woburn Abbey) also ordered *vedute* from Canaletto by the dozen. Between 1746 and 1755 Canaletto was working in England, where he painted numerous masterpieces, such as his *View of Oxford* in the National Gallery, London, before returning to Venice. Somewhat tardily, the Venice Academy finally opened its doors to him in 1765, but he was to die only three years later. Graphic work played an important part in Canaletto's life. Between 1741 and 1744 he issued a series of thirty-five etched *vedute* which he dedicated to Consul Smith, and several hundred drawings have been identified, about half of them in the Royal Collection, Windsor Castle.

**Francesco Guardi** (Venice 1712–93). The younger brother of Gian Antonio, until about 1740 Francesco divided his time in the workshop between making copies and producing decorative and religious paintings. When Canaletto left for England, Francesco replaced him in Venice as a painter of *vedute* ('views') and, from that stage in his life, devoted himself almost entirely to this type of work. In the 1770s he completed the twelve *Feste ducali* (Venetian Festivals) taken from the prints by Canaletto-Brustolon, nearly all of which are in the Louvre. In 1782 he was commissioned by the Republic of Venice to paint a series of pictures as a record of the state visit of the Archduke Paul of Russia and Maria Feodorowna; these were executed in a style that was suddenly free of the Canaletto influence in its sensitive freedom of stroke and whimsical imaginativeness – the *Concert for the Ladies*, now in Moscow, is a particularly fine example. Before embarking on any painting, Guardi, a prolific draughtsman, made a complete sketch of quite remarkable detail, executed in short, impetuous strokes of the pen or brush. He also made a number of large finished drawings for connoisseurs. The largest collection of his work is in the Museo Correr in Venice, which received it through a great-grandson of the artist.

**Gian Domenico Tiepolo** (Venice 1727–1804). Having worked with his father since boyhood, Gian Domenico was able to imitate his technique perfectly, to the point where it became impossible to distinguish whose hand had been at work in the frescoes and large canvases. All this time, however, he had been developing his own individual talent; this tended towards the bizarre and was based on a palette of cold colours in shades that are typically chalky. This can be seen in some of his less important frescoes, such as those painted in 1757 in the guest-rooms of the Villa Valmarana in Vicenza, as well as in little canvases depicting popular subjects, like the 'Masked Balls' in the Louvre and in Barcelona. Gian Domenico accompanied his father to Würzburg and Madrid, working closely with him all the time, and in later life – about 1792 – he completed most of the decoration in the family's country home at Zianigo, with caricatures of all kinds of people including clowns and tumblers. These frescoes have now been transferred to the Ca' Rezzonico in Venice. A keen engraver, he produced the original series of both the *Way of the Cross* and the *Flight into Egypt* as etchings. Hundreds of his drawings are in existence, but the attribution is often questionable due to the similarity between the work of Gian Domenico and that of his father, Gian Battista.

Sebastiano Ricci
(Belluno 1659–Venice 1734)
*Landscape with Figures*
Black pencil, pen and brush, brown ink and
sepia; $14\frac{1}{2} \times 20\frac{1}{2}$ in. (370 × 520 mm.)
Provenance: Zanetti; Cernazai; Dal Zotto
Venice, Gallerie dell'Accademia,
inv. S.R. p. 54

There is a broad, open feeling about this
composition which combines with the artist's
desire to depict certain effects of light; this
he does with rapid, disjointed strokes of the
pen accentuated by brushwork shading.
Such outstanding qualities leave no doubt
that this drawing is completely autograph. It
belongs to Ricci's later period, dating from
the same time – about 1729 – as the four
'Landscapes' at Hampton Court on which he
worked with his nephew, Marco.
*Bibliography*: Morassi, 1926, p. 263;
Pignatti, 1973, no. 24; Rizzi, 1975, no. 121

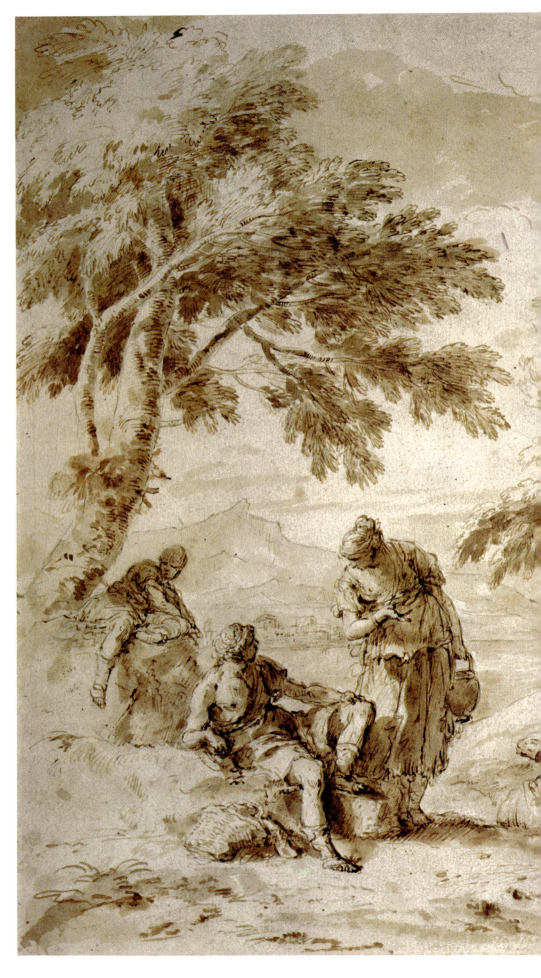

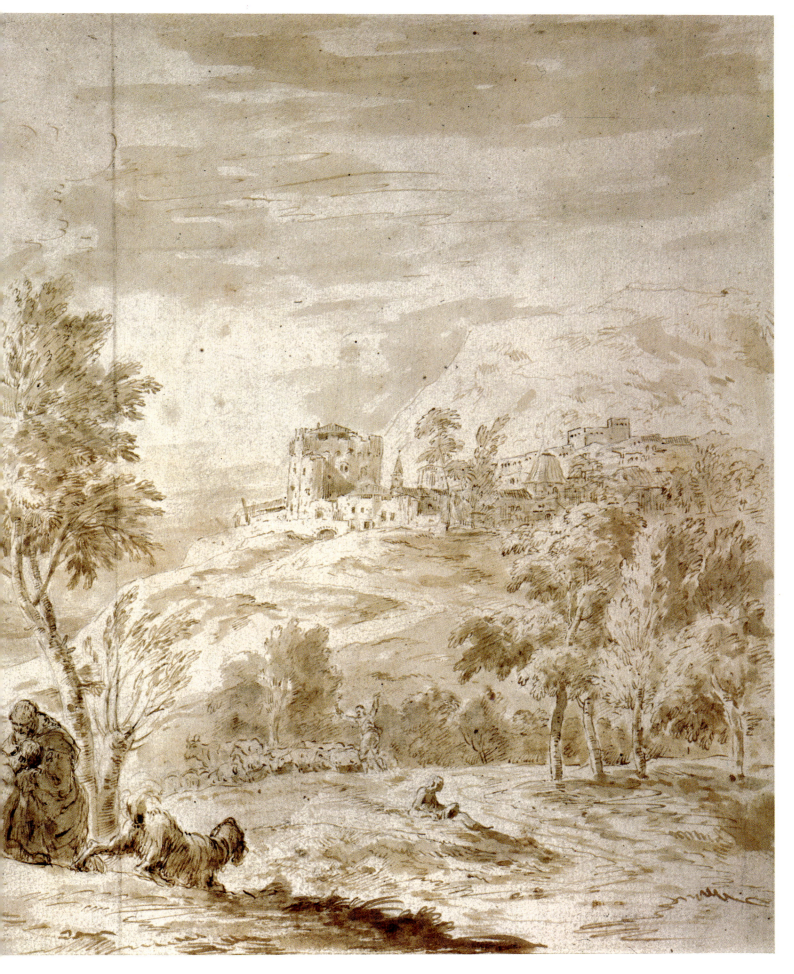

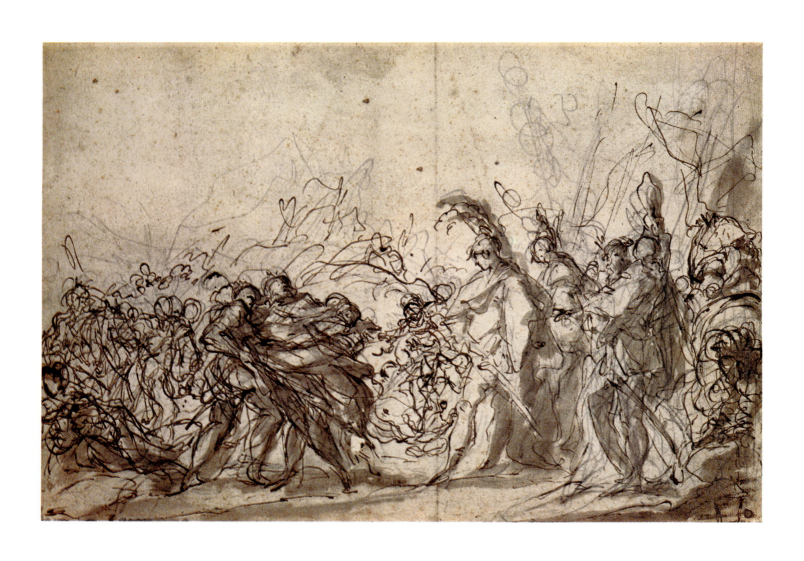

238

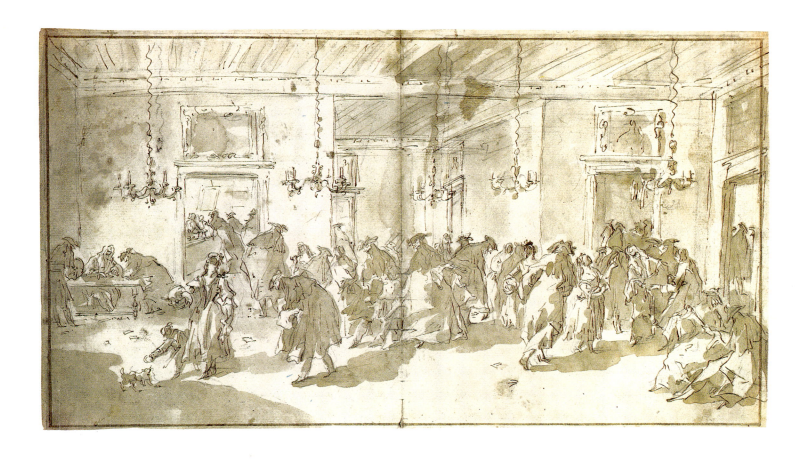

Gian Antonio Pellegrini
(Venice 1675–1741)
*The Body of Darius Brought before Alexander*
Pen and sepia ink over pencil; $10\frac{3}{4} \times 15\frac{5}{8}$ in.
(274 × 398 mm.)
Provenance: Salvotti; Fiocco
Venice, Fondazione G. Cini, inv. 30.012

This study, which is a preliminary drawing
for part of Pellegrini's large canvas of the
same name (Cassa di Risparmio Collection,
Padua), belongs to the artist's youthful
period, prior to his departure for London.
The imposingly tall figures are sketched in
with a flowing, entangled line that gives this
animated composition its life. The influence
of Baciccio, under which the artist came
during his year's stay in Rome (1700–1), is
evident.
*Bibliography*: Bettagno, 1959, no. 64; *idem*,
1963, no. 51; Pignatti, 1973, no. 26

Gian Antonio Guardi
(Vienna 1699–Venice 1760)
*The Casino*
Pen and brown wash over pencil;
$11\frac{5}{8} \times 20\frac{3}{8}$ in. (295 × 516 mm.)
Provenance: Schwabach; Blake
Chicago, Art Institute of Chicago, Gift of
Tiffany and Margaret Blake, inv. 1944.579

This drawing, which is almost identical to
the painting in the Ca' Rezzonico attributed
to Francesco, actually has the signature
'Ant. Guardi' on the *verso*; as this is in
eighteenth-century handwriting, it cannot be
doubted. This gives rise to the surmise that it
was drawn by Gian Antonio and then
copied on to canvas by Francesco, which
was normal practice in their workshop. The
flowing graphic style and lightness of touch
are typical of Gian Antonio.
*Bibliography*: Joachim, 1963, no. 18;
Pignatti, 1974, no. 54; Morassi, 1975, no. 56

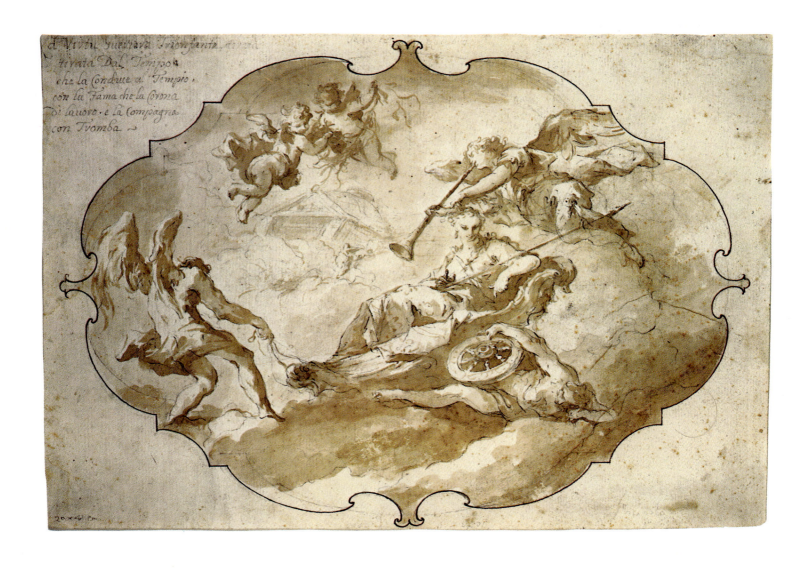

240

Gian Antonio Guardi
*The Triumph of Virtue*
Black chalk, pen and brush with sepia wash;
9⅞ × 17¾ in. (250 × 450 mm.)
Provenance: Meissner; Morassi; entered in
1966
Venice, Museo Correr, inv. 8221

This drawing is part of a large group relating
to the decoration of a ceiling, the theme of
which is explained by this autograph
inscription: *'La Virtù guerriera
trionfante/tirata dal tempo/che la conduce al
tempio/con la fama che la corona di lauro e la
compagna con la tromba'* ('Virtue, the
triumphant warrior/pulled by Time/who
takes her to the temple/with Fame who
crowns her with laurel and accompanies her
on the trumpet.'). The presence of the
signature *'Giovan Antonio Guardi veneto
pitore'* (G.A.G. Venetian painter') on the
*verso* makes this sheet – which is stylistically
similar to paintings such as the Cini *Aurora*
– one of the most important documents in
his work. It is datable to between 1750 and
1760.
*Bibliography*: Pignatti, 1967, pl. VII;
Morassi, 1975, no. 40

Gaspare Diziani
(Belluno 1689–Venice 1767)
*Costumes for Rowers*
Charcoal, pen, sepia ink, coloured chalks on
straw-coloured paper; 6¼ × 4¾ in.
(158 × 120 mm.)
Provenance: Vason
Venice, Museo Correr, inv. 5791

The use of coloured chalks over a sketch in
charcoal and pen makes the two costumes
being studied seem almost alive. As
indicated by the inscriptions, which are
probably in Diziani's own hand, they were
being designed for the *barcaroli* (boatmen)
and *sonatori* (musicians) taking part in a
*bissona* (an eight-oared Venetian gondola).
This sheet has been attributed to Diziani,
although no similar drawings are known, on
the basis of a stylistic comparison with a
picture by him in the Ca' Rezzonico, Venice,
the *Feast of St Martha*, painted in about
1750.
*Bibliography*: Pignatti, 1964, no. 22; Zugni
Tauro, 1971, fig. 350; Pignatti, 1973, no. 36

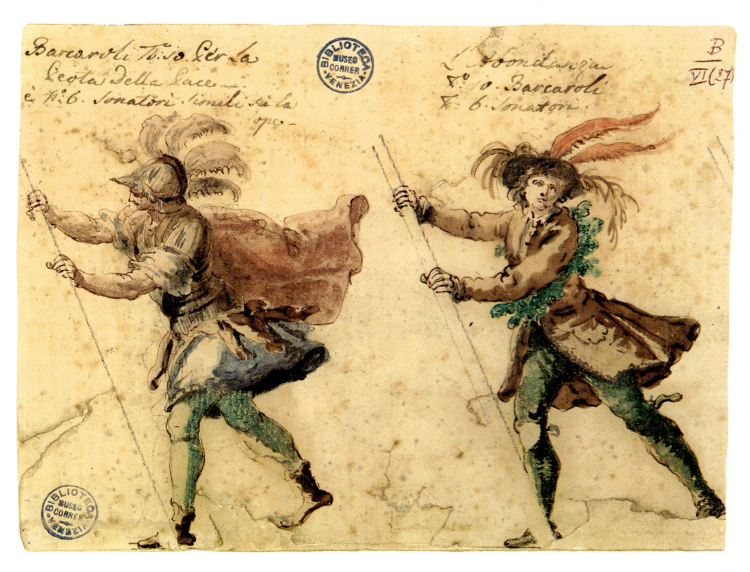

Donato Creti
(Cremona 1671–
Bologna 1749)
*Male Nude Sleeping*
Brush and brown and white
oil on thick paper;
11 × 16⅜ in. (280 × 410 mm.)
Provenance: Fernandez-
Duran
Madrid, Museo del Prado,
inv. F.D. 2179

Almost a monochrome
sketch, this is a preliminary
study for one of the paintings
to go over a door which were
executed by Creti for
Marcantonio Collina
Sbaraglia in the 1720s, and
which are now in the
Pinacoteca Comunale,
Bologna. An academic
classicism in the tradition of
Carraccio and an echo of
Guido Reni's influence are
the basic stylistic
components of this elegant
sleeping nude.
*Bibliography*: Pérez Sánchez,
1977, no. 64

242

243

244

Gian Battista Piazzetta
(Venice 1683–1754)
*Portrait of Marshal Schulemburg*
Black and white chalks on ivory paper;
19¾ × 15 in. (501 × 379 mm.)
Provenance: Schulemburg and his heirs; P.
Drey Gallery
Chicago, Art Institute of Chicago, Joseph
and Helen Regenstein Collection,
inv. 1971.325

A famous man in his day, the Marshal
(1661–1747) commissioned numerous
portraits of himself as gifts for his friends; to
cite only two, there is the canvas in the Ca'
Rezzonico, Venice, and the drawing by

Castello of Milan. He was one of the most
prominent figures in the eighteenth-century
Venetian collecting world and his collection
included thirteen pictures and at least
nineteen drawings by Piazzetta. The incisive
quality of the drawing shown here, which is
datable to around 1740, has been obtained
by the use of black and white chalks on
ivory paper to produce an exquisitely
painterly *sfumato* effect.
*Bibliography*: Morassi, 1952, pp. 85–91;
Joachim, 1974, no. 4

Gian Battista Piazzetta
*Girl with a Rose*
Charcoal highlighted with opaque white-lead
pigment on yellowish-grey paper;
14⅝ × 10⅝ in. (373 × 270 mm.)
Provenance: Bossi
Venice, Gallerie dell'Accademia, inv. 304

The special qualities of this sheet lie in its
elegance of expression combined with a
luminous and sensual atmosphere.
Stylistically, it is datable to around 1740. In
his handling of the charcoal, with frequent
highlights of bodycolour, Piazzetta has
created an illusion of colour through a
delicate chiaroscuro.
*Bibliography*: Pallucchini, 1956, p. 54;
Pignatti, 1973, no. 43

Marco Ricci
(Belluno 1676–Venice 1730)
*Landscape with Water-Mill*
Pen and sepia ink; $8\frac{5}{8} \times 9\frac{3}{8}$ in.
(220 × 238 mm.)
Provenance: Brass; entered in 1964
Venice, Museo Correr, inv. 8220

A difficult drawing to date, this may once
have belonged to the Cernazai volume in
Belluno. Similar scenes, with a Titianesque
theme and characterized by a neo-sixteenth-
century feeling, recur quite frequently in
Ricci's work from his youthful phase right
up to the period of engraved prints during
the last decade of his life.
*Bibliography*: Pilo, 1961, pp. 172 ff; Pignatti,
1964, no. 60; *idem*, 1973, no. 56

Alessandro Magnasco
(Genoa 1667–1749)
*Landscape with Figures and Musicians*
Brown wash heightened with white over
black chalk on yellowish paper; $18\frac{3}{8} \times 14\frac{1}{2}$ in.
(466 × 370 mm.)
Provenance: de Giuseppe; Wertheimer;
Slatkin
Chicago, Art Institute of Chicago, Joseph
and Helen Regenstein Foundation,
inv. 1962.585

The linear tension produced by brushwork
over charcoal was a technique that suited the
'demoniacal' art of Magnasco particularly
well. Scenes populated by bizarre figures of
monks, soldiers, vagabonds and masked
people, in which the influence of Jacques

Callot's engravings can be detected, form the
basis of all his compositions. Whilst the
themes are similar, however, the artist's
treatment of them was always different.
*Bibliography*: Scholz, 1967, p. 239; Joachin,
1974, no. 2

Francesco Zuccarelli
(Pitigliano 1702–Florence 1788)
*Landscape with Figures*
Pen and dark brown ink, grey wash
heightened with white; 12¼ × 18½ in.
(310 × 468 mm.)
Detroit, Detroit Institute of Art, Octavia W.
Bates Fund, inv. 34.156

In complete contrast to the naturalism of
Marco Ricci, Zuccarelli's handling of the
Venetian landscape – he was Tuscan by
birth but Venetian by upbringing – shows a
distinct tendency to the idyllic with an
Arcadian flavour. His subtle elegance and
refined touch are the basic features of his
best drawings, of which this is one.
Zuccarelli spent several years in England,
returning to Venice in 1771, and it would
seem that this drawing can be dated to about
that time.
*Bibliography*: Vitzthum, 1970, no. 84;
Pignatti, 1974, no. 97

Claude Monet (Paris 1840–Giverny 1926)
*The Church at Varengeville*
Black *crayon*; 12⅝ × 16½ in. (320 × 420 mm.)
Paris, private collection

In 1882 Monet portrayed the church at Varengeville in a picture for the Smith Collection in Houston, Texas, subsequently using the same subject in two other versions. The drawing reproduced here is the preliminary study for one of these, identified by the two trees in the foreground. This is one of only a few drawings by this artist, its fluent use of *crayon* linking the style with a traditional technique that is still reminiscent of the eighteenth century. The modern Impressionist can certainly be detected, though, in the flashes of white that give the effect of light fragmented into dazzling patches of iridescence.
*Bibliography*: Huyghe-Jaccottet, 1956, no. 107

Claude Monet
*Fishermen in Two Boats*
Black *crayon*; 10 × 13½ in. (256 × 344 mm.)
Provenance: Sachs
Cambridge, Mass., Fogg Art Museum,
Harvard University, Meta and Paul J. Sachs
Bequest, inv. 1965.312

This is one of Monet's rare drawings; it is
signed 'Claude Monet' and relates to a
picture dated 1882 called *Fishermen on the
Seine at Poissy*, now in the Belvedere in
Vienna. By using a special technical device,
in the form of a graphic (or Hebraic) granite
tablet, the artist has succeeded in bringing
out the luminous vibration of the reflections
on the water which, although characteristic
of his paintings, is an even greater
achievement in black and white.
*Bibliography*: Mongan, 1949, p. 182;
Moskowitz, 1963, no. 874

324

Edouard Manet (Paris 1832–83)
*Seated Nude Woman*
Sanguine on ivory paper; $11 \times 7\frac{7}{8}$ in.
($280 \times 200$ mm.)
Provenance: Pellerin; Guérin; Indig-Guérin;
Wildenstein
Chicago, Art Institute of Chicago, Helen
Regenstein Collection, inv. 1967.30

Manet's links with tradition are especially
apparent in his drawings, as here, where the
influence of Rembrandt's graphic work can
clearly be seen. The plastic modelling of the
nude, which is stylistically akin to the artist's
1862 etchings, seems to absorb the effects of
the light through the way in which the pale
as well as the mellow tones of the sanguine
have been used.
*Bibliography*: de Leiris, 1969, no. 186;
Joachim, 1974, no. 73

Edgar Degas (Paris 1834–1917)
*Ballerinas*
Black *crayon*, pastel and tempera (?) over
pencil; $8\frac{3}{4} \times 6\frac{1}{2}$ in. ($223 \times 167$ mm.)
Provenance: Marx; Kélékian; Genthe;
Carstairs; Hanna
Cincinnati, Art Museum, Gift of Mary
Hanna, inv. 1946.105

The ballet appears constantly in Degas'
work from 1872; he used the setting as a
starting-point for some formal research into
finding a way to achieve a balance between
the luminous chromatic effects of an
Impressionist painting and the French
representational tradition. In this sheet,
which is signed 'Degas' and is datable to
around 1879, the artist has extended his
experiment into a technical area by
superimposing tempera and pastel.
*Bibliography*: Browse, 1949, no. 135;
Dwight, 1952, pp. 8–11; Spangenberg, 1978,
no. 38

Edgar Degas
*After the Bath*
Charcoal and pastel; $17\frac{1}{8} \times 13$ in.
($435 \times 332$ mm.)
Provenance: Sachs
Cambridge, Mass., Fogg Art Museum,
Harvard University, Meta and Paul J. Sachs
Bequest, inv. 1965.259

The extreme linear simplification of this
female nude has produced a drawing that is
almost a pure example of a study in
chromatic values. The artist has gone over
the basic charcoal lines in flowing brown,
red, green and azure pastel strokes which
imbue the figure with a strong sense of
plasticity and volume.
*Bibliography*: Pečirka, 1963, pl. 59

Pierre-Auguste Renoir
(Limoges 1841–Cagnes-sur-Mer 1919)
*Study for 'The Bathers'*
Pencil, sanguine, black and white chalks
retouched with brush on ochre paper;
$38\frac{7}{8} \times 25\frac{1}{4}$ in. ($985 \times 640$ mm.)
Provenance: Hébrard; Brewster
Chicago, Art Institute, Kate L. Brewster
Bequest, inv. 1949.514

This drawing is one of many preliminary
sketches for one of the most famous of
Renoir's paintings, *Les Grandes Baigneuses*
(Carrol S. Tyson Collection, Philadelphia),
which he completed in 1885. The artist seems
still to have been influenced by the elegance
of Ingres, as is apparent here in the linearity
of the figure, although this does not prevent
the colour from vibrating freely in the
atmosphere.
*Bibliography*: Rewald, 1946, no. 41;
Joachim, 1963, no. 113

Paul Cézanne (Aix-en-Provence 1839–1906)
*Female Nude, Figure and Self-Portrait*
Black chalk and pencil on white paper;
$19\frac{5}{8} \times 12\frac{5}{8}$ in. (498 × 322 mm.)
Rotterdam, Museum Boymans-van
Beuningen, inv. F-II-122

The formal precision of Cézanne's work is expressed even in these drawings, in which the artist has built up the forms with detached, confident strokes while keeping only to the essential lines. The sheet as a whole includes a number of studies, amongst which is a copy made by Cézanne in the Louvre of the sculpture *Psyche abandoned*, by Augustin Pajou. Judging by the *Self-Portrait*, it is datable to about 1879-82; it is a fine likeness and closely resembles Renoir's pastel portrait of Cézanne made in 1880.
*Bibliography*: Venturi, 1936, no. 1479; Bouchot Saupique, 1952–53, no. 163

Pierre-Auguste Renoir
*Mademoiselle Jeanne Samary*
Pastel on paper; $27\frac{1}{2} \times 18\frac{3}{4}$ in.
(697 × 477 mm.)
Provenance: Chavasse; Mayer; Gold Gallery; Reid and Lefèvre; Knoedler; Hanna
Cincinnati, Art Museum, Mary Hanna Bequest, inv. 1946.107

In his pastels as in his paintings, Renoir's first concern seems to have been to represent the effects of light in his impressionistic style and knowledgeable handling of complementary tones. In this portrait of Jeanne Samary, the young Comédie Française actress who modelled for him so often between 1877 and 1880, the artist reveals the secret of the framework on which his figure drawing was built, which goes right back to Titian and the other great sixteenth-century Venetian painters.
*Bibliography*: Meier-Graeffe, 1929, p. 108; Spangenberg, 1978, no. 106

329

Paul Cézanne
*Black Château*
Pencil and watercolour; $14\frac{1}{8} \times 20\frac{7}{8}$ in.
(360 × 528 mm.)
Provenance: Cassirer; Koenigs; entered in
1930
Rotterdam, Museum Boymans-van
Beuningen, inv. F-II-212

In his landscapes, in which the artist often
repeats the same themes – as this one of the
*Black Château* – Cézanne often under-plays
the shapes, merely indicating their presence
with a subtle hatching in pencil and a few
brushfuls of discreetly placed watercolour.
In contrast with the Impressionists, he does
not delve into the colouristic effects of light
but creates space and volume with it.
*Bibliography*: Venturi, 1936, no. 1034;
Haverkamp Begemann, 1957, no. 82

James Abbott McNeill Whistler
(Lowell, Mass. 1834–London 1903)
*Woman Reading*
Charcoal and white chalk on brown paper;
$6\frac{5}{8} \times 5$ in. (168 × 127 mm.)
Washington, DC, Freer Gallery of Art,
Smithsonian Institution, inv. 05.145

The masterly handling of charcoal, recalling
the flowing lines of Degas, creates an
impressive effect of artificial light
surrounding the woman who reads with such
concentration. American by birth, Whistler
lived in both Paris and London while
developing – under the influence of the
recently arrived Japanese prints – a language
that presaged the arrival of the decorative
linearity to be known as Art Nouveau.
*Bibliography*: Moskowitz, 1963, no. 1041

Giuseppe de Nittis
(Barletta 1846–St Germain-en-Laye 1884)
*Poplars in Water*
Indian ink and watercolour on yellowed
white card; $12\frac{7}{8} \times 9\frac{7}{8}$ in. ($326 \times 251$ mm.)
Provenance: Martelli
Florence, Uffizi Gallery, inv. 599 G.A.M.

An accentuated graphic linearity
characterizes this sheet, datable to 1878
when the artist was friendly with Martelli in
Paris – the drawing bears the dedication
*'all'amico Diego – De Nittis'* ('to my friend
Diego – De Nittis'). This type of
watercolour, obviously inspired by the
elegant stylization of Japanese prints,
probably represents the most worthwhile
aspect of this painter's work.
*Bibliography*: C. del Bravo, 1971, no. 126

Federico Zandomeneghi
(Venice 1841–Paris 1917)
*The Leg-of-Mutton Sleeve*
Pastel; $15\frac{3}{4} \times 19\frac{3}{4}$ in. ($400 \times 500$ mm.)
Milan, private collection

In this delicate pastel drawing, which
belongs to Zandomeneghi's more mature
period, the artist's handling of the chromatic
vibrations developed in the azure tones is
quite remarkable. From 1874 he worked for
more than forty years in Paris. Here he came
under the influence of the Impressionists,
having formed a friendship with both Renoir
and Degas, which had a determining effect
on his artistic development as a painter.
*Bibliography*: Cinotti, 1960, pl. XI

Odilon Redon
(Bordeaux 1840–Paris 1916)
*The Spider*
Charcoal on yellow paper; $19\frac{1}{2} \times 15\frac{3}{8}$ in.
(495 × 390 mm.)
Paris, Musée National du Louvre, inv. 29932

Fundamental to Redon's work is his
absolutely personal language and, until 1890,
total rejection of colour. In his lithographs
as well as in his black and white drawings –
such as this monstrous spider with the
humanoid leer brought out by Redon as a
print in 1887 – he developed an art of such
imaginative, symbolic quality that entitles
him to be regarded as a precursor of
Surrealism.
*Bibliography*: Bouchot Saupique, 1952–3,
no. 170

Georges Seurat
(Paris 1859–91)
*Profile of a Woman*
Conté crayon on ivory paper; $18\frac{7}{8} \times 12\frac{3}{8}$ in.
(479 × 314 mm.)
Provenance: Davies; Rockefeller
New York, Museum of Modern Art, Abby
Aldrich Rockefeller Bequest

This study relates to the female figure that
appears in the centre of *Sunday on the Island
of La Grande Jatte* – now in the Art
Institute, Chicago – which was the second of
the large works designed by Seurat between
1884 and 1886 to demonstrate his theories of
complementary colours and static qualities.
The rigorous *pointilliste* technique that was
to be applied to the painting seems almost to
have been anticipated by the unusual graphic
effect produced by the Conté crayon on the
textured paper.
*Bibliography*: Rich, 1935, no. 3; Dorra-
Rewald, 1959, no. 138

Auguste Rodin
(Paris 1840–Meudon 1917)
*Female Nude*
Pencil and watercolour; 16 × 12 in.
(404 × 306 mm.)
Chicago, Art Institute of Chicago, Alfred
Stieglitz Collection, inv. 49.900

It is easy to see this is the drawing of a
sculptor because of the overriding
concentration on the plastic and volumetric
values of the female figure. This
characteristic is further stressed by the
contrast between the flat way in which the
watercolour has been applied and the light
pencil strokes that indicate the gauzy nature
of the background drapery.
*Bibliography*: Mendelowitz, 1967, p. 414

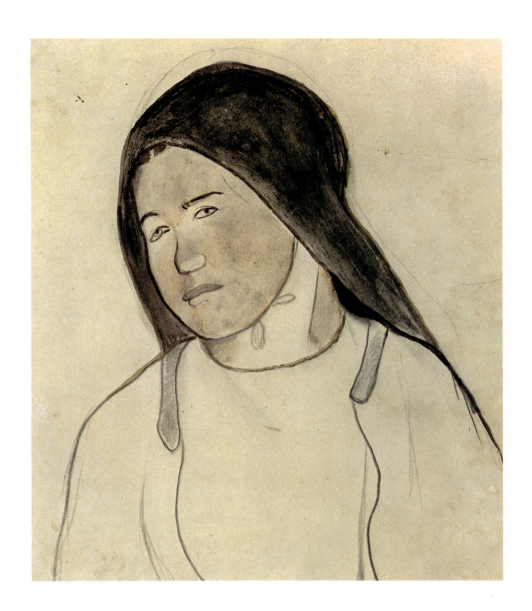

Paul Gauguin
(Paris 1848–Marquesas Islands 1903)
*Nave Nave Fenua*
Brush with black ink and watercolour;
$16\frac{1}{2} \times 10\frac{1}{4}$ in. (419 × 260 mm.)
Provenance: Rosenwald
Washington, DC, National Gallery of Art,
Rosenwald Collection, inv. B-14, 393

This watercolour relates to Gauguin's
Tahitian experience and was painted
between his first return to Paris in 1893 and
his second – and final – departure for the
island two years later. The inscription, *'pas
écouter li li menteur'* ('Do not listen to the
liar'), suggests the meaning implied in the
composition. The influence of the indigenous
art in the South Sea Islands, which Gauguin
interpreted and modified in the light of his
own European culture, was the determining
factor in his work.
*Bibliography*: Robison, 1978, no. 105

Paul Gauguin
*Portrait of a Young Breton Peasant Girl*
Pencil, black and red *crayon*, black
watercolour; $8\frac{7}{8} \times 13\frac{1}{2}$ in. (224 × 344 mm.)
Provenance: Vignier; Sachs
Cambridge, Mass., Fogg Art Museum,
Harvard University, Meta and Paul J. Sachs
Bequest, inv. 1965.283

The date of this sheet is uncertain but it
must be between 1889 – when Gauguin,
escaping from Paris, sought refuge in
Brittany in order to paint – and 1895, when
the artist left France for ever. The simple but
clear-cut expressiveness of the girl,
emphasized by the contrasting flat colours
used so uniformly, make this one of
Gauguin's most moving drawings.
*Bibliography*: Mongan-Sachs, 1946, no. 690;
Rewald, 1958, no. 14; Leymarie, 1960, no. 27

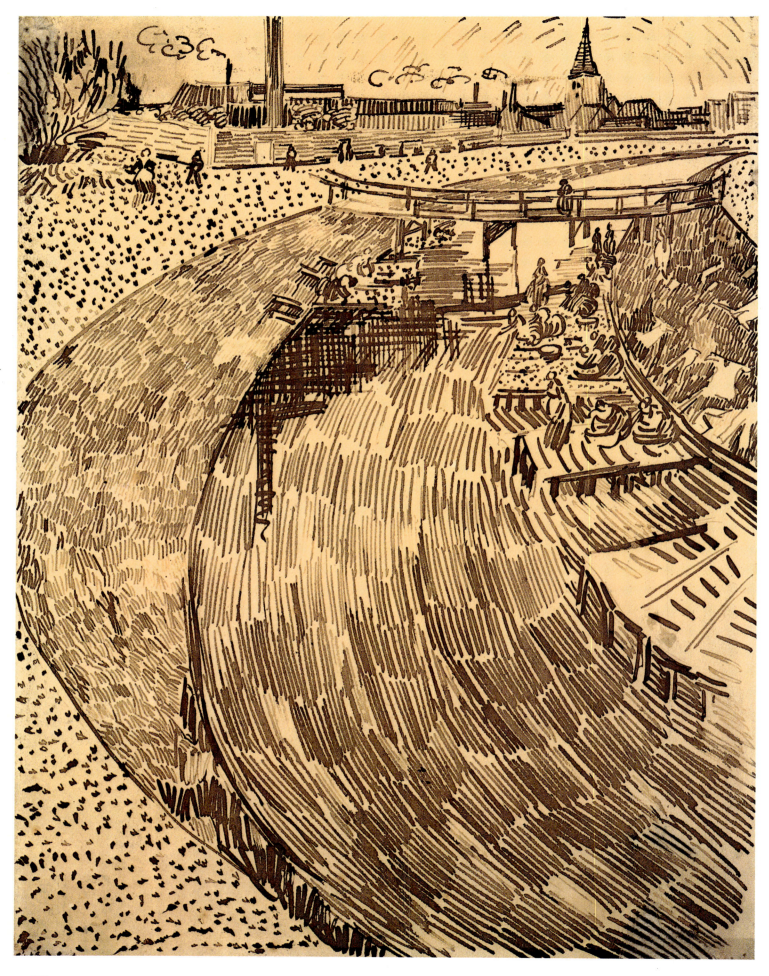

338

Vincent van Gogh
(Groot Zundert 1853–Auvers-sur-l'Oise
1890)
*Canal with Washerwomen*
Pen and ink; $12\frac{1}{2} \times 9\frac{1}{2}$ in. (315 × 240 mm.)
Otterlo, Kröller-Müller State Museum

This emblematic drawing, dated 1888, is
characterized by its Neo-Impressionist style.
The lively brushwork, so rich in light and
colour, which was typical of van Gogh's
paintings at the end of his Parisian period
and in the early phase of his stay in Arles, in
the French Midi, seems to find new life in
these well-defined ink lines drawn with a
reed pen.
*Bibliography*: de la Faille, 1970, no. 1444;
Liebermann, 1973, no. 32; Hulsker, 1980,
no. 1507

Vincent van Gogh
*The Girl with the Ruffled Hair*
Black chalk and brush with grey and white
watercolour; $17\frac{1}{8} \times 9\frac{7}{8}$ in. (435 × 250 mm.)
Provenance: van Gogh; Kröller-Müller
Otterlo, Kröller-Müller State Museum

Van Gogh's existential anxiety finds
expression in this portrait of a young girl,
who was probably a daughter of Sien, the
prostitute who was befriended by the artist
about 1882. This black and white technique,
which tends to produce painterly effects, was
just a part of the experimentation he was
carrying out at that time.
*Bibliography*: Regteren Altena, 1958, no.
143; de la Faille, 1970, no. 1007; Hulsker,
1980, no. 299

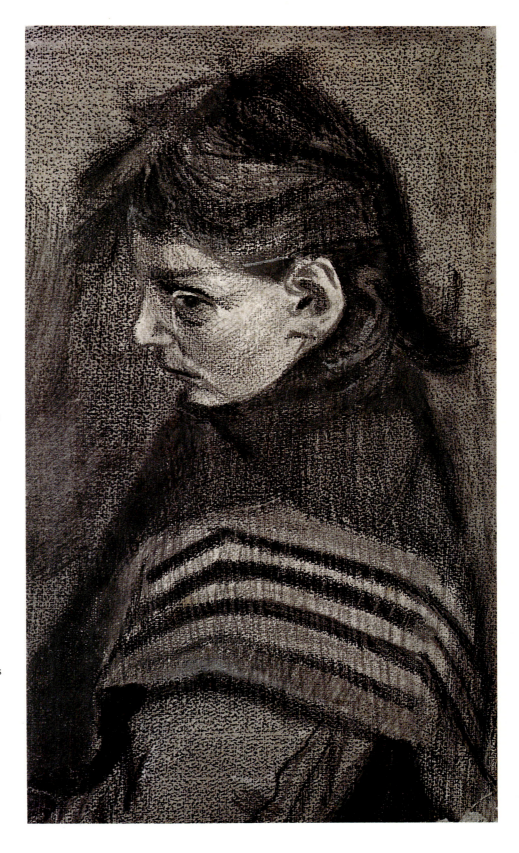

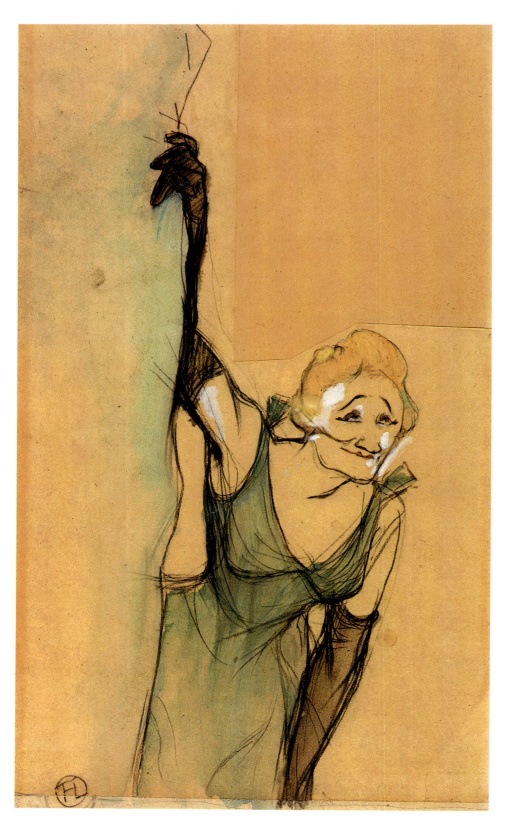

Henri de Toulouse-Lautrec
(Albi 1864–Malromé 1901)
*Yvette Guilbert Takes a Curtain Call*
Pastel and watercolour; 16⅜ × 9 in.
(416 × 229 mm.)
Providence, Rhode Island, Rhode Island
School of Design, Gift of Mrs Murray S.
Danforth, inv. 35.540

In 1894 Toulouse-Lautrec made an album of
lithographs for Yvette Guilbert, one of the
*védettes* (star performers) of the Tout-Paris.
The singer is portrayed in a number of
studies which, whilst emphasizing her
vivacious, witty personality, portrayed her
eccentric appearance in such a veristic way
as to cause some embarrassment among her
friends. This particular study, in which the
pastel lines encroach unashamedly on the
areas of colour, was executed in preparation
for a painting now hanging in the Musée
Albi which is one of the artist's most
important late works.
*Bibliography*: Mack, 1938, fig. 27;
Moskowitz, 1963, no. 910

Henri de Toulouse-Lautrec
*Mademoiselle Cocyte*
Pencil and sanguine heightened with white;
13¾ × 10 in. (350 × 255 mm.)
Provenance: Heim; Blot; Bergaud; Duhem
Chicago, Art Institute of Chicago, Joseph
and Helen Regenstein Collection,
inv. 1965.14

The world of the cabaret, with its wide
variety of characters – often portrayed with
pitiless verism in all their squalor and
vulgarity – typifies most of the work of
Toulouse-Lautrec. This sketch was made
towards the end of his life when he was in
Bordeaux; with only a few lines in pencil
and sanguine, the artist has achieved a
strongly expressive portrait, in a well-
balanced, formal stylization.
*Bibliography*: Dortou, 1971, no. D4 642;
Joachim, 1974, no. 77

Ferdinand Hodler
(Berne 1853–Geneva 1918)
*Portrait of a Young Girl*
Pencil – *sfumato*; $7\frac{7}{8} \times 6\frac{1}{8}$ in. (199 × 155 mm.)
Basle, Oeffentliche Kunstsammlung,
inv. 1926.56

In the vast graphic output of Ferdinand
Hodler, one cannot but be aware of the
complexity of its development. Styles range
from Impressionism to Symbolism, finally
crystallizing into the forms of Art Nouveau.
This portrait, signed and dated 1910, is
characterized by a particularly firm yet
plastic pencil line.
*Bibliography*: Hugelshofer, 1967, no. 100

Aubrey Beardsley
(Brighton 1872–Mentone 1898)
*'J'ai baisé ta bouche' ('I kissed your mouth')*
Pen and ink; $10\frac{7}{8} \times 5\frac{3}{4}$ in. (276 × 146 mm.)
Princeton, NJ, University Library, Gallatin
Beardsley Collection

The Pre-Raphaelite style and a great
admiration for Japanese prints are the basic
components of Beardsley's elegant Art
Nouveau linearity. The pen-and-ink
draughtsmanship is stylized, clear-cut and
entirely without chiaroscuro. This drawing
was probably the deciding factor in the
decision to commission Beardsley to
illustrate Oscar Wilde's *Salome* in 1894 – a
partnership which resulted in an unusually
close relationship between illustrations and
text for a modern book.
*Bibliography*: [Marillier], 1899, ed. 1967, pl.
64

343

Georges Barbier (Nantes 1882–?1932)
*Le Tapis Persan (The Persian Carpet)*
Gouache, gold and silver over pencil;
12¼ × 10 in. (311 × 254 mm.)
Provenance: Wildenstein
Cincinnati, Art Museum, inv. 1921.190

This drawing relates to the studies executed
by Barbier in 1920 for the costumes and
stage designs for the ballet *Le Tapis Persan*
by Jean Nouguès. Decorative linearity
blends with a stylized Persian motif in an
exquisite formal balance worthy of a
technique that used not only gouache but
also touches of gold and silver to make the
costumes for the two leading dancers more
impressive.
*Bibliography*: Flamant, 1924, pp. 180–1;
Spangenberg, 1978, no. 11

Gustav Klimt (Vienna 1862–1918)
*Profile of a Woman Reading*
Pencil; 21½ × 12⅝ in. (545 × 322 mm.)
Vienna, Graphische Sammlung Albertina,
inv. 23.541

This drawing is probably datable to about
1911, when Klimt was working on the frieze
for the Palais Stoclet in Brussels (1909–11).
The elongated, sinuous figures, the taste for
decorative and symbolic features – mainly
identifiable in the spiral motifs derived from
Byzantine mosaic art – as well as a marked
tendency to two-dimensionality constitute
the more typical characteristics of this
stylistic phase.
*Bibliography*: Breicha, 1978, no. 152

# From Cubism to the Present Day

**Henri Matisse** (La Cateau 1869–Cimiez 1954). Matisse began to draw with coloured *crayons* during a period of convalescence when he was twenty-one. As a result, he went to work in the artist's quarter of Paris, where he came into contact with Auguste Rodin, Camille Pissarro and Paul Signac. In 1905 he became one of the founders of the group that became known as '*Les Fauves*' ('the Wild Beasts'), of which he came to be the leader. At the age of about forty Matisse retired to the French Riviera, where he produced some of his most joyful pictures, including the decoration of the chapel of the Dominican convent at Vence in 1951. His work, during this latter period especially, has a luminous quality and is rich in brilliant and pure colours. His drawings, which are often coloured, display great strength in their formal composition, presenting a valid alternative to Cubism in their vitality.

**Georges Braque** (Argenteuil 1882–Paris 1963). In Paris from 1900 onwards, Braque started following the Impressionists and the Fauves. Soon, however, he was developing the ideas of Cézanne and from 1908 beginning to devise the poetical basis of Cubism with his friend, Pablo Picasso. His favourite themes were still-lifes of musical instruments and domestic objects, which he depicted both in paintings and in a great many drawings, often using a composite technique which incorporated collage. In his later work Braque sometimes seems to have gone beyond Cubism to achieve a more classic, restful expressiveness, occasionally verging on Abstractionism.

**Pablo Picasso** (Malaga 1881–Mougins 1973). The son of an art teacher, Picasso began to draw when he was very young. From Barcelona, where his family had settled, he went to Paris and Madrid, returning to Paris to live in 1901. He made the acquaintance of Henri Matisse in 1906 and about two years later got to know Georges Braque. A kind of working partnership developed between Picasso and Braque, and they produced the first Cubist works together. Up to then, that is during his Blue and Pink Periods, Picasso had painted only realistic subjects. He made use of every known technique and was at once a draughtsman, engraver, sculptor, painter and potter. His life was one of inexhaustible activity, enriched by his constant seeking after new ways of dealing with shapes. During the Spanish Civil War, Picasso became politically involved in the struggle against Francoism and painted his famous *Guernica*, for which he prepared a great many graphic studies. His sensitive illustrations of modern poetry consist of engravings and drawings that clearly demonstrate his masterly handling of line, which, although fine, is full of vibrant vitality.

**Fernand Léger** (Argentan 1881–Paris 1955). Léger's first important artistic experience was in the realms of Cubism, in which he made a particularly dynamic impact with his geometric composition and de-composition of the image. He frequently used themes relating to the industrial and mechanical aspects of modern life to great effect.

**Amedeo Modigliani** (Leghorn 1885–Paris 1920). At the age of twenty-one Modigliani moved to Paris, where he remained, apart from a few brief periods, for the rest of his life. From 1909 onwards he seems to have become totally immersed in negro sculpture, the influence of which is particularly apparent in his drawings and three-dimensional work. He neglected his painting almost entirely, especially portraiture, until an art dealer named Zborowski persuaded him to return to his brushes and canvases. Within a few years Modigliani had produced hundreds of paintings which have a distinctive linear style with a profound rhythmic quality.

**Kasimir Malevich** (Kiev 1878–Leningrad 1935). From 1907 to 1912 Malevich was inspired in his painting by a Russian Neo-Primitive style that tended to break shapes down into geometrical blocks, with a strong emphasis on colour. He then progressed through Cubism and Futurism, using typical 'trick' effects in the form of collages, superimpositions, and so on. Because of official opposition to Abstract Art, Malevich emigrated to Germany. He later returned to Russia, but in 1930 was arrested and obliged to restrict his artistic expression to the realistic forms of traditional painting.

**Oskar Kokoschka** (Pöchlarn 1886–Montreux 1980). Having started painting in the atmosphere of the Vienna *Sezession*, Kokoschka turned – with his contributions to Herwarth Walden's magazine *Der Sturm* – towards Expressionism and the 1911 *Blaue Reiter* movement (named after a picture of Kandinsky's, *The Blue Rider*). Kokoschka's

charcoal drawings and lithographs were intensely realistic, too, and he expressed his bitter opposition to Nazism in graphic work that was both grotesque and full of irony.

**Georges Rouault** (Paris 1871–1958). Rouault was attracted by the poetic approach of Gustave Moreau and developed an intensely dramatic style in which colour was laid between heavy lines, giving a nocturnal effect. From 1910 he painted subjects drawn from street life, such as prostitutes and clowns. He was also a prolific lithographer and etcher.

**Carlo Carrà** (Quargnento 1881–Milan 1966). A signatory of the Futurist Manifesto in 1910, and a contributor to such avant-garde journals as *La voce* and *Lacerba*, Carrà in 1916 joined Giorgio de Chirico's *Pittura metafisica* (Metaphysical Painting) movement. An example of his painting in this style is *The Engineer's Mistress* in the Mattioli Collection, Milan. In his landscapes, Carrà pursued a more classic line, with a simplification of form that is almost primitive, recalling that early period of the *Valori Plastici* (Plastic Values) movement in the tradition of Giotto and Masaccio.

**Marc Chagall** (Vitebsk 1887). In spite of the Cubist sympathies he acquired in Paris as a young man, Chagall soon turned to highly imaginative surrealistic forms in which he evoked his ancestral Russian culture with scenes from village life in paintings, drawings and lithographs. Although he was at first sympathetic towards the aims of the Russian Revolution, he was in 1922 obliged to emigrate and went to Paris, where he continued to paint. After some years he found himself being persecuted once again, this time by Nazism, and in 1941, at the invitation of the Museum of Modern Art in New York, went to the United States, returning to Paris in 1947. Among the large works executed in the latter part of his life are the decorations for the New York Metropolitan Opera House (1966).

**Umberto Boccioni** (Reggio Calabria 1882–Verona 1916). A leading figure in Italian Futurism, Boccioni studied in Rome with Giacomo Balla in the early 1900s. He then moved to Milan, where he sought to capture the life of the modern city in drawings and paintings that certainly caught its linear dynamism. He signed the Futurist Manifesto

with Filippo Marinetti in 1910 and did all he could to spread its aesthetic ideas throughout Europe.

**Gino Rossi** (Venice 1884–1947). In his short career, which was interrupted in 1927 by the onset of madness, Gino Rossi went through most of the phases of French Post-Impressionism. From the early 1900s onwards his work shows a resemblance to that of Gauguin and of the Nabis – a late nineteenth-century group in Brittany devoted to flat, pure colours who put great importance on subject matter. Rossi's next phase took him into Cubism, with heavy graphic constructions that recall Cézanne. Finally he was to adopt the arabesque style of Matisse's middle period, although quite unable to achieve that great artist's superb luminous quality.

**Giorgio Morandi** (Bologna 1890–1964). Morandi lived and worked in the most austere isolation, meditating mainly on the great Renaissance masters on whom he drew for the classical spirit that pervades his interesting still lifes. He was a draughtsman and etcher of outstanding talent whose work seems to echo that of Corot and Cézanne.

**Pio Semeghini** (Quistello 1878–Verona 1964). Semeghini studied and worked in Paris until 1914. Later he was to spend long periods on the island of Burano, in the Venetian lagoon, where – with Moggioli and Gino Rossi – he formed a group of artists who called themselves the *Ca' Pesaro*. Semeghini's sensitive talent for painting, expressed in a language of delicate, almost evanescent colours, often also found an outlet in coloured pencils, which he used to great effect.

**Filippo Tibertelli, called De Pisis** (Ferrara 1896–Milan 1956). A poet and writer, De Pisis started painting in 1944; he concentrated mostly on still lifes and landscapes. He associated himself with the various avant-garde movements in Italy, although without any real conviction, remaining faithful throughout to a poetical Post-Impressionism in which the importance of form was paramount. De Pisis lived in Paris from 1925 to 1940, moving thence to Milan and later Venice.

**Alberto Viani** (Quistello 1906). Viani is a sculptor of large figures positioned pictorially in space, which give the appearance of relating solely to the plastic abstractions of

Jean (Hans) Arp. In fact, Viani has preserved his Venetian roots intact in a sculptural form that never lost sight of Man's physical reality or of his life in coloured space. Viani is a fine draughtsman whose line-drawing conveys a sense of intensely meaningful plasticity, in a blending of profoundly classical rhythms.

**Giacomo Manzoni, known as Manzù** (Bergamo 1908). Besides being one of Italy's leading sculptors, Manzù is an excellent draughtsman and engraver, expressing himself in Post-Impressionist terms with a synthetically modern cultural outlook. A sensitive, intimate portraitist, he also devoted a great deal of time to such gigantic schemes as the doors of the cathedrals of Salzburg and Rotterdam, as well as the great bronze doors for the Basilica of St Peter in Rome.

**Marino Marini** (Pistoia 1901–Viareggio 1980). In his sculpture, Marini sought to achieve a synthesis between an archaic positioning of masses and a meaningful expressionistic strength. This approach is also apparent in his graphic work, with its violent linear characters. This artist's favourite theme of horse and rider lends itself to infinite variations which, on the one hand, recall the archaism of the millenary Chinese terracotta figures and, on the other, conjure up an abstract conception of form.

**Paul Klee** (Münchenbuchsee 1879–Muralto 1940). Initially Klee belonged to the Jugendstil movement, as it was known in Germany but which elsewhere was called Art Nouveau. He published a series of etchings and monotypes while under the influence of the Parisian Symbolists; as a result of this contact he found much in common with Wassily Kandinsky, whose theories on abstract art he absorbed and passed on to the students of the Bauhaus in Weimar, where he taught from 1920 onwards. In 1933 he returned to Switzerland in order to escape from the Nazi threat. He settled in Berne, where most of his work is now preserved.

**Wassily Kandinsky** (Moscow 1866–Neuilly-sur-Seine 1944). Having decided at the age of thirty to become a painter, Kandinsky became a student at the Academy of Fine Arts in Munich. His earliest works were mainly landscapes, both on canvas and as drawings and xylographs (i.e. white-line wood-engravings). From 1909 onwards, the artist showed an increasing tendency to

detach himself from Nature and to become more and more abstract, in a musical harmony of lines and brilliant, luminous colours. He thus became the father of contemporary Abstract Art within the Blaue Reiter movement, defending his revolutionary ideas on art with books and pamphlets.

**Piet Mondrian** (Amersfoort 1872–New York 1944). Mondrian began by painting landscapes. In 1911 he went to Paris, where he found himself drawn to Cubism and changed his naturalistic style into a geometry of colours and shapes. Six years later in Holland he founded the magazine *De Stijl* as the organ for Neo Plasticism, his own name for the style of abstract painting he had evolved, which was two-dimensional and had as its basic elements straight lines meeting at right angles and a limited number of primary colours. He moved to New York in 1940 and died there four years later.

**Max Ernst** (Brühl 1891–? 1976). After being involved with the Blaue Reiter group in Munich in 1919 Max Ernst started the Dada movement. In this, art was turned inside out; it was seen as a crazy amusement – a medium for going beyond all limits of normality – and found expression in eccentric montages and collages. From 1921 onwards, Ernst was drawn towards Surrealism, on which he wrote a treatise. From 1939 to 1953 Ernst lived in the United States, where he exerted a powerful influence both on painting and on the graphics of Abstract Expressionism.

**Joan Miró** (Barcelona 1893). In 1919 this artist was working along similar lines to Picasso, but later turned to the freer forms of Dadaism and Surrealism. His paintings, as well as his numerous lithographs and drawings – which represent one of the milestones of modern Abstract Expressionism – should be interpreted with this in mind. After the Second World War, Miró went to the United States, where, in addition to his studio work, he devoted himself to producing large ceramic and mural decorations such as those in the UNESCO headquarters, New York.

**Salvador Dalí** (Figueras 1904). Having started out in Spain as a Cubist and Futurist, Dalí has subsequently concentrated on surrealist modes of expression under the inspiration of Freud's theories on the meaning of dreams. In 1939 he settled in the United States, where he has produced a great many

paintings and a vast amount of graphic work, all based on the motifs of Surrealism, of which he has become the leading exponent.

**Anton Zoran Music** (Gorizia 1909). After studying in Zagreb and Madrid, and producing his first works in Venice, Music devoted himself to a poetic evocation of the Dalmatian atmosphere, painted with carefully dried materials and drenched with light. From 1952 onwards, Music was working in non-representational styles, studying above all the effect of light in evanescent and iridescent perspectives. Lastly, to add to his prolific output of drawings and lithographs, as well as paintings, he has re-evoked the tragic experience of the extermination camp at Dachau, bringing its newly burnt colours into the stricken landscapes of rocks and cities.

**Graham Sutherland** (London 1903–80). This artist's origins were in the field of graphic art, especially as a book illustrator in the style of Blake. It was not long, however, before he was approaching Surrealism, with a strong bias towards material subjects. He has covered a wide range of themes, from those which are inspired by reality seen as a disturbing nightmare, to those that deal with the unconscious mind.

**Gino Bonichi, known as Scipione** (Macerata 1904–Arco 1933). Having studied in Rome under Mafai, Scipione instigated a gradual revival of the artistic languages of the late Renaissance and the Baroque. He made his début in 1925 with works of profound dramatic import like his *Cardinal Decano* (1929–30), in the Galleria d'Arte Moderna, Rome. In the graphic field, he openly confessed to his interest in a Neo-Baroque revival at an Expressionist level.

**Alberto Giacometti** (Stampa 1901–Chur 1966). One of the leading sculptors of our time, Giacometti also devoted himself to painting and the graphic arts. He worked in Paris from 1922 onwards, in contact with all the most modern styles but never allowing himself to be deflected from his own, which especially in his graphic work assumes an incisive character as the artist strives for a painterly *sfumato* effect.

**Max Beckmann** (Leipzig 1884–New York 1950). Max Beckmann lived and worked in the Expressionist movement in Berlin and

Düsseldorf until the Nazi persecution of 1937, when he emigrated to Holland. From there he went to the United States, where he eventually died. During his later period his dramatic, chiaroscuro graphic work became much softer and he tended to use shapes that lent themselves to expressive colouring.

**Henry Moore** (Castleford 1898). From his period of study spent in London at the Royal College of Art, Henry Moore was fired by the desire to revive an archaic world, with sculpture still in pure volume, which he retained unchanged throughout his long career. Although he was aware of all the artistic movements that had succeeded one another in the twentieth century, Henry Moore stayed firmly with his re-conquest of the classical spirit. This is apparent, too, from his accurate and patient graphic study of the natural subject which only later would he transform into an apparently non-figurative three-dimensional object such as his *Reclining Figure* (1930) in the National Gallery of Canada, Ottawa. In the graphic field, his *Shelter Sketchbook*, which he drew from life in the London underground shelters during the air raids in 1940, is undoubtedly his best-known work.

**Georg Grosz** (Berlin 1893–New York 1959). Georg Grosz made his début as a satirical draughtsman in 1917. This was with a collection of violently anti-bourgeois drawings aimed at the corrupt ruling class. He continued to produce political satires, both paintings and graphic works, until he was denounced as a 'degenerate artist' by the Nazi regime and forced to leave Germany. Emigrating to the United States in 1932, he settled in New York, where he was to spend the rest of his life. Here he continued to produce drawings, engravings and paintings, and was a major influence on the generation of American Realists.

**Roy Lichtenstein** (New York 1923). One of the originators of Pop Art *c.* 1959–60, Roy Lichtenstein shared in the aesthetic viewpoint which was directed at the dangerous tendency to glorify the mass media, with all their power to negate the survival of the individual. In making use of the glibly expressive idiom of modern pictorial advertising, Lichtenstein's drawings and engravings stand for our vainly dreamed hopes of a real life which is being overwhelmed by the bewildering turmoil of the Machine Age.

350

Henri Matisse
(Le Cateau 1869–Cimiez 1954)
*Spanish Lady with Fan*
Charcoal and stump; $20 \times 15\frac{7}{8}$ in.
$(510 \times 402$ mm.)
Provenance: presented to the Musée du
Luxembourg by the artist
Paris, Centre Georges Pompidou, Musée
National d'Art Moderne, inv. LUX 1074 D

This is the working study prepared by
Matisse for his *Spaniard, Harmony in Blue*
painted in 1923 and now in the Metropolitan
Museum, New York. 'Odalisque' and
'Spanish lady' themes recur frequently in the
work of Matisse's maturer years, as though
he were using them as a medium through
which to achieve chromatic harmony, as in a
musical composition.
*Bibliography*: Monod Fontaine, 1979, no. 36

Georges Braque
(Argenteuil 1882–Paris 1963)
*Still Life*
Sanguine; $17\frac{1}{8} \times 24$ in. ($435 \times 610$ mm.)
Paris, private collection

In his youthful Cubist period, Braque used
drawing as a means of analyzing, in detail,
the breakdown of shapes. In this perspective
study of a table, drawn in 1919, the objects
are drawn over shadow to give the
characteristic three-dimensional and
simultaneous effects of the artist's new
aesthetic theory.
*Bibliography*: Ponge-Descargues-Malraux, p.
135; Leymarie, 1975, no. 47

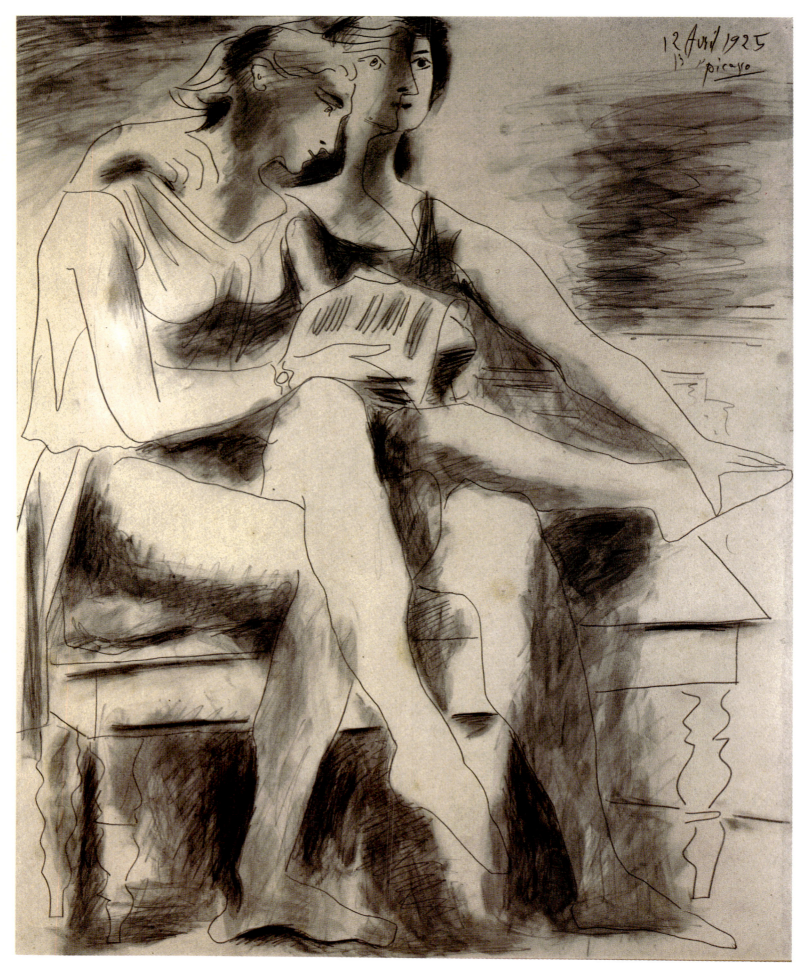

352

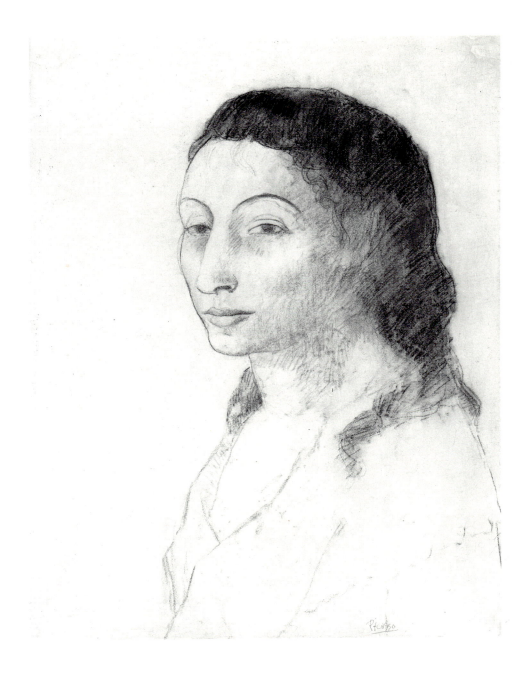

Pablo Picasso
(Malaga 1881–Mougins 1973)
*Two Female Figures*
Pencil; 20 × 16 in. (510 × 410 mm.)
Provenance: Earl Beatty; entered in 1953
Dublin, National Gallery of Ireland, inv.
3271

In the ten years between 1915 and 1925,
Picasso developed a style of painting and
drawing strongly reminiscent of Classicism,
although he was at the same time deeply
involved in what was later to be called
Analytical Cubism. As is indicated by the
inscription, *'12–13 Avril 1925 Picasso'*, this
drawing corresponds chronologically to his
Cubist painting of the *Three Dancers*. It is
almost as though Classicism and Cubism
have become reconciled in the flowing
outlines and sculptural quality of the pencil
strokes, in contrast with the dynamic volume
of the composition.
*Bibliography*: Zervos, 1952, no. V5; White,
1967, no. 105

Pablo Picasso
*Fernande Olivier*
Charcoal: 24⅛ × 18 in. (612 × 458 mm.)
Provenance: Waldeck
Chicago, Art Institute of Chicago, inv.
51.210

A feeling of monumentality and expressive
power in his use of the graphic medium
reveal Pablo Picasso's exceptional qualities
as a portraitist. He drew this likeness of
Fernande Olivier in 1906 when, having come
to the end of his Pink Period, the artist was
already experimenting with Cubism. He used
this style for *Les Demoiselles d'Avignon*,
which was probably started at the end of the
same year.
*Bibliography*: Joachim, 1963, no. 154

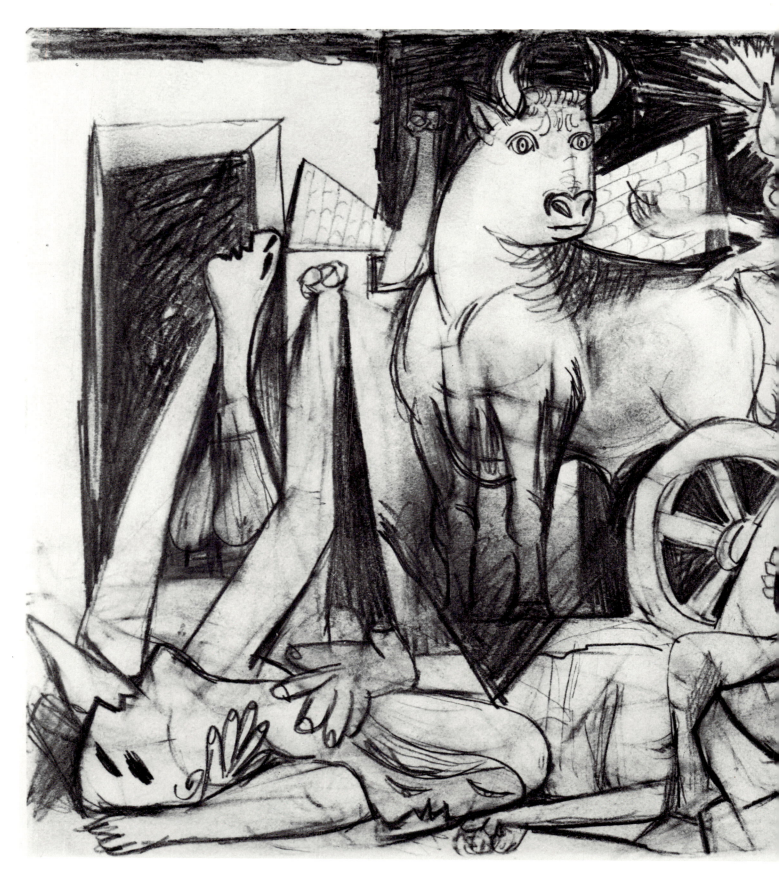

Pablo Picasso
*Guernica*
Pencil on white paper; 9½ × 17⅞ in.
(241 × 454 mm.)
New York, Museum of Modern Art

This drawing, which contains several differences – some quite significant – from the final painted version, is one of a number of preparatory studies by Picasso for his *Guernica*, now in the Prado, Madrid. In this large canvas, with its allusive and symbolic language, the painter has expressed his condemnation of the destruction of the little Spanish town of Guernica that took place on 9 May 1937; in effect, it symbolizes a protest against the horror and destruction brought about by war anywhere.
*Bibliography*: Mendelowitz, 1967, p. 233

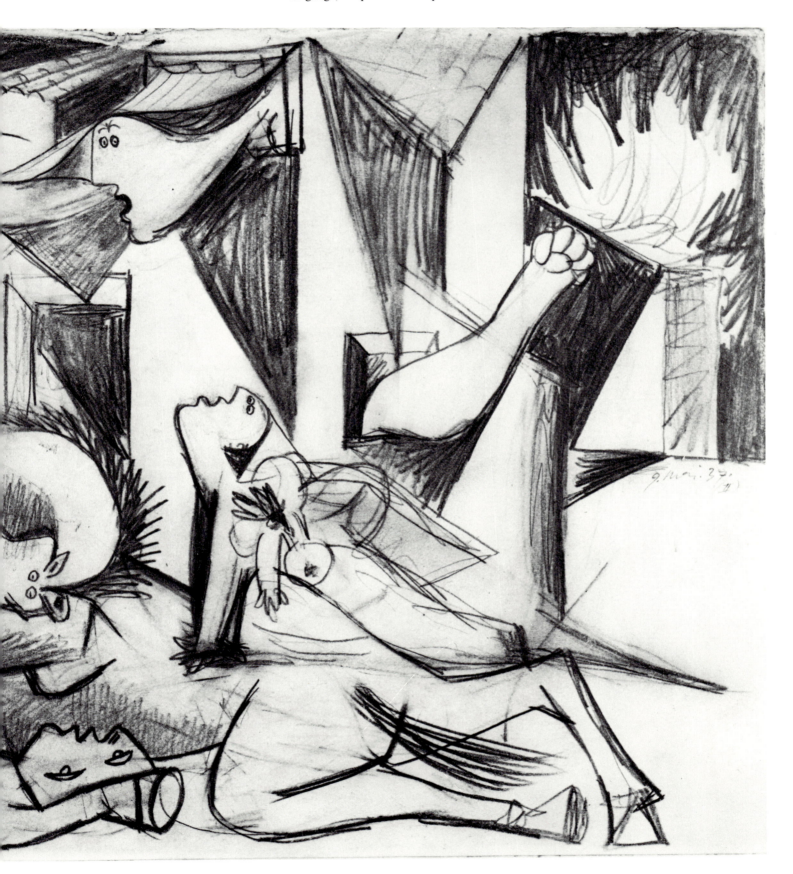

Fernand Léger (Argentan 1881–Paris 1955)
*Mother and Child*
Crayon; $11\frac{7}{8} \times 15\frac{3}{8}$ in. (300 × 390 mm.)
Philadelphia, Museum of Art, A. E. Gallatin
Collection, inv. 52-61-69

This drawing, as the autograph and date
'F.L. 24' affirm, belongs to the advanced
phase of what Léger himself described as his
*'époque mécanique'* ('mechanical era'). In this
and similar works, the artist is seeking a
definition of the relationship between the
plane and space. To this end, he has created
a complex series of relationships in the
various component parts; here, for instance,
the human figure itself – hitherto absent
from Léger's work – is considered essentially
from the point of view of its three-
dimensional qualities.
*Bibliography*: Cassou-Leymarie, 1972, p. 48
and no. 102

Amedeo Modigliani
(Leghorn 1884–Paris 1920)
*Seated Nude Woman*
Pencil; $16\frac{3}{4} \times 9\frac{7}{8}$ in. (425 × 250 mm.)
Provenance: Swift van der Marwitz
Chicago, Art Institute, Gift in memory of
Tiffany Blake, inv. 1951.22

The sinuosity of pure line characterizes this
late pencil nude, datable to 1918, which is in
the series dedicated to Jeanne Hebuterne.
The accentuated linearity has a certain
affinity with some the drawings by Matisse,
which also relate to his contact with the
Fauves.
*Bibliography*: Joachim, 1963, no. 158

357

Kasimir Malevich
(Kiev 1878–Leningrad 1935)
*They are Going to Church*
Pencil on paper; 5½ × 4 in. (140 × 99 mm.)
Paris, Centre Georges Pompidou, Musée
National d'art Moderne, inv. AM 1975-227

The deep attachment of the Russian people
to religion was already a favourite theme of
Malevich in the years 1911 to 1912 and he
has used it again in this drawing datable to
after 1930. An accentuated geometrical style,
directly related to Cubism, characterizes the
figures of the peasants.
*Bibliography*: Andersen, 1978, vol. IV, p.
256; Martin, 1978, no. 17

Oskar Kokoschka
(Pöchlarn 1886–Montreux 1980)
*Study for 'The Concert'*
Lithographic pencil; 26½ × 19⅛ in.
(675 × 487 mm.)
Tutzing, Hahn Collection

The artist has made full use here of the
technical possibilities offered by the broad,
clean line of the lithographic pencil to
emphasize, in an expressionistic way, the
psychological aspect of the model. As the
autograph note *'Kokoschka – 1920 – für
Concert'* indicates, this study from 1920
relates to the 'Concert' theme on which
Kokoschka produced a series of lithographs.
*Bibliography*: Oskar Kokoschka, 1966, no.
60

Georges Rouault (Paris 1871–1958)
*Prostitute in Front of a Mirror*
Watercolour; 28½ × 21¾ in. (724 × 552 mm.)
Paris, Centre Georges Pompidou, Musée
National d'Art Moderne, inv. AM 1795 D

This watercolour, in its polemic
aggressiveness and the strongly contrasting
tones of the colours in which the figure is
painted, is indicative of Rouault's burning
Expressionism when he was about twenty-
five. Although exhibiting with the Fauves at
this time, he remained aloof from their
research into form for its own sake in order
to confront a controversial social topic.
*Bibliography*: Moskowitz, 1963, no. 935

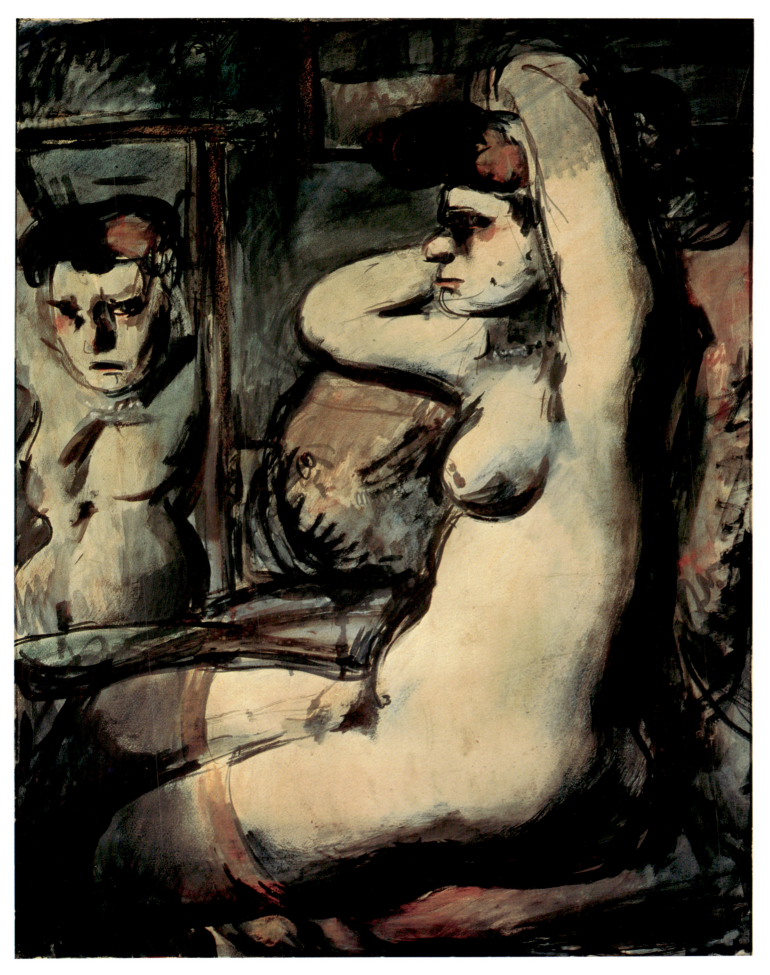

« Testa di fanciulla » Carrà 916

Carlo Carrà (Quargnento 1881–Milan 1966)
*Head of a Girl*
Ink on light brown paper; $13\frac{3}{4} \times 7\frac{1}{2}$ in.
(350 × 190 mm.)
Milan, Castello Sforzesco

It was Carrà himself who named this
geometrical study *Testa di fanciulla* ('Head
of a Girl'), which is signed and dated '916',
that is 1916, the year in which he began to

be drawn to Metaphysical Painting.
Sculptures similar to this 'Head' often
appear in paintings by Carrà, such as *The
Inebriated Gentleman*, which dates from 1916
and is now in the Frua Collection, Milan, or
*The Engineer's Mistress* of 1921, in the
Mattioli Collection, Milan.
*Bibliography*: Carrà, 1977, no. 179; Massari,
1978, no. 25

Marc Chagall (Vitebsk 1887)
*The Anniversary*
Pencil; 9 × 11½ in. (229 × 292 mm.)
Provenance: presented by the artist
New York, Museum of Modern Art

Realism and Symbolism blend in this
fascinating pencil drawing, signed and dated
'Chagall 1915 7/7'. It is squared-up because
the artist produced it as a preliminary study
for the first of a series of paintings to
celebrate family occasions. There are two
painted versions of this sheet, both of which
are in New York – one, dated 1915, in the
Museum of Modern Art, the other, 1915–23,
in the Guggenheim Museum.
*Bibliography*: Moskowitz, 1963, no. 953

Umberto Boccioni
(Reggio Calabria 1882–Verona 1916)
*Dynamism of a Cyclist*
Pen and brush with ink hatching;
$8\frac{1}{4} \times 12\frac{1}{8}$ in. (211 × 309 mm.)
Milan, Castello Sforzesco

One of the leading exponents of the Futurist
movement in the field of the figurative arts,
Umberto Boccioni founds his artistic
expression on the concepts of dynamism and
simultaneity. This pen and brush study bears
a close resemblance to another version of the
same subject that appeared in *Lacerba* on 1
October 1913.
*Bibliography*: Ballo, 1964, no. 554; Fezzi,
1973, no. 23

Gino Rossi
(Venice 1884–Sant'Artemio di Treviso 1947)
*Breton National Dress*
Pencil; $9 \times 11\frac{1}{4}$ in. (230 × 285 mm.)
Venice, private collection

This sheet belongs to the period beginning in
1907 that the artist spent in Brittany. Rossi's
contact there with the strongly delineated
painting and three-dimensional use of colour
of the group known as the Nabis, as well as
his acquaintance with the linear style of Art
Nouveau, greatly increased his graphic
fluency.
*Bibliography*: Unpublished

Giorgio Morandi
(Bologna 1890–1964)
*Still Life*
Watercolour; $7\frac{7}{8} \times 11\frac{7}{8}$ in. (200 × 300 mm.)
Venice, private collection

The many 'Still Lifes', drawn, painted and
engraved, which were inspired by the style of
Cézanne, have a symbolic purpose in
Morandi's art. They provide him with the
means to explore the values of shapes and
spatial relationships of material things,
without ever losing his extraordinary
awareness of the pictorial value of form, in
an atmosphere where even the most subtle
chromatic effect vibrates.
*Bibliography*: Leymarie, 1968, no. 16;
London Exhibition, 1970–1, no. 82; Paris
Exhibition, 1971, no. 82

364

Pio Semeghini (Quistello 1878–Verona 1964)
*Little Girl with Fruit in Her Lap*
Pencil, pen and pastels; $8\frac{1}{4} \times 11$ in.
($210 \times 280$ mm.)
Verona, Semeghini Collection

Impressionism and the influence of Cézanne,
combined with the Lombardic-Venetian
chromatic tradition, are at the root of Pio
Semeghini's artistic expression. In his works,
which are characterized by an intensely
lyrical vein, the colour seems to melt away,
leaving the shape transformed into effects of
pure light.
*Bibliography*: Magagnato, 1979, no. 173

Filippo De Pisis (Ferrara 1896–Milan 1956)
*Portrait of Pirandello*
Ink wash on paper; $19\frac{3}{8} \times 13\frac{7}{8}$ in.
($490 \times 350$ mm.)
Venice, private collection

In this incisive portrait of Luigi Pirandello,
executed in 1930, De Pisis has adopted a
rapid, spontaneous technique that permits
no uncertainties or changes of mind. With a
few decisive strokes of his brush he has
created an intensely expressive likeness that
has skilfully captured the sitter's personality.
*Bibliography*: Valsecchi, 1971, no. 8; Birolli,
179, p. 191

Alberto Viani
(Quistello 1906)
*Figure*
Pen and black ink;
$27\frac{3}{8} \times 19\frac{3}{8}$ in.
(695 × 491 mm.)
Venice, private collection

This study is in the same style as the artist's most recent group of sculptures which, especially those of the 1970s, tend towards the straightforward Naturalism typical of his early work. The linear quality of his penmanship shows the influence of Ingres and Rodin.
*Bibliography*: unpublished

Giacomo Manzu
(Bergamo 1908)
*The Painter and His Model*
Pencil; $14\frac{1}{8} \times 18\frac{7}{8}$ in.
(358 × 478 mm.)
Ardea, Friends of Manzú Collection

The theme of the artist and his model, a favourite of Manzù since he was a young man, is returned to here in 1959. The work of a sculptor, this drawing is characterized by its plastic rhythm and the play of light on the smooth surfaces of the female nude in contrast with the background figure, drawn in with a few, decisive strokes.
*Bibliography*: Rewald, 1966, p. 93

Marino Marini (Pistoia 1901–Viareggio 1980)
*Composition in Red*
Tempera on card;
$15\frac{1}{4} \times 9\frac{3}{8}$ in.
(287 × 238 mm.)
Milan, Castello Sforzesco

The 'rider and horse' theme that recurs constantly in Marini's work from 1935 to 1960 returns in this *Composition in Red*, which is signed at centre bottom 'Marino 1950'. Ignoring plasticity in favour of two-dimensionality, the artist has reached the limits of abstraction, without losing the characteristic expressiveness of his style.
*Bibliography*: Precerutti, Garberi, 1973, D81

367

Paul Klee
(Münchenbuchsee 1879–Muralto 1940)
*Symbiosis*
Pencil; $19 \times 12\frac{5}{8}$ in. ($482 \times 320$ mm.)
Berne, Felix Klee Collection

Paul Klee's graphic work is closely linked
with his painting, as in both media he is
searching for an 'absoluteness' of form. In
fact, his drawing – which is often executed in
thread-like lines – depicts images that assail
his whole poetic world in an unstable
balance between reality and its projections
into the realms of dreams, fantasy and
magic.
*Bibliography*: Grohmann. 1959, p. 175

Wassily Kandinsky
(Moscow 1866–Neuilly-sur-Seine 1944)
*Study for 'Improvisation 160 b'*
Watercolour; $14\frac{3}{4} \times 21\frac{5}{8}$ in. (375 × 550 mm.)
New York, Solomon R. Guggenheim
Museum, Hilla Rebay Collection, inv.
190.127

This 1912 watercolour, in which the artist
has abandoned Representationalism, belongs
among the early results of his research into
the abstract qualities of colours and shapes,
begun in 1910 with his *First Abstract
Watercolour* and developed along parallel
theoretical lines. Blotches of deep colour,
transparent blurring and linear tracks, create
a feeling of space in movement which is
typical of the whole series of paintings called
'Improvisations'.
*Bibliography*: Zander Rudenstine, 1976, p.
248

Piet Mondrian
(Amersfoort 1872–New York 1944)
*The Sea*
Charcoal and gouache; $3\frac{1}{2} \times 4\frac{7}{8}$ in.
(90 × 123 mm.)
Venice, Peggy Guggenheim Collection

This symbolic drawing, dated 1914, is one of a series of works which demonstrate the progressive process of abstraction followed by Mondrian in his representation of Nature. It was, indeed, through this – as he declared many years later – that he had come to understand how to capture 'extensiveness, calm and unity' by making use of 'a multiplicity of crossed verticals and horizontals' to convey the 'plastic function' of the sea, the sky and the stars.
*Bibliography*: Guggenheim, 1942, p. 54; Seuphor, 1956, p. 125 and cat. 229

Max Ernst (Brühl 1891–Paris 1976)
*Motherhood*
Pencil heightened by white chalk on orange paper; 19 × 12 in. (479 × 308 mm.)
Provenance: Levy
New York, Museum of Modern Art, Gift in memory of William B. Jaffe

Max Ernst became involved in Surrealism after he had moved to Paris. A remarkable fluidity of line characterizes this study which he produced as a preparatory drawing for his *Surrealism and Painting* in the Copley Collection, Longport-sur-l'Orge. In the drawing, the artist has made use of the traditional technique of black pencil heightened with white to give life to this mysterious and inscrutable symbol of motherhood.
*Bibliography*: Lieberman, 1961, no. 228

Joan Miró (Barcelona 1893)
*The Family*
Black and red chalks on emery paper;
29½ × 41 in. (750 × 1040 mm.)
Provenance: Mitchell
New York, Museum of Modern Art

This composition dates from 1924, the year
in which Miró began to associate himself
with the Surrealist movement through his
friendship with André Masson. The work
seems like a revaluation of the unconscious:
in a world of dreamlike images, it is laden
with allusions and symbolism, the figures of
the father, mother and son becoming like
menacing insects.
*Bibliography*: Penrose, 1970, no. 24

Salvador Dalí (Figueras 1904)
*Study for 'The Madonna of Port Lligat'*
Chinese ink and watercolour; 7½ × 5½ in.
(190 × 140 mm.)
Paris, private collecdion

In his drawing as in his painting, Dalí's
underlying ideology is based on
Metaphysical and Cubist impressions with
vigorous grafts of psychoanalytical theory.
Thus the artist combines – especially in his
drawings – the most delirious fantasy, as in
this preparatory study for one of Dalí's best-
known paintings, *The Madonna of Port
Lligat*, in Lady Beaverbrook's collection in
Canada.
*Bibliography*: Descharnes, 1962, p. 176